SMALL TOWN
America

SMALL TOWN

America

The Missouri Photo Workshops
1949-1991

Cliff and Vi Edom • Verna Mae Edom Smith

FULCRUM PUBLISHING • GOLDEN, COLORADO USA

PRODUCER:	RICH CLARKSON; *Denver, Colorado*
DESIGNERS:	BILL MARR; *Philadelphia, Pennsylvania*
	KIM MOLLO; *Philadelphia, Pennsylvania*
EDITOR:	JANE LAGO; *Columbia, Missouri*
PICTURE EDITOR:	SANDRA EISERT; *San Jose, California*
TEXT EDITOR:	DARYL MOEN; *Columbia, Missouri*
COORDINATOR:	BILL KUYKENDALL; *Columbia, Missouri*
ASSISTANT:	DAVID STERLING; *Columbia, Missouri*
ADVISORY GROUP:	BILL EPPRIDGE; *Wilmington, Delaware*
	T. MIKE FLETCHER; *St. Louis, Missouri*
	WILBUR E. GARRETT; *Great Falls, Virginia*
	ROBERT E. GILKA; *Arlington, Virginia*

The editorial preparation of this book and the curatorial work for an exhibition of Missouri Workshop photographs were made possible by grants from:

ENERGIZER PHOTO BATTERIES, *St. Louis, Missouri*

HALLMARK CARDS, *Kansas City, Missouri*

SOUTHWESTERN BELL TELEPHONE CO., *St. Louis, Missouri*

Copyright © 1993 by Viola C. Edom and Verna Mae Edom Smith

LIBRARY OF CONGRESS CATALOGING-IN-PUBLICATION DATA
Edom, Cliff.
 Small town America : the Missouri photo workshops, 1949-
1991 / Cliff and Vi Edom, Verna Mae Edom Smith
 p. cm.
 Includes bibliographical references (p.) and index
 ISBN 1-55591-167-6
 1. Cities and towns—Missouri—Pictorial works.
 2. City and town life—Missouri—Pictorial works.
 I. Edom, Vi. II. Smith, Verna Mae Edom. III. Title.
HT 123.5.M57E36 1993
307.76'2'09778—dc20 92-23715
 CIP

Printed in Hong Kong
by C & C Offset Printing Co., Ltd.

Fulcrum Publishing
350 Indiana Street, Suite 350
Golden, Colorado 80401-5093

CONTENTS

THIS BOOK IS DEDICATED
TO THE GRANDCHILDREN AND GREAT-GRANDCHILDREN OF CLIFF AND VI EDOM:

Tony Smith
Teri Smith Freas
Tessa Elizabeth Freas
Sarah Catherine Freas

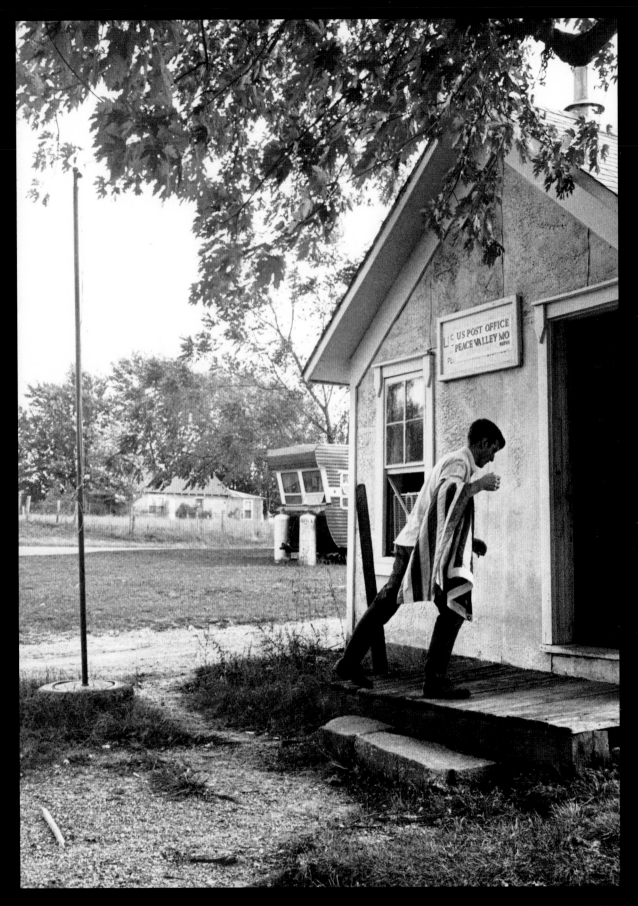

WEST PLAINS 1971

Photograph by Brian Moss

EDITORS' NOTE:

There was no precedent for this type of workshop, nor for the operations in the darkroom that supported it. Unfortunately, some of the negatives were not identified, and it has proved impossible to provide the names of all the photographers. Likewise, because the daily critiques during the workshops were verbal, no record is available to tell us about the subjects or the circumstances of the photographs. Yet a picture is worth a thousand words, and we hope that all these pictures will speak elegantly without any additional caption information.

SMALL TOWN
America

CLIFF EDOM
1907 – 1991

"We believe that documentary photography is the background—the roots, if you please—of modern photojournalism. In an effort to echo and reecho the Roy Stryker concepts of picture communication, the Missouri Photo Workshop was begun. The serious in-depth approach to a picture story at a Workshop adds to the spontaneity, the integrity, and the believability of the pictures. It is truth with a camera."

—CLIFF EDOM

TRUTH WITH A CAMERA

Verna Mae Edom Smith, Ph.D.

MENTION SMALL TOWN AMERICA AND WE ENVISION IDYLLIC IMAGES OF laughing children at play, neighbors sitting on front porches after dinner, and entire families dressed for Sunday church. These towns are characterized as places of familiarity, where people are presumed to really care about one another. Sociologists describe close-knit communities as having "face-to-face" relationships, as being made up of "primary groups" where "social control" is easy because all share the same values and expectations.

This is in contrast to the crowded cities where people who live next door don't know each other, where life is rushed and impersonal, where expectations are almost impossible—and everyone longs nostalgically for the small towns of the past or of the imagination.

Pictured from these Missouri Workshops is the real importance of family—often an extended family—living wonderfully in the same community for generations. Everyone knows everyone else at school, at church, at Rotary, and the town editor knows more than he prints.

These pictures take us beyond the greeting-card images of small towns because of the real people in them: the strength of individualism and the frailties of fear that we recognize as our own. We find that disease, divorce, poverty, drugs, alcoholism, and pain also live here. Through the rich archive of these workshop pictures we feel like we belong—belong with the teenagers at the Rexall Drug Store, the adults at the diner or pool hall, the aged at the retirement home. We share the feelings of flirting teenagers, of proud grandparents, of gossiping barbershoppers.

And the photographers whose sensitivity and skill preserved these moments for us were simply returning to the small towns they once knew or wish they had known. For many, it was a new experience to be in a place where car doors—often front doors—are left unlocked and one can be invited to dinner at the drop of a Missouri hat. Through these photographs we experience the reality of Small Town America, the feelings and dreams of those people who live there. It is, indeed, *truth with a camera.*

VERNA MAE EDOM SMITH PH.D.
is the daughter of Cliff and
Vi Edom and a sociology
educator, freelance writer,
and photographer.
She teaches at Northern Virginia
Community College
in Manassas, Virginia.

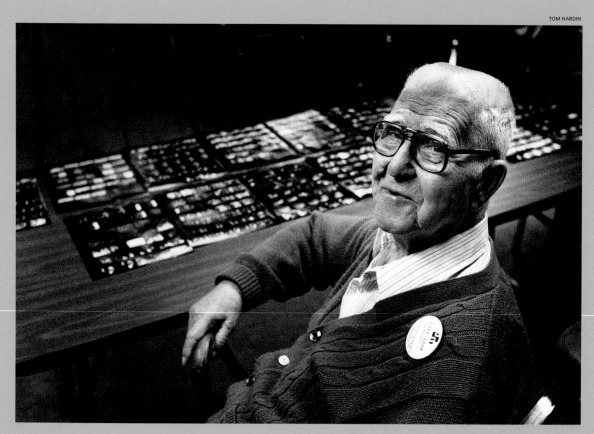

CLIFF EDOM,
founder of the Missouri Photo Workshop
and father of photojournalism education.

THE EDOM YEARS

Howard Chapnick

IN 1949 AN EXPERIMENT IN PHOTOGRAPHIC EDUCATION CALLED THE UNIVERSITY
of Missouri Photographic Workshop took place in Columbia, Missouri. It realized the dream of
Professor Clifton C. Edom, an unprepossessing down-home taciturn midwesterner whose
combative jutting jaw, direct eyes, and close-cropped hair underscored his no-nonsense approach
to education. That first workshop was an unpretentious, modest effort to provide a group of
twenty-three photographers access to the community life of this small Missouri college town for
the purpose of honing and developing their photojournalistic skills.

Forty-three years later more than two thousand students and three hundred staffers have had
their journalistic philosophies shaped by their involvement with this unique workshop. In the
process they have produced a visual biography of Missouri rural life with an unparalleled
collection of documentary photographs. Without a conscious effort, a historical record has been
made of decades that span dramatic changes in the mores and customs of American life in
general and rural life in particular. Life in rural Missouri has been affected by television and
technology, the decline of the family farm and the rise of agribusiness, the generational schism of
the 1960s, the wars in Vietnam, Korea, and the Gulf, and an unprecedented sexual revolution.
Yet it remains a comparatively bucolic anchor in a world of increasing complexity.

This book is a family album. The family is composed of Missourians whose daily lives were
preserved by the photographic efforts of workshop students under the guidance of Cliff Edom
and the staffs he assembled. To understand the work produced by photographers at the Missouri
Workshop, we must place it in the context of photojournalism and documentary photography.

Almost every realistic photograph that provides information of a factual nature based on actual
events is a documentary photograph. The documentary photograph often bears witness to
history. It refutes the lies of historical revisionists. It captures the richness of life's arena and
explores the darkest corners of the human experience. There is implied objectivity, a

HOWARD CHAPNICK
is retired president of Black
Star Publishing Company,
New York City, and a faculty
member at thirteen
workshops since 1966.

recording of people, places, and things as they are. That implied objectivity also mandates that the documentary photographer is restricted to taking unmanaged, unmanipulated, and unrehearsed images.

Pure objectivity in photography probably doesn't exist. Subjectivity inserts itself into what is photographed and when, what is included or excluded, and what vantage points are chosen. By their very nature, photographs are ambiguous, and much of what the photograph means depends on the viewer. That ambiguity is recognized in the Thematic Apperception Test (TAT), a psychological test that uses interpretations of photographs as a determinant of normal responses. Naomi Rosenblum says in *The History of Photography,* "Documentary photographs are most memorable when they transcend the specifics of time, place and purpose. When they invest ordinary events and objects with enduring resonance. When they illuminate as well as record."

The American documentary tradition owes a debt to the cumulative realization of nineteenth-century photographers that the camera was ideal for topographical, sociological, anthropological, and historical recording. Those photographers documented and preserved for us and future generations the opening of the American West, the construction of its railroads, and the grandeur of its wilderness. The twenty photographers who composed what became known as the Mathew Brady group left us an engrossing visual document of America's most destructive war, the Civil War. The photographs showed us the harvest of the battlefield—uncompromising valor and agonizing death. Scientific and medical documentation gave us new insights into human physiology and psychology. Through documentary photography we visually preserved the natural beauty of the landscape, extended architectural knowledge, and realized its power to affect public thought and opinion on socially related issues.

Documentary photography often serves to authenticate anthropological study by preserving observations about societal customs and culture. It saves the past from becoming the detritus of history, reflects the present, and anticipates the future. It helps us to understand the constantly changing social and physical universe mankind inhabits.

Documentary photography and photojournalism have become virtually synonymous in the eyes and minds of today's photographers. The socially conscious work of such photographers as Jacob Riis, Lewis Hine, Dorothea Lange, and W. Eugene Smith was prologue to the deeply probing efforts of contemporary photojournalists. Many documentary humanistic photographers no longer make a pretense of objectivity and are now most often the protagonists of social change.

1951
Cliff Edom and Russ Lee at
the Hermann workshop.

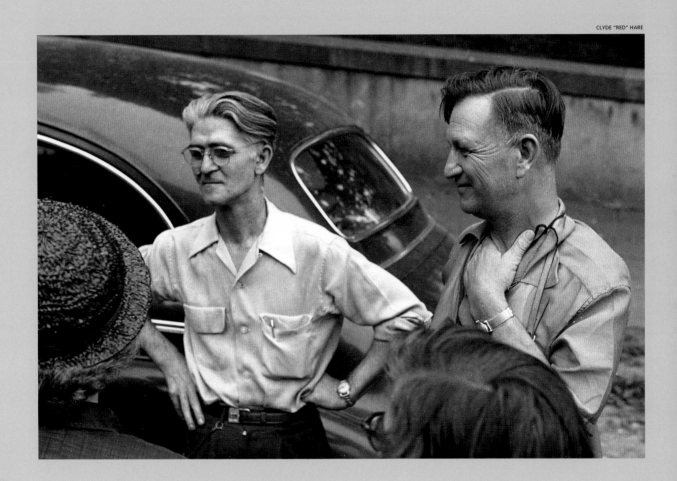

1952
The workshop assembled in
Jefferson City.

They are imbued with the spirit of Roy Emerson Stryker's Farm Security Administration (FSA) project, the most definitive record of rural life in America ever made.

Roy Stryker brought together a remarkable group of photographers, which included the likes of Gordon Parks, Dorothea Lange, Arthur Rothstein, Russell Lee, Ed Rosskam, Walker Evans, and Ben Shahn, to visually interpret the underbelly of American rural life during the Great Depression. This overtly propagandistic effort was designed to generate a congressional response to the economic plague that engulfed the heartland of America during the Great Depression of the 1930s. Strong-willed, stubborn, and tenacious, Roy Stryker was uniquely qualified to withstand political pressures, protect the photographers from interference in their personal vision and interpretation, gain acceptance for the photographs in the press, and provide for the preservation of this historic documentary project in the Library of Congress.

It seems fated that in 1943 the triumphant Roy Stryker, fresh from his success at the Farm Security Administration, and Clifton C. Edom, an obscure, unknown, newly appointed photography professor at the University of Missouri, would come together. They were kindred spirits with matched personalities united in commitment to the importance of documentary photography. Stryker had moved from the government bureaucracy to an important and highly financed photographic documentary project on American industry supported by Standard Oil of New Jersey.

Edom was struggling with the development of a cogent photojournalistic teaching program at Missouri. Photojournalism in the United States was still in its infancy, just having been fertilized by Henry Luce in the startup of *Life* and by the Cowles publishing empire's launching of *Look* magazine in 1936. They launched a new era in photography as the first large-circulation mass-media picture magazines emphasizing journalistic and documentary work.

Henry Luce was a journalistic innovator and visionary who had familiarized himself with the successful groundbreaking picture journalism efforts in Germany and England. His prospectus for *Life* read, "To see life, to see the world; to witness great events; to watch the faces of the poor and the gestures of the proud; to see strange things—machines, armies, multitudes, shadows in the jungle and on the moon; to see man's work—his paintings, towers, and discoveries; to see things thousands of miles away, things hidden behind walls and within rooms, things dangerous to come to; the women that men love and many children; to see and take pleasure in seeing; to see and be amazed; to see and be instructed."

Photojournalism teaching techniques were foreign to academia. It was through his frustration and disappointment with the inability of standard photographic curricula to respond to this new dimension in photography that Edom began to correspond with Stryker. In 1949, that correspondence resulted in the birth of the University of Missouri Photographic Workshop under the stewardship of Cliff Edom and his energetic wife, Vi. As an employee of the Missouri Press Association, Vi had contacts with small-town newspapers throughout rural Missouri. That contact later helped the workshop to access small Missouri towns.

It was a modest beginning, with five staff members drawn from the top echelon of the meager practitioners of photojournalism. Headed by the eminent Roy Stryker, the staff included two photographers, Rus Arnold and Harold Corsini, and two top picture editors, one from a newspaper and one from a magazine: Stan Kalish of the *Milwaukee Journal* and John Morris of the *Ladies' Home Journal*.

That first workshop was an experiment that brought together the five staff members with twenty-three students who were challenged to interpret their vision of life in Columbia, Missouri. The photographers were asked to find story ideas in the town that would reveal its uniqueness as well as its universality. One week later, the staff selected seventy-five pictures that purported to tell the story of Columbia. But, in fact, what had been accomplished was that the workshop participants had learned a new way to think about and see pictures.

The genius of Cliff Edom lay in his understanding that by bringing budding photographers to the small towns of Missouri, he was providing them with a laboratory that could serve as a microcosm of life in small town America everywhere. He recognized that in these small towns the people would be more approachable for photographers than would the people in large, bustling, impersonal metropolitan areas. In these towns was the stuff of life where people lived close to the land in the heartland of America. The idyllic qualities of rural life were counterbalanced by the problems of poverty, disease, alcoholism, divorce, and the many complications that affect all communities.

In the early years of the workshop there was a tendency for the photographers to choose positive story ideas that glorified the towns and their inhabitants and romanticized rural life. Professor Edom welcomed that approach since he was concerned about offending the host communities with stories that might reflect adversely on the towns and their people. Such stories reinforced a

1955
Critique of students' work
during the evening session.

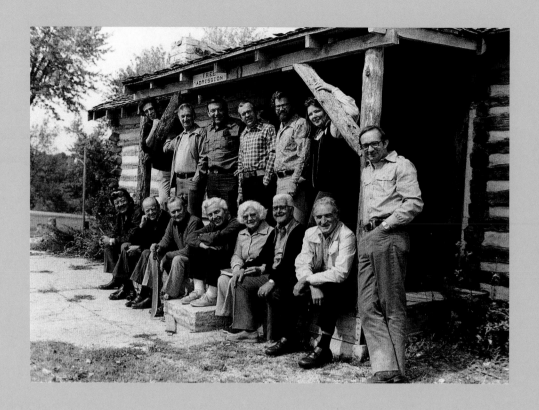

1976
The faculty in Forsyth.
Back row: Bill Eppridge,
Russell Lee, Earl Seubert,
Rich Clarkson, Chip Maury,
Sandra Eisert. **Front row:**
K. Kenneth Paik, George
Shivers, Howard Chapnick,
John Morris, Vi and Cliff
Edom, Gerald Holly, and
Bill Strode.

Norman Rockwell misconception that real-life problems were foreign to rural America. This resulted in a yearly proliferation of redundant stories about the country doctor, the village blacksmith, the bank president, the mayor, and the town sheriff.

Under the prodding of the staff, Edom was ultimately convinced that meaningful documentary photography in a community required that the workshop photographers should penetrate into darker corners of town life. Coincident with parallel explorations in newspapers and magazines, the subject matter dealt with by the workshoppers embodied conflict and substantive content. Subjects like teenage pregnancy, single parenthood, and homosexuality became common themes in workshop stories.

Forty-three years later, the annual Missouri Workshop has evolved into a structured institution where the original serendipitous activity has been replaced by a well-defined educational approach. Cliff and Vi Edom's legacy lies in their contributions to photojournalistic education and the historical preservation of an unprecedented multiyear photographic record of life in small town America. The rural America of 1991, buffeted by the winds of social and technological change, is dramatically different from that of 1949. The depth-of-time photographic document on these pages is punctuated by a sense of time and place. In the process of making these images, those photographers have been shaped in a demanding educational crucible. Many have emerged as better photojournalists for the experience. The Missouri Workshop is a four-year college education condensed into one fantastic, exhilarating, exhausting, brutal week where one learns not only about photography but also about one's self.

The decades spanned by the Missouri Photographic Workshop have witnessed an astounding commitment by documentary and journalistic photographers worldwide to recording hitherto undocumented areas of society. David Douglas Duncan revolutionized war photography during the Korean War by showing us the human dimension of war as it had never before been recorded. An army of war photographers descended on Vietnam to show us scenes of unforgettable, unbearable, and uncensored violence. Those visual documents changed a country's perceptions about the justness of the war and ultimately crystallized a public outcry against further U.S. involvement.

Almost simultaneously photojournalists were recording the volatile social ferment of events in America and affecting the outcome of the civil rights struggle to repair the injustices perpetrated on the discriminated and disenfranchised. The raucous protests marking the generational schism

underlined the efforts of young people to change the values of what they perceived as an overly materialistic society. Photographers confronted these issues and recorded the alternative life-styles that characterized the flower-child movement of the 1960s. In sum, a whole generation of photographers with no organization like the Farm Security Administration to fund or organize them developed their own tradition of concern for photographic social documentation. Personal vision and personal concern replaced objective documentation throughout the world.

Newspaper photojournalism throughout the years has been strongly affected by the University of Missouri curriculum and the yearly workshop. Prior to the establishment of a photojournalism sequence at Missouri by Cliff Edom, newspaper photographers had little photojournalistic education. They learned by doing. Edom had a seminal influence in expanding the horizons of newspaper photography, in providing newspapers with a flow of well-informed photographers and picture editors steeped in the philosophy and ethical principles defined by Missouri. The "Missouri Mafia," as influential people in the field of photojournalism have come to be known, have spread the gospel to the remotest corners of American journalism.

"Show truth with a camera," said Cliff Edom. If he made no other contribution to photojournalism, Edom will be remembered as a man who brooked no tampering with the integrity of the journalistic photograph. To Edom honesty was a sacred trust. You didn't organize, manipulate, or manage a photograph. You didn't make a photograph. You took it. You photographed the reality of things as they were, not the way you preconceived them or would have liked them to be.

Cliff Edom was an instinctive alchemist and catalyst. He was less a teacher than a dominating presence. The educational mixture he brewed came from the supportive loyalty and tireless energy of his wife, Vi, from designing an itinerant campus of Missouri small towns, and from bringing together staff members characterized by their diversity. Cliff forsook staff homogeneity in favor of differing backgrounds, temperaments, philosophies, knowledge, opinions, and expertise.

That dominating presence is gone now. Cliff Edom attended his last workshop in 1990 shortly before his death. Nothing is forever, but the Missouri Workshop lives on in his image. It remains a voyage of personal and photographic discovery based on one week's total immersion in a thinking process that demands determination and toughness to survive the experience. This book is his gift to all generations of Missourians and photojournalists. This book is his testament to the two worlds he loved.

VI EDOM,
ever present in all
Cliff's endeavors, stands
backstage during a
Pictures of the Year
awards presentation at
the University of Missouri.

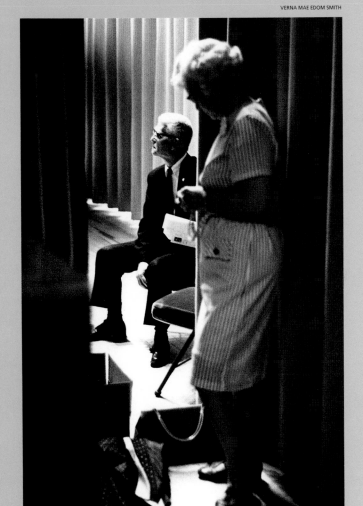

ROLLA 1955

James L. Grant

SMALL TOWN AMERICA

Frank Conroy

IF AMERICA SEEMS VAST TO US NOW, HOW MUCH VASTER IT MUST HAVE BEEN in the imaginations of those living in it before commercial jets, the interstate highway system, instantaneous satellite communications, and the standardization of retail goods through franchising. American culture is not homogeneous today—not by a long shot given the geographical concentration of the poor (on a scale undreamed of by previous generations), the new wave of immigration from Asia and Latin America (no homesteaders this time), and the bone-deep regional pride of so many of our citizens ("Missouri," says the license plate, "the show-me state"). Differences remain, but they no longer seem virtually infinite, as they once did. The mall in East Lexington, Massachusetts, is not much different from the one in Seven Sisters, Texas. It may be the Pizza Huts, Midas Mufflers, and Walmarts that stitch this country together, threads running from Florida to Oregon, from New Orleans to Chicago, from Arizona to Maine, and the efficiency of the system is nothing to be sneezed at. (It's the envy of the world, in fact.)

But something has been lost, or if not lost, eroded: the stabilizing, civilizing, intimate communal experience of the small town. For a very long time it was the small towns that held the country together, that kept it from fragmenting as a result of its great centrifugal energies. If the first social unit was the family, then the second was the small town. Tens upon tens of thousands of them across the wide face of the land, as numerous as stars in the night sky, they provided the reference points for the moral sextant of the country. It was the towns, and not the cities, that provided the underpinnings for the great American experiment.

What were the forces that gave rise to them? No doubt at first the economics of barter and trade played a large part. The image of the small town as the commercial and civic hub of an agricultural area perhaps fifty times the size of the town itself is familiar. The courthouse played a role as well, perhaps; certainly the general store did, along with the blacksmith, the barbershop, and pharmacy, the church, the school, and so on. Representing sudden densities of population in

FRANK CONROY is director of the Iowa Writers' Workshop, author of *Stop Time* and *Midair,* and a regular contributor to magazines including the *New Yorker* and *Harper's.*

the enormous, thinly settled or empty expanses of land, towns formed in the prairies, at the entrance to a mountain pass, at the junction of a river and a railroad, at the center of a fertile plateau or delta, at a convenient source of water power—indeed, almost everywhere the lay of the land provided the slightest encouragement. Economics conjoined with topography, and communities were born that knew exactly what they were about—to handle the harvest, refine the ore, mill the lumber, get the cattle to market, manufacture the item, give rest to the traveler, or any of a host of missions responsible for the existence of the town in the first place. Towns flourished or withered according to how well the work got done, and people pulled together out of a sense of common interest.

Not everyone liked it, of course. When the towns got big enough and secure enough the generally conformist mores began to be challenged. Pulling together sometimes meant thinking together, and some people felt confined. In the days of the American writer Sherwood Anderson—and that was not so long ago—or of Sinclair Lewis's *Main Street* small towns were sometimes seen as ossified, intolerant, narrow-minded enclaves in which anyone the slightest bit different—the artist, the intellectual, the misfit, the genius—would eventually be crushed. Hence a kind of brain drain to the cities occurred. Very few of these exiles returned because in those days, when the cities still worked, those who left the small towns actually did find the freedom they wanted without having to pay too high a price. (Today, of course, one would have to be obscenely rich, insane, or very young to move to someplace like New York, Los Angeles, or Chicago. As many of the intelligentsia who can manage to leave those places are doing so, reversing historical trends.) But if it was a weakness of small towns that everybody knew everyone else, and everyone else's business, it was also a strength. There was a sense of communal responsibility, of taking care of one's own, that moved basic, hard-learned family values out into the larger framework of society itself. We should remember where the Town Meeting—that most justly revered American invention—came from.

In a certain sense, small towns were a dramatization of people's connection to the land, a constant reminder of our rootedness in physical nature. From that, and from the tangible reality of the social dynamic in what amounted to an extended family, came a strong sense of identity and, more often than not, pride. It may be just a small town, but, by God, it's our small town, was what people felt.

From the vantage point of the end of the century it may require a certain amount of imagination to move past the faintly patronizing imagery of a Norman Rockwell and get a handle on what it

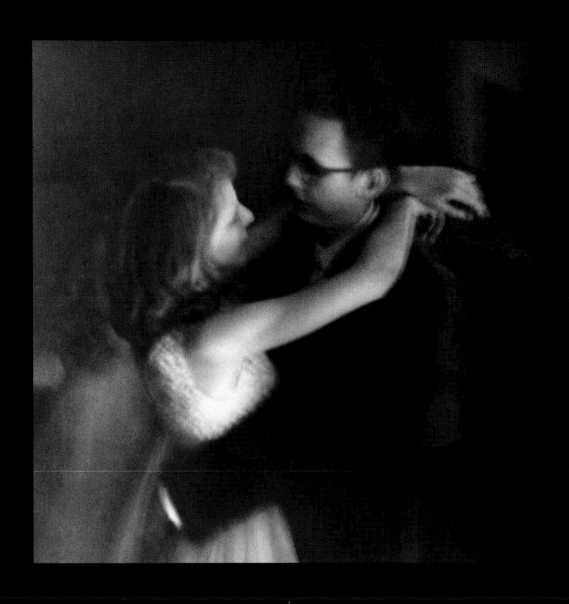

HANNIBAL 1957

must have felt like to live in one of those towns. A ten-year-old boy, too old to have his hair cut any longer at home by his mother, walks into the Main Street barbershop to sit for the first time in the very seat his father has occupied once a month for as long as the boy can remember. Or a girl goes to Miss Hicks's first-grade class knowing that her mother also went to Miss Hicks's first-grade class. A man walks down the street and nods to virtually everyone he passes because he knows them, and they know him. A woman has coffee with the spinster sisters next door every afternoon at four for twenty-five years. Downtown no one ever goes out of business—the soda fountain, the bakery, the five-and-ten, the movie theater, the hardware store, the bank, the hotel are all institutions, somehow larger than life. The rhythms of existence are long, steady, and even. The names on the war memorial in the town square are recognized by everyone who looks at them. Some who look bear the same names as those on the plaque. People came and went, were born and died, and the town endured.

Small towns were complex social organisms made up of rich and poor, Protestants and Catholics, smart and not-so-smart, ambitious and easygoing, moral and amoral, givers and takers, bullies and bullied, and so on—in other words the whole infinite spectrum of human nature. As a function of intimacy, stresses between various groups and interests were very much a part of life, and could not be escaped as they might in the cities. As a very crude example let us consider a man who loses his temper after a fender bender at an intersection and gets abusive with the other driver. In a small town he must be very careful (and is indeed subconsciously trained to be careful), lest he make an enemy he will be forced to deal with for the rest of his life. In Chicago, of course, he could simply pop the other driver in the mouth and take off, never to see him again. At a higher level people had to work responsibly to deal with each other in the attempt to reconcile forces and attitudes that might come up in deciding whether to build a new school, change the liquor laws, let the village idiot sleep in the park in the summer, put in a stoplight, change the zoning, declare a holiday, and on and on. These processes, and this care, exercised over generations, created an intangible moral center toward which the citizens inevitably positioned themselves. Again, this must surely have strengthened their sense of individual identity.

Every healthy small town had that intangible *center,* which one is tempted to go so far as to call a soul. The center would arise not so much from unanimity or from conformism, but precisely because people were so different, and yet were forced by circumstance to find common ground in order to live and grow. People in small towns could not back off from their civic and social responsibilities because to do so could result in swift, powerful, and potentially dangerous changes in their day-to-day lives, to say nothing of the lives of their children. The center may

have begun with economics and topography, but it quickly grew to include aspects of the social, the moral, and even the spiritual. It may be just a small town, but, by God, it's *our* small town. It's our life, in fact.

Now we witness the decline of the small town as an American institution. External forces have pulled at the edges to the point where the center cannot hold. A small island off the coast of Massachusetts, whose population had held at six thousand since the introduction of kerosene, is completely overwhelmed by the influx of money and people during the summer, progressive over a number of years, and finally ends up mostly owned by an investment corporation based on the mainland. The town square in Fairfield, Iowa, is architecturally intact, but mostly deserted, the shops changing hands frequently to provide marginal services such as photocopying, video renting, and the selling of science-fiction books, knickknacks, second-hand clothes, and new-age crystals. Three-quarters of a mile outside town are Walmart, Sears, the supermarket, the franchise malls, and the gas stations, motels, and Dunkin Donuts to serve the interstate highway. The automobile demands its own kind of space and imposes its own rhythms. Tens of thousands of towns wither away because the topography has changed and the economy has shifted. The common purpose has dissolved and with it the idea of the intangible center. People turn inward, and nostalgia settles like a fog.

It is ironic that at precisely the moment America reassesses the importance of family values, the particular mechanism that most efficiently weaves them into society—the small town—is fast disappearing into history. For most of our children it will be a longer and more difficult jump into the world.

MISSOURI. Seventy thousand square miles divided into one hundred and fifteen counties. River traffic north and south on the Mississippi River, and west on the Missouri River. To the north, open prairie, and to the south the Ozark plateau. A rich topography, and an economy more complicated than one might expect. Mines that yield more than ninety percent of the country's lead, more working farms than any other state with the exception of Texas, and a transport hub to boot. Small towns sprang up everywhere in this busy, populous state, once the gateway for western expansion, and as we study these photographs we can see an important part of our nation's history. "Show me," says Missouri, and we hasten to obey.

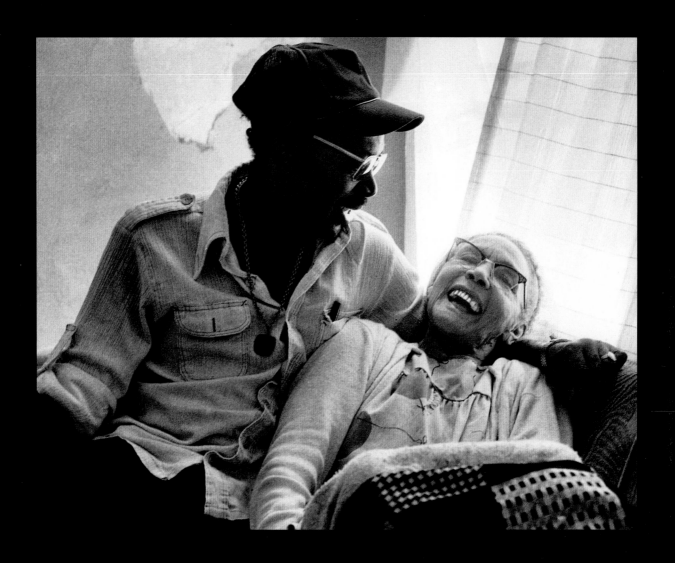

HANNIBAL 1986
Karen Mitchell

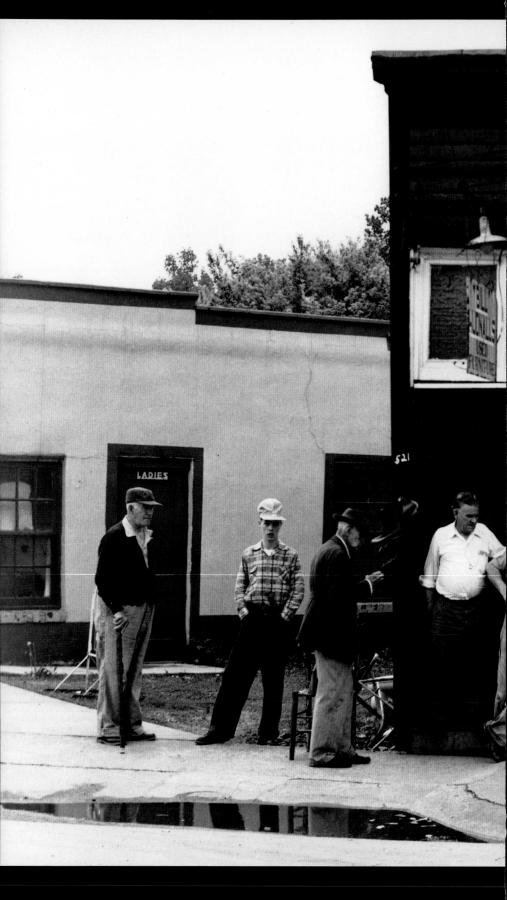

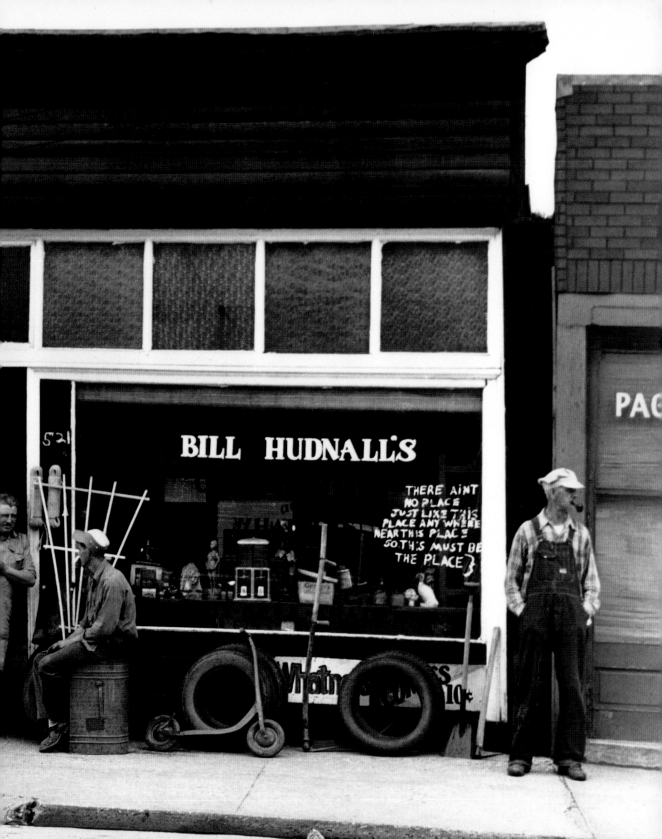

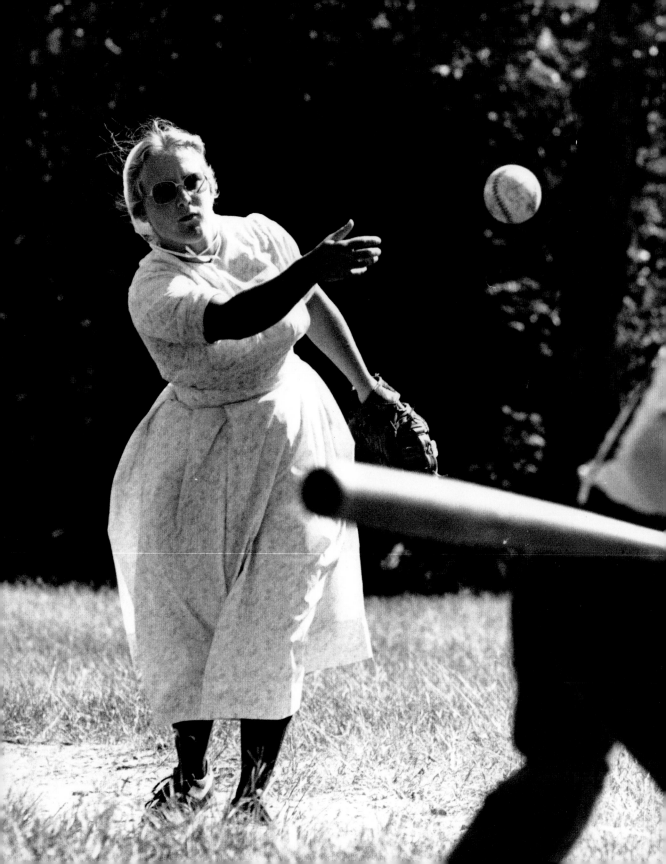

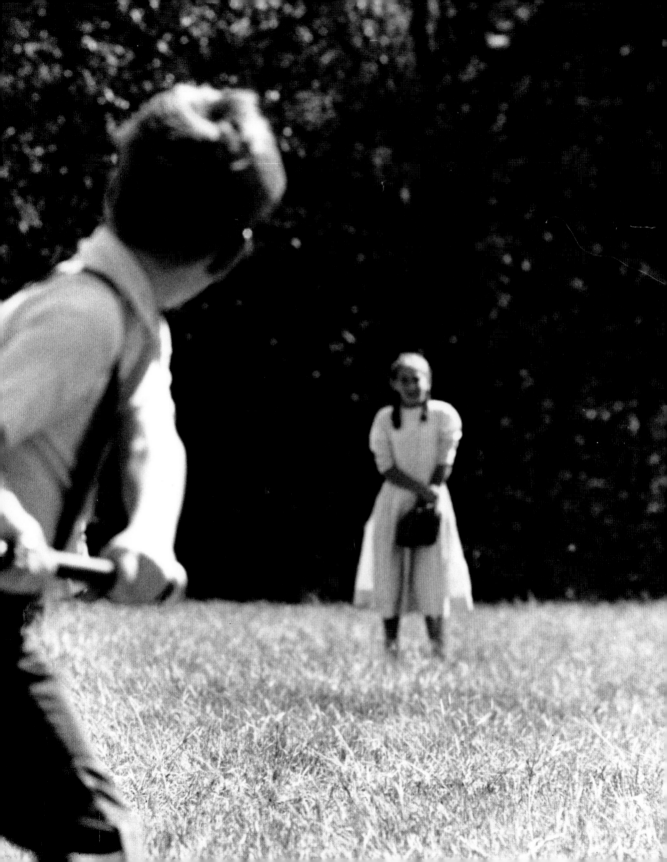

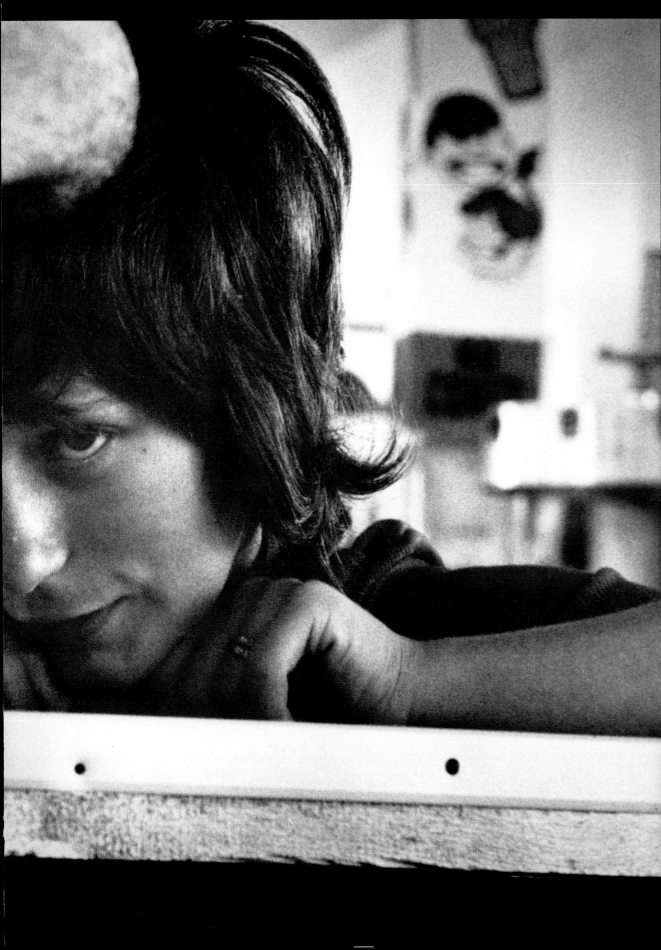

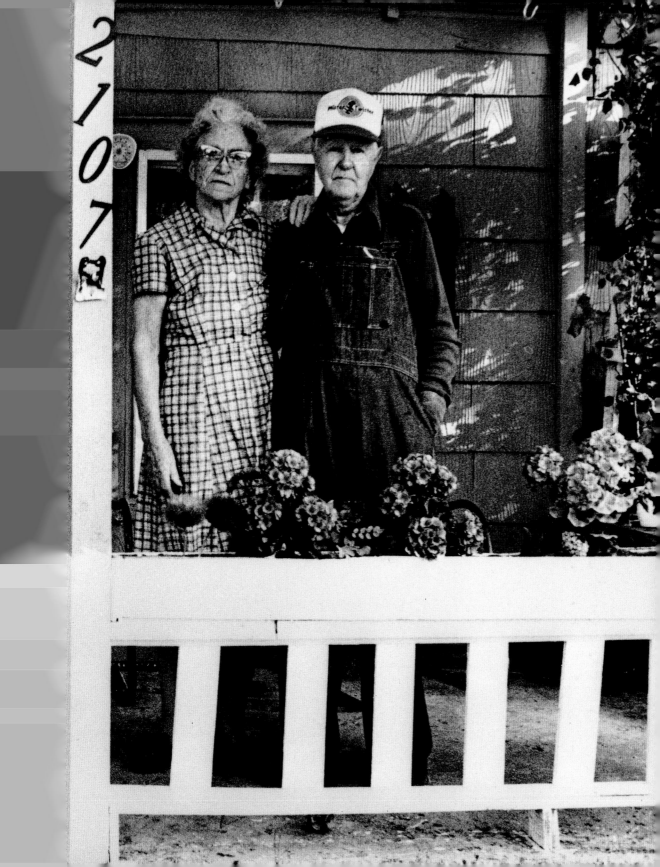

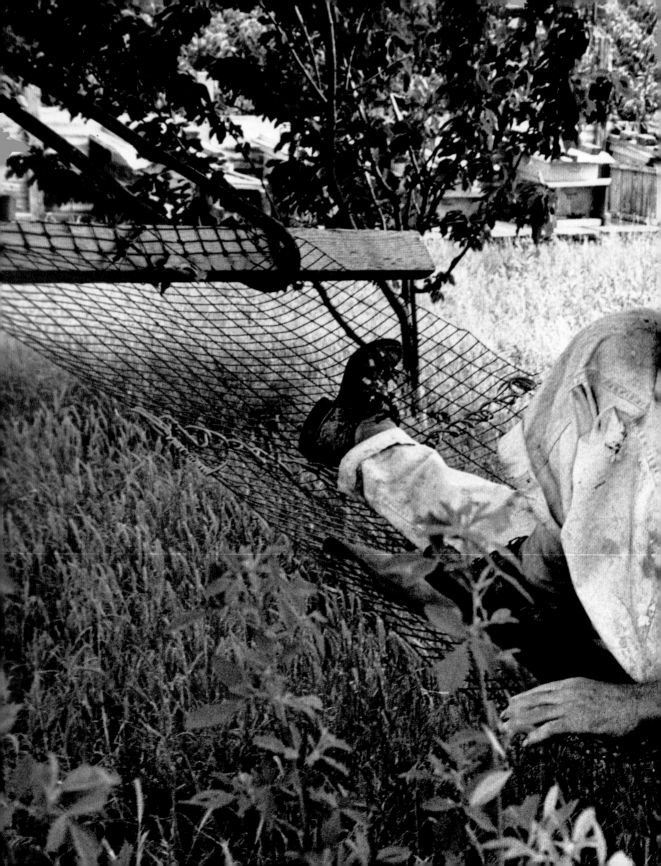

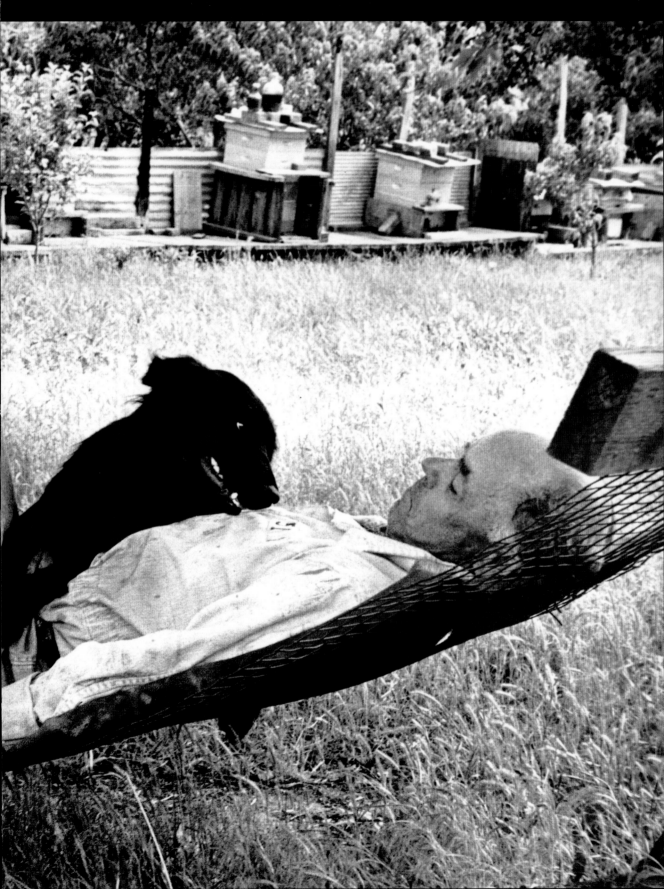

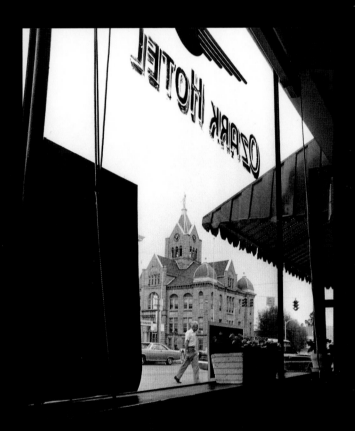

BOLIVAR 1970
Chapin Day III

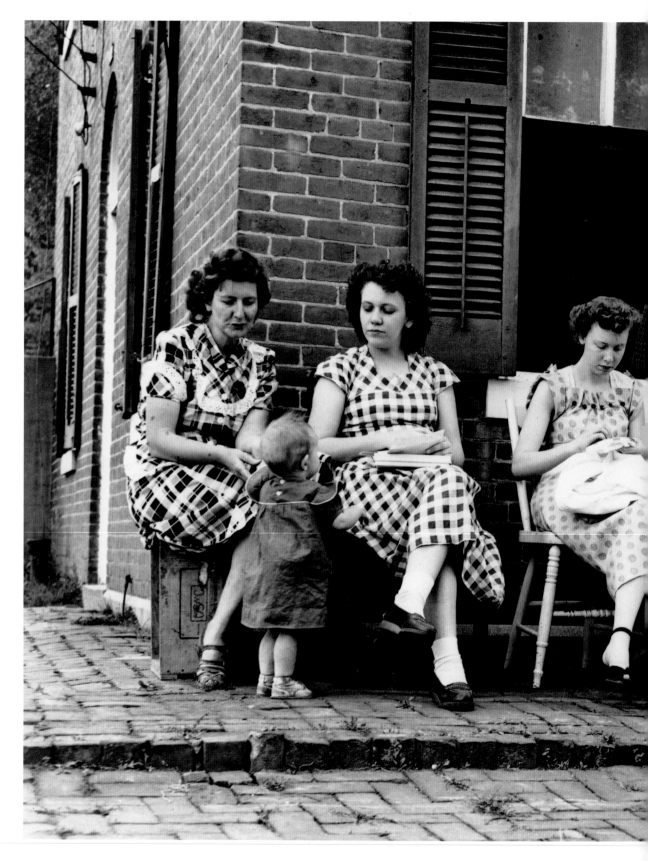

HERMANN 1951
Clyde Hare

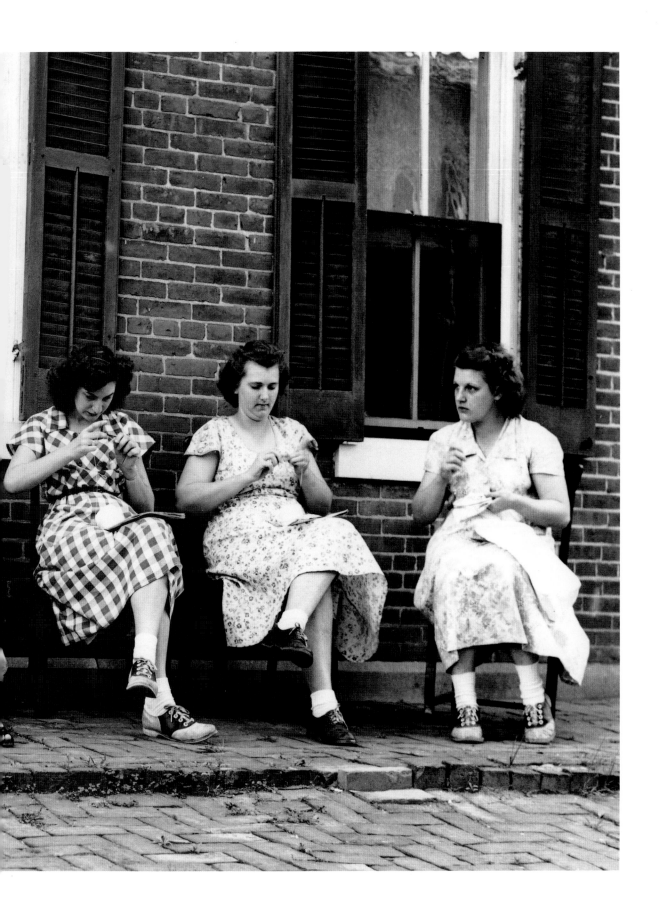

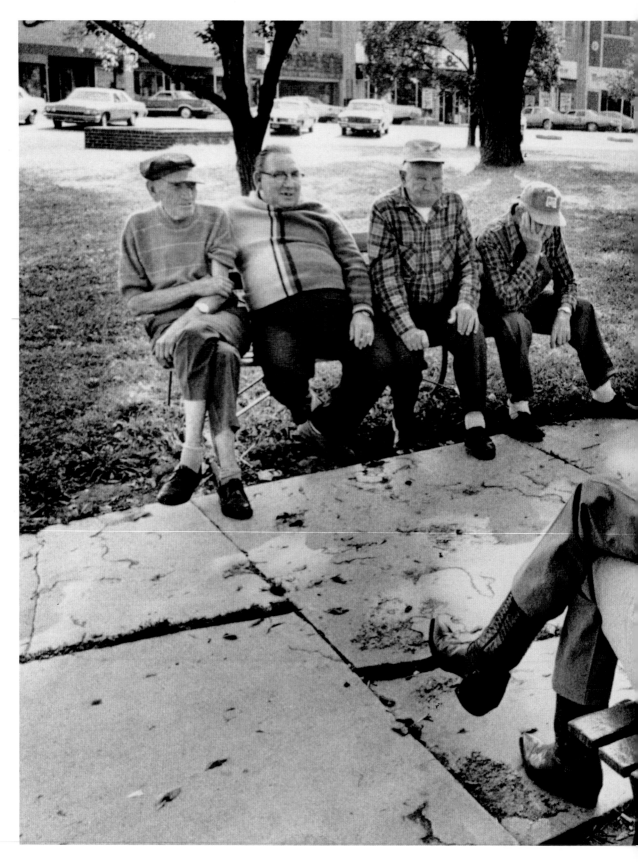

NEVADA 1975

Scott Witte

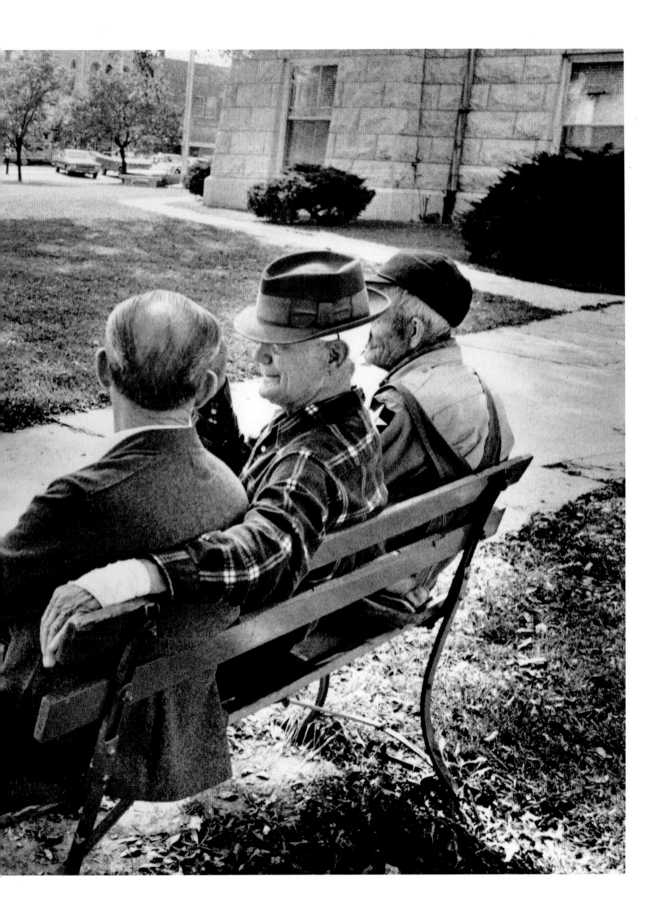

AURORA 1960

Charles M. Kolb

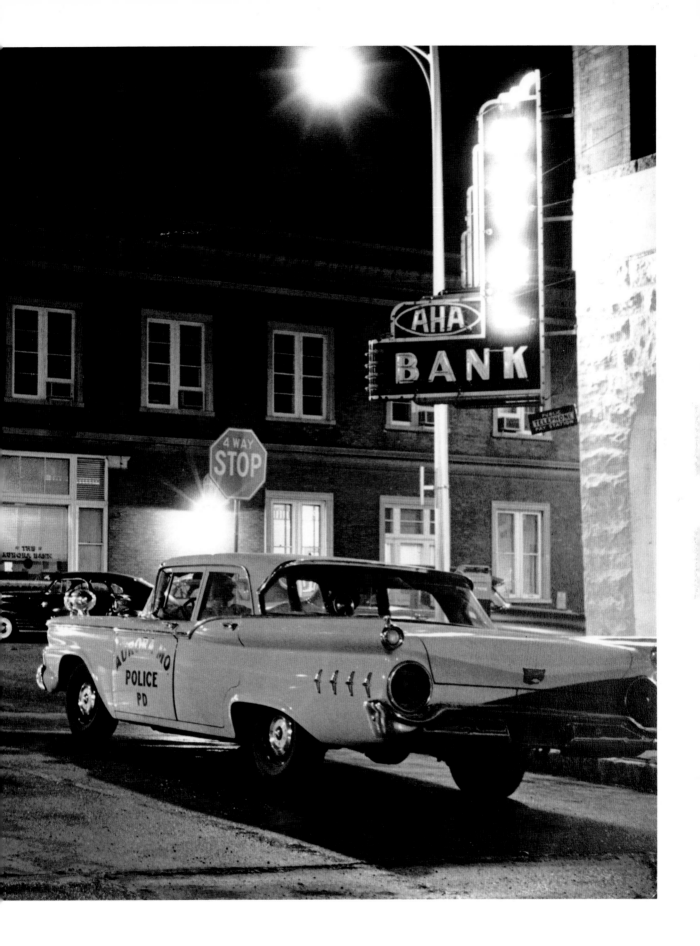

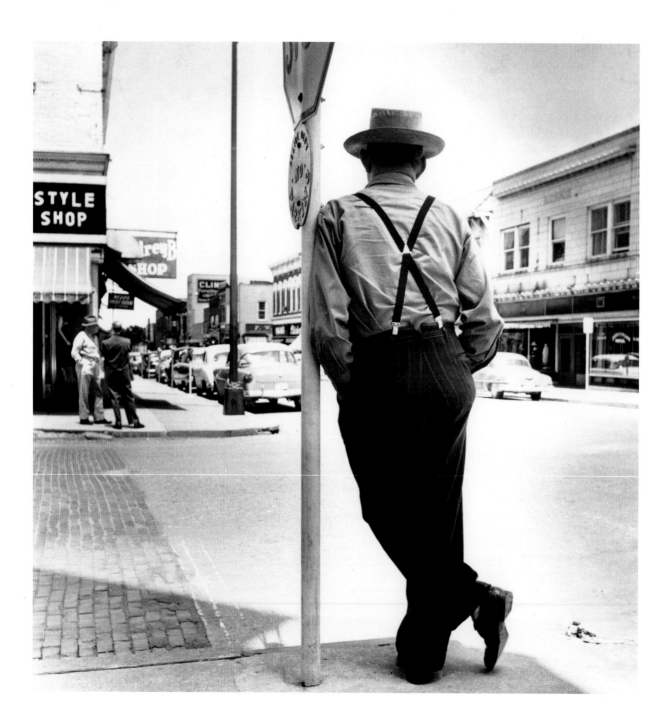

MEXICO 1954

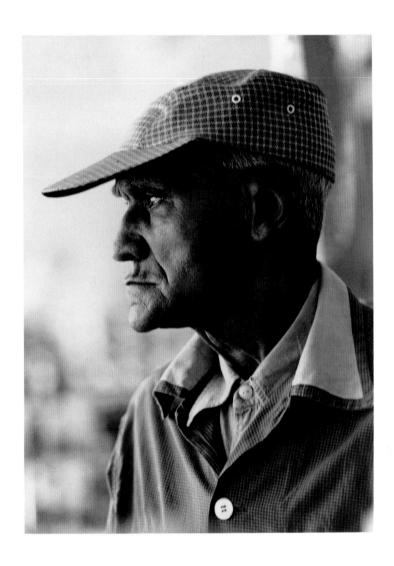

CAPE GIRARDEAU 1961

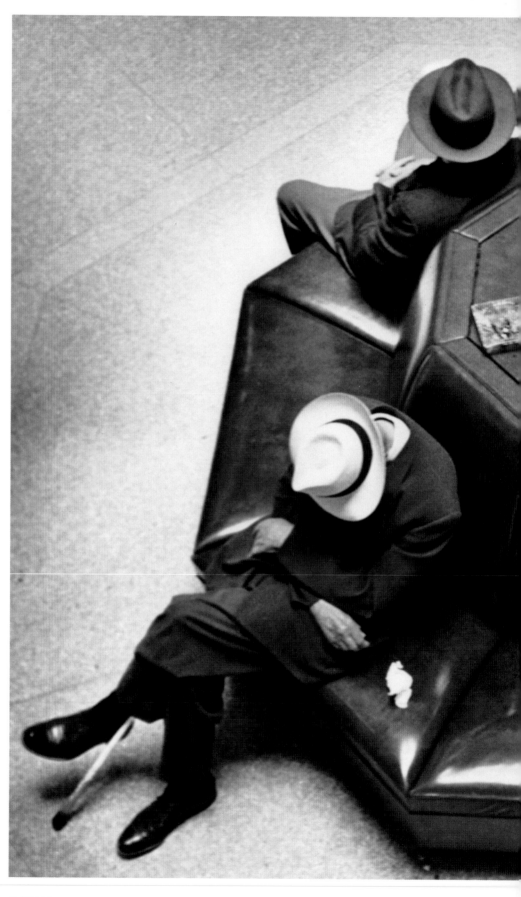

MEXICO 1954
Hal Power

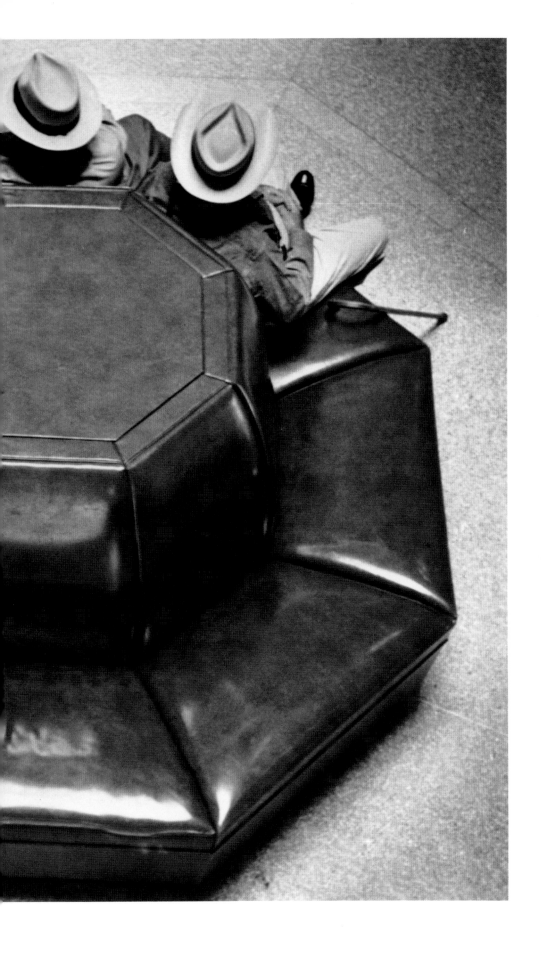

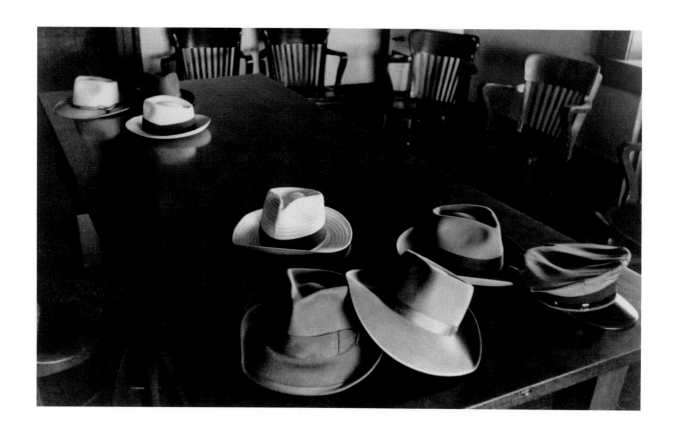

COLUMBIA 1949

Francis Reis

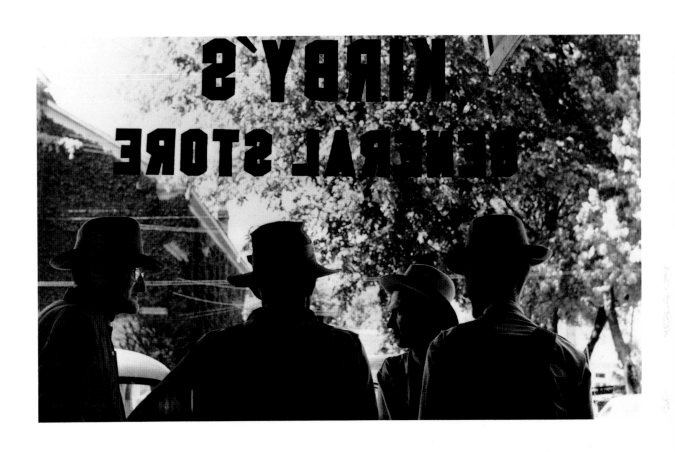

FORSYTH 1950
Angus McDougall

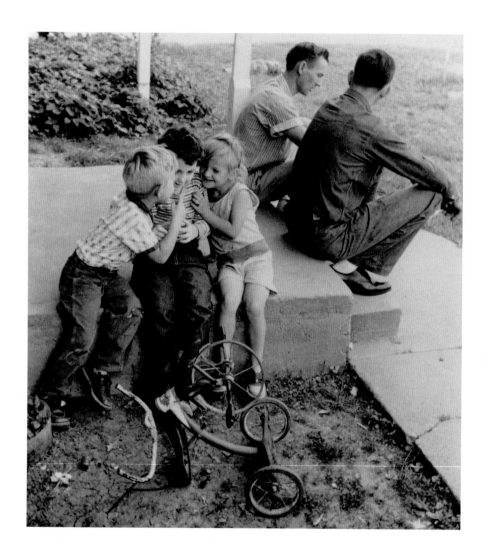

SIKESTON 1958

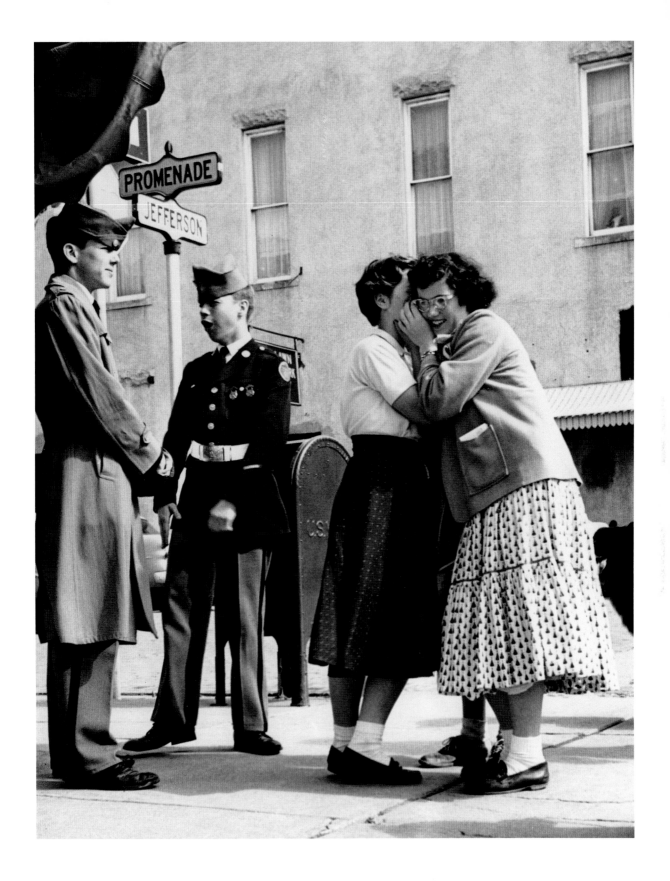

SEDALIA 1980

Sandra Shriver

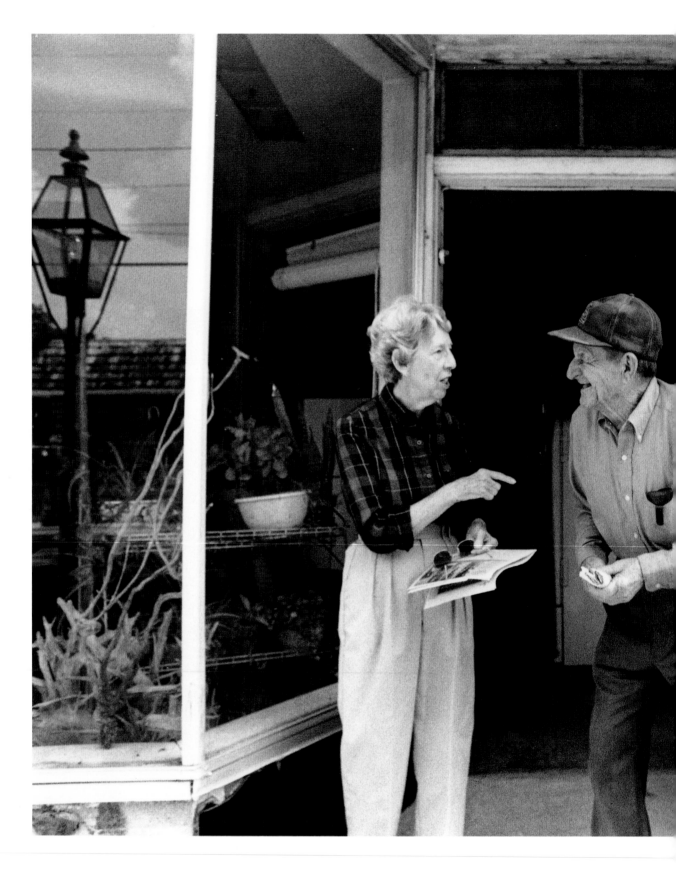

STE. GENEVIEVE 1991
Ric Francis

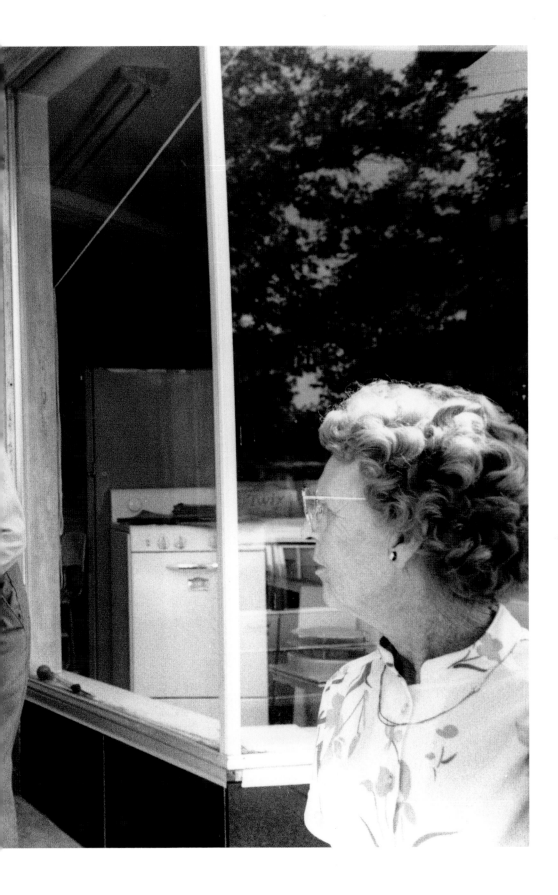

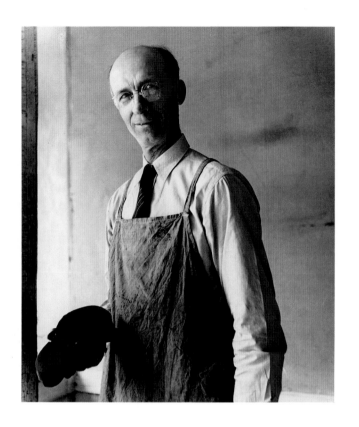

BOONVILLE 1953

Ivan Massar

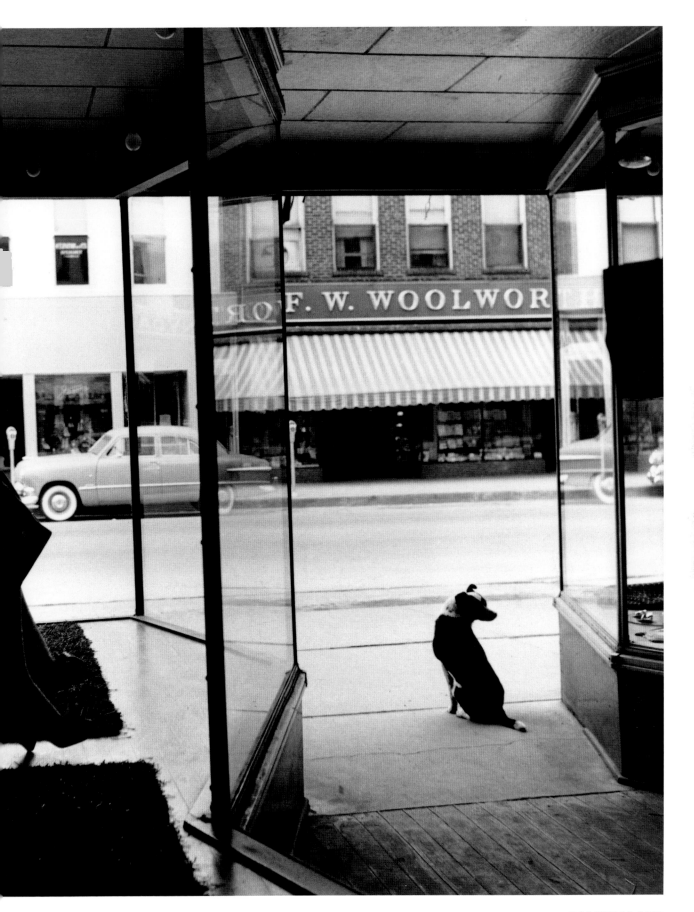

BOONVILLE 1953

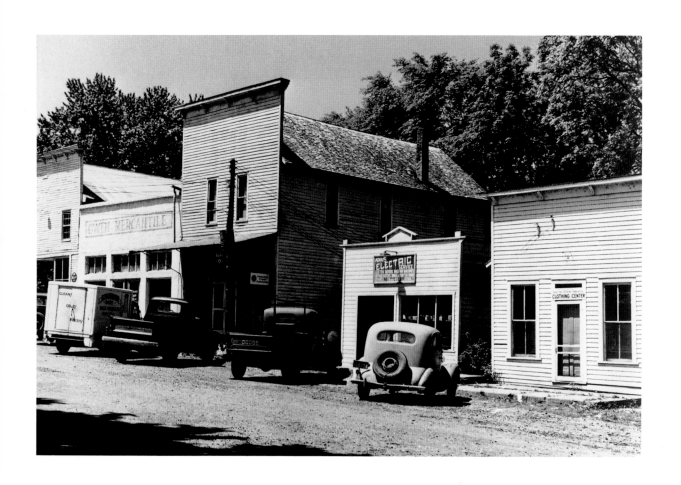

FORSYTH 1950

Don Peterson

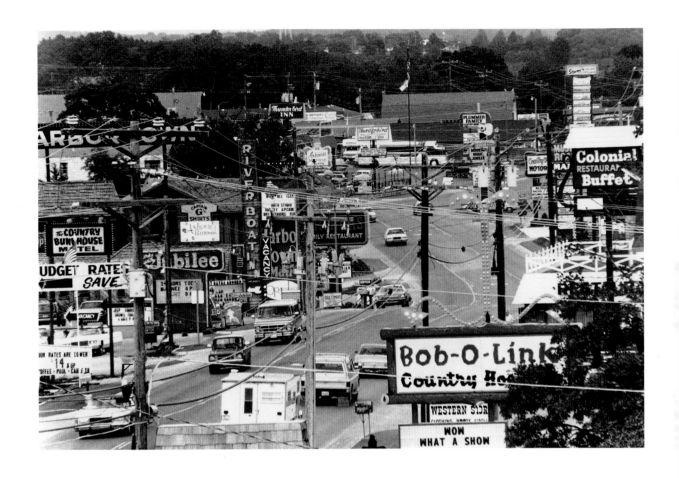

FORSYTH 1984

Richard Saal

BOONVILLE 1953

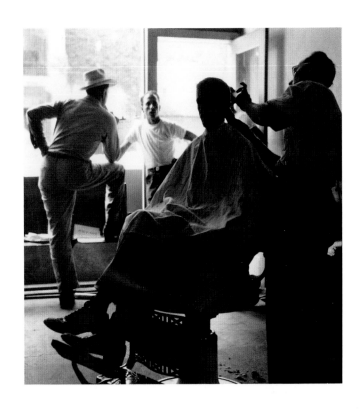

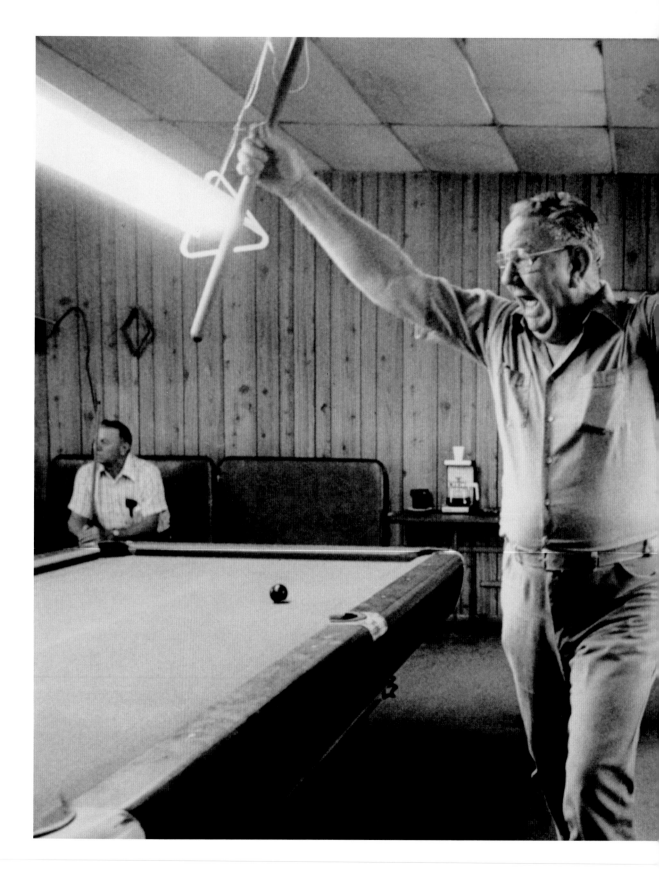

MT. VERNON 1983

Jim Laragy

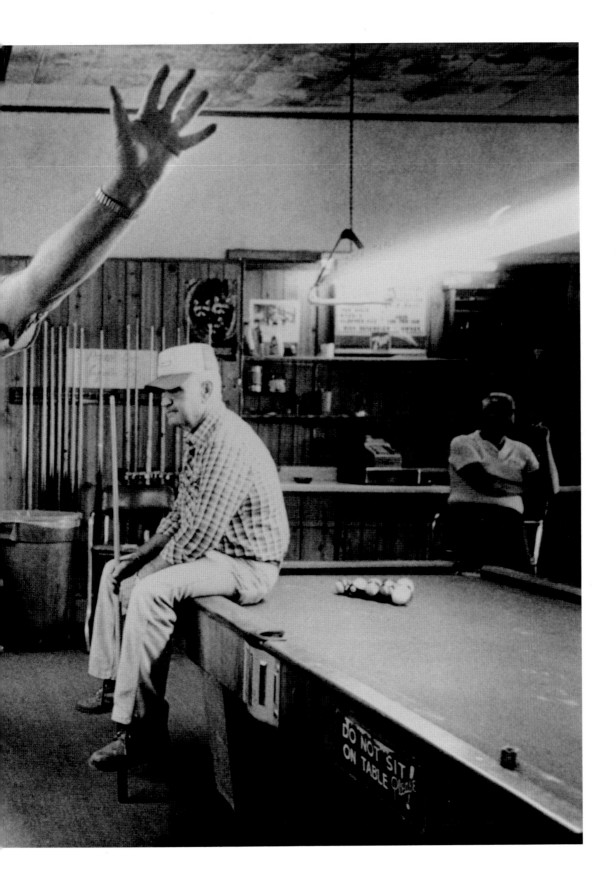

SIKESTON 1958

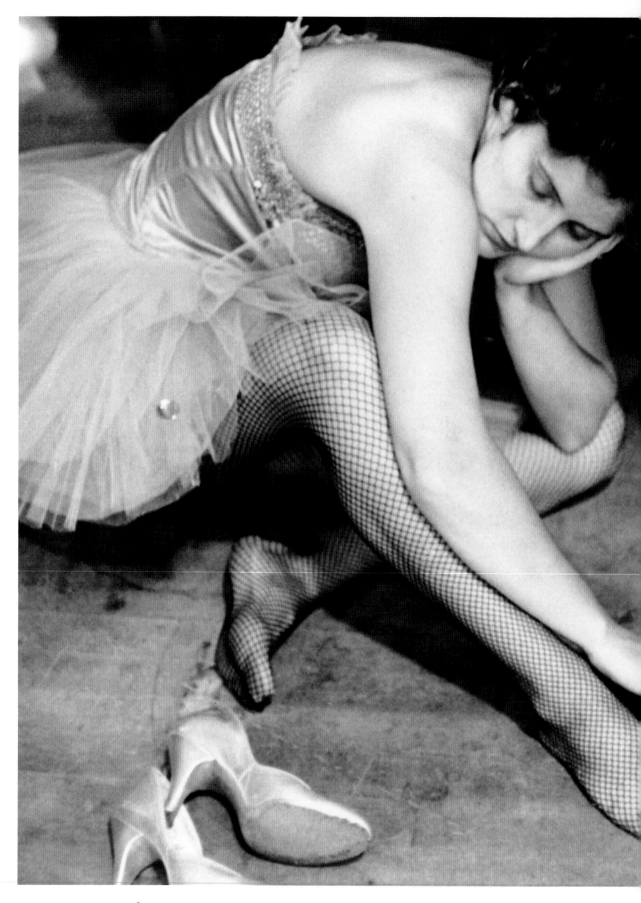

CAPE GIRARDEAU 1961
Gilbert Barrera

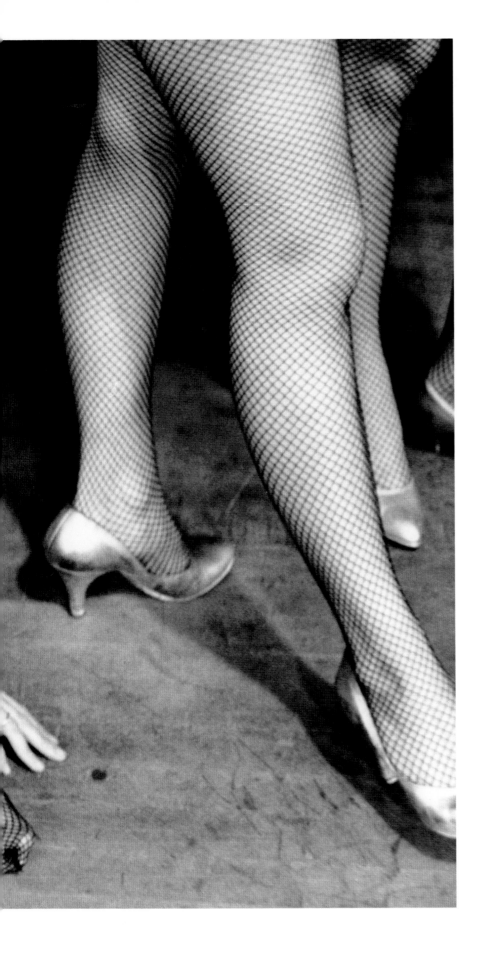

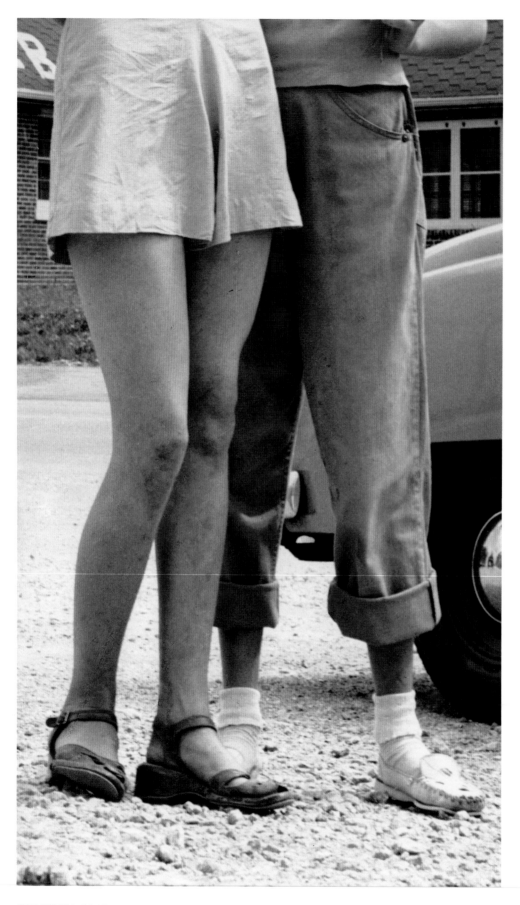

COLUMBIA 1949

Tony Martinez & Otha Spencer

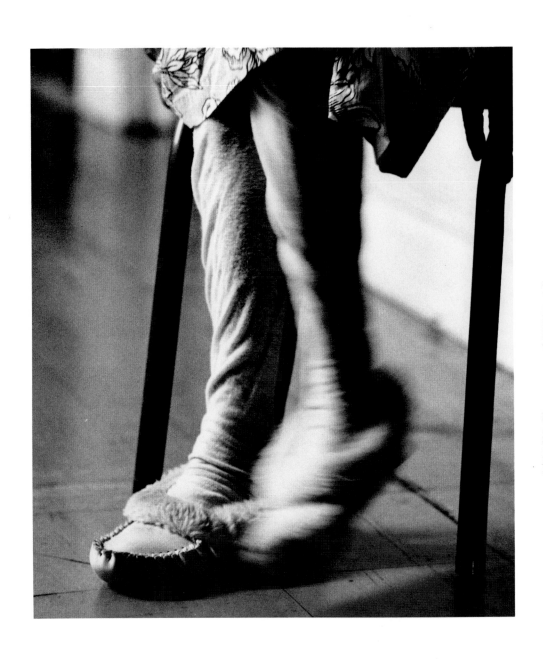

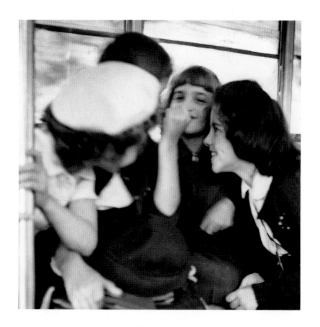
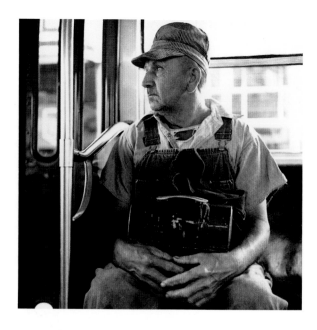
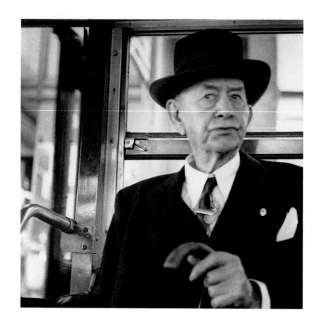
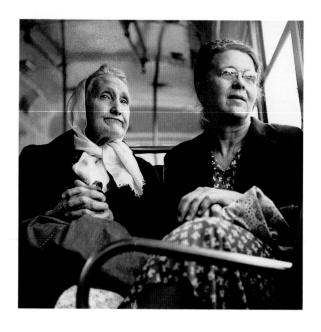

JEFFERSON CITY 1952
Jack Welpott

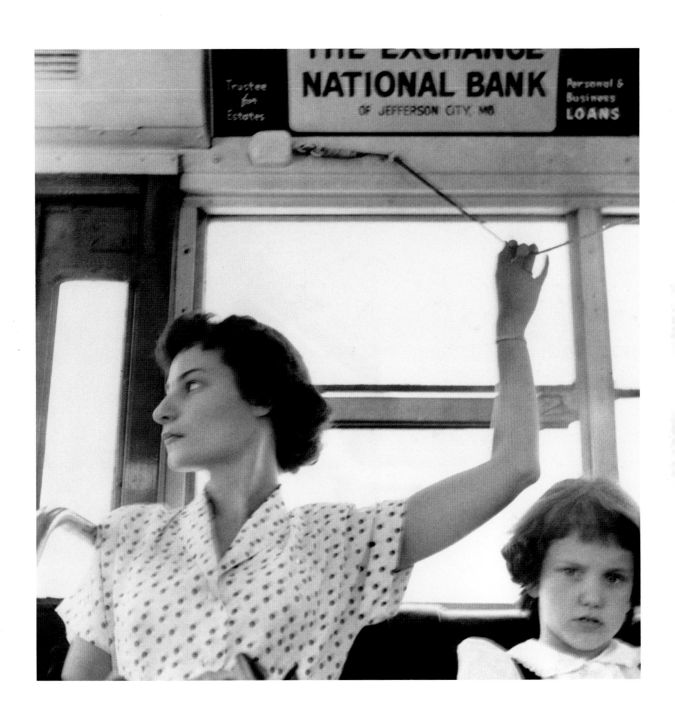

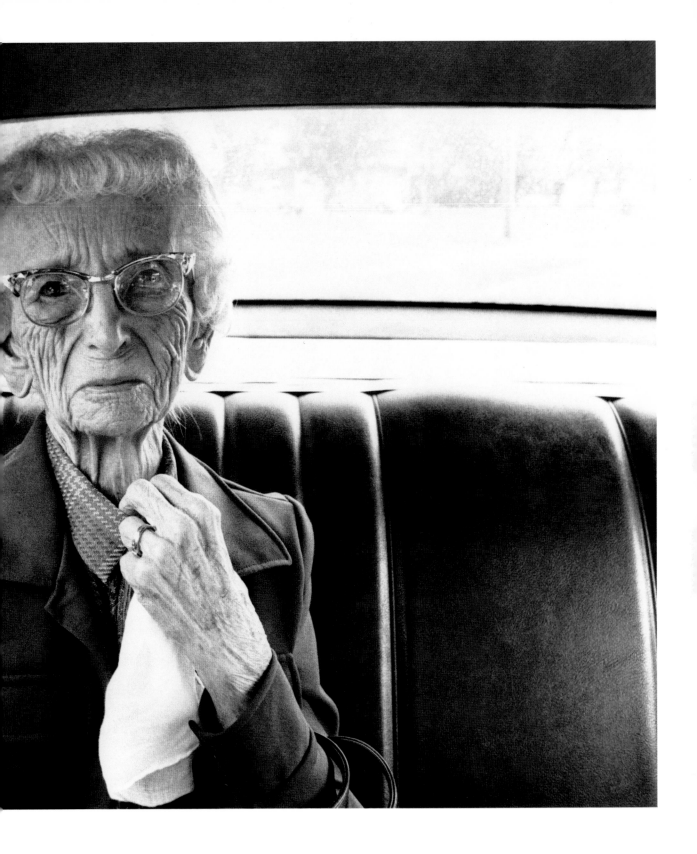

CLINTON 1982

David Sharpe

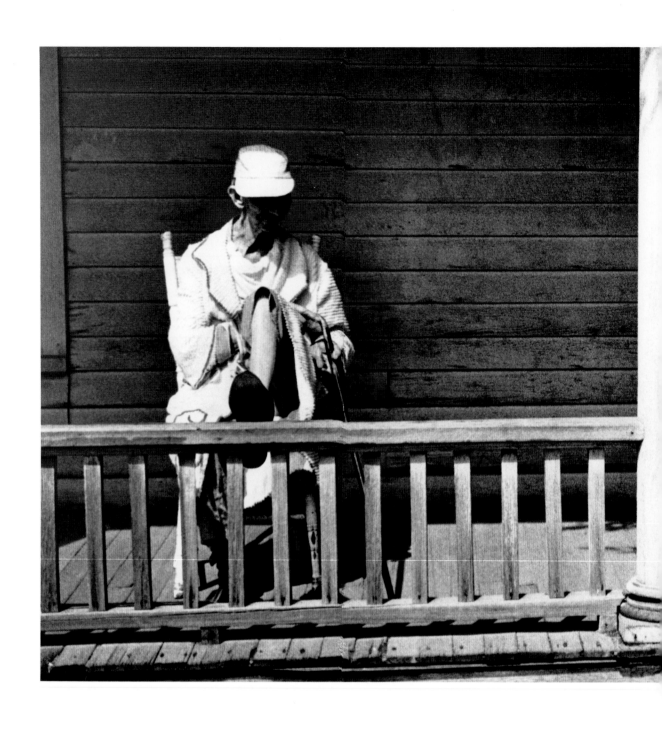

CHILLICOTHE 1963

Hugo Harper

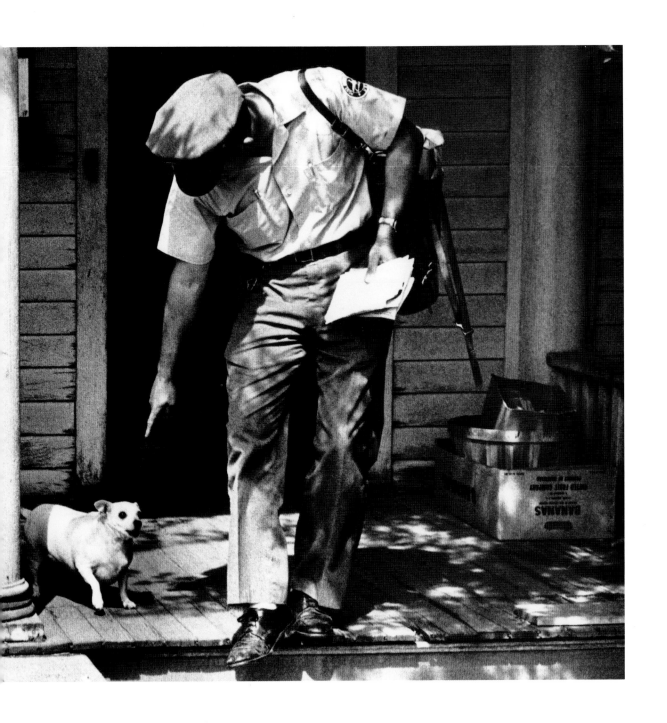

MONETT 1979

Barbara Baker

WEST PLAINS 1971

Dennis A. Kagan

WARRENSBURG 1974

Diego Goldberg

FORSYTH 1984

Karen Whiteley

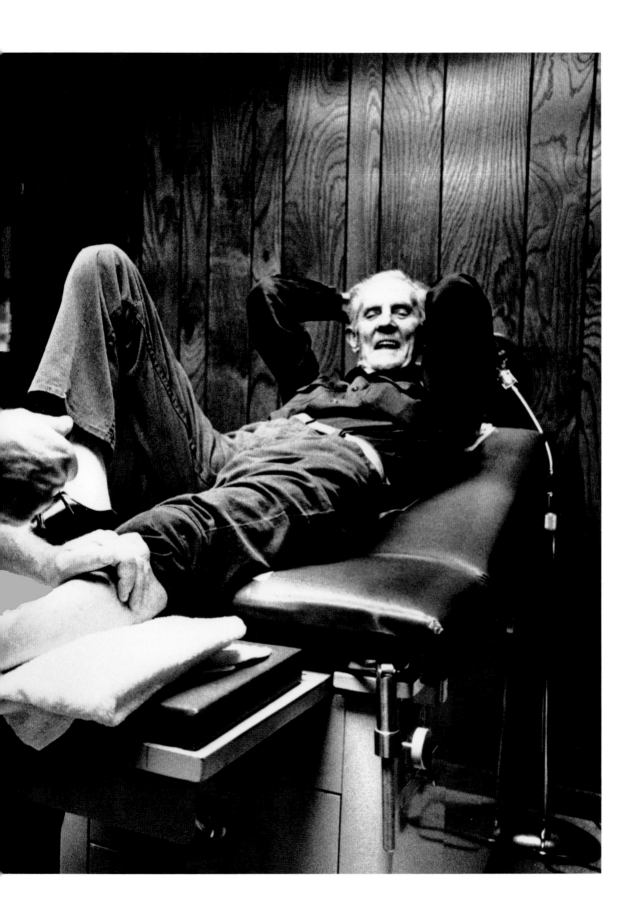

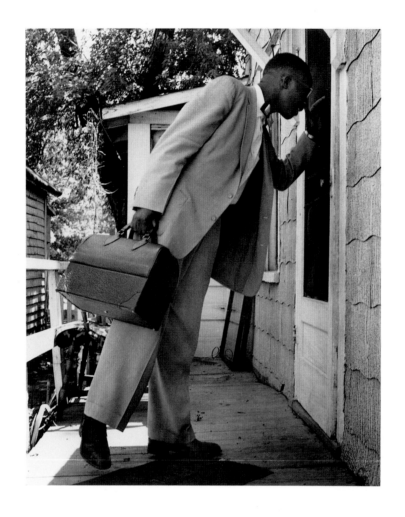

HANNIBAL 1957

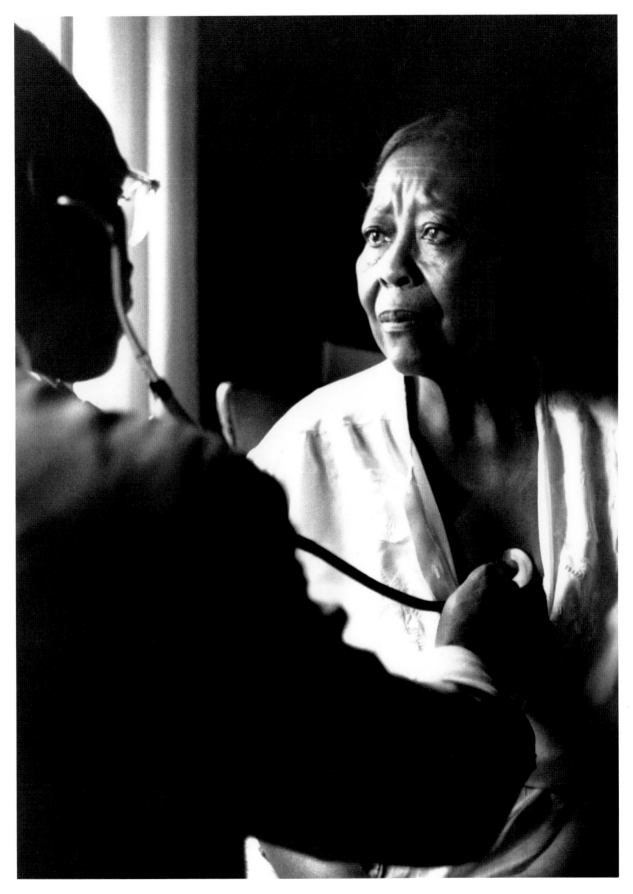

HANNIBAL 1957

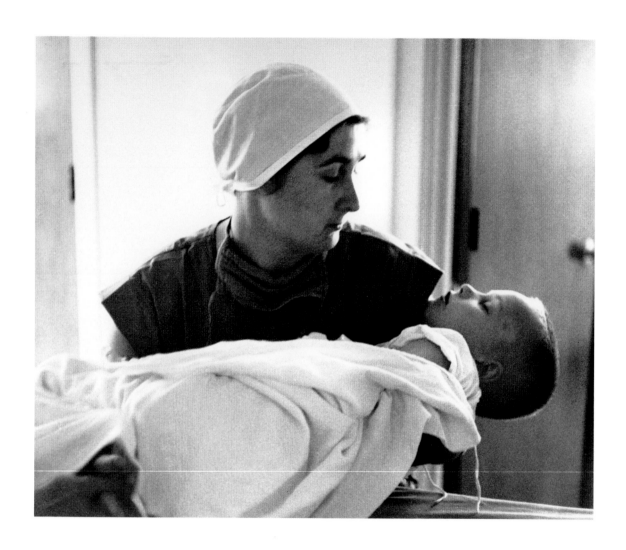

LEXINGTON 1956

W. E. Garrett

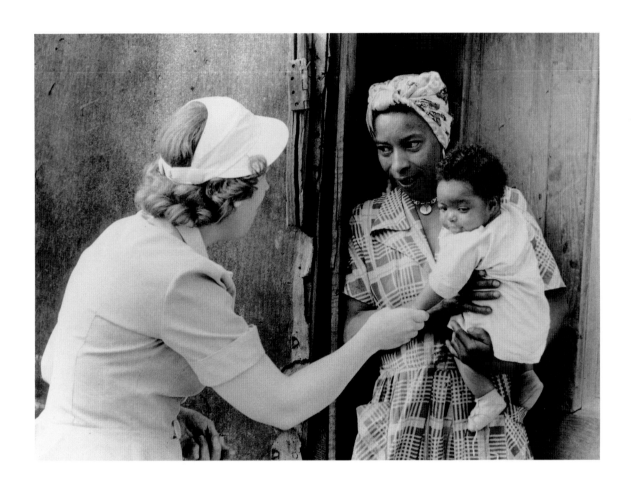

LEXINGTON 1956

Lynn Abercrombie

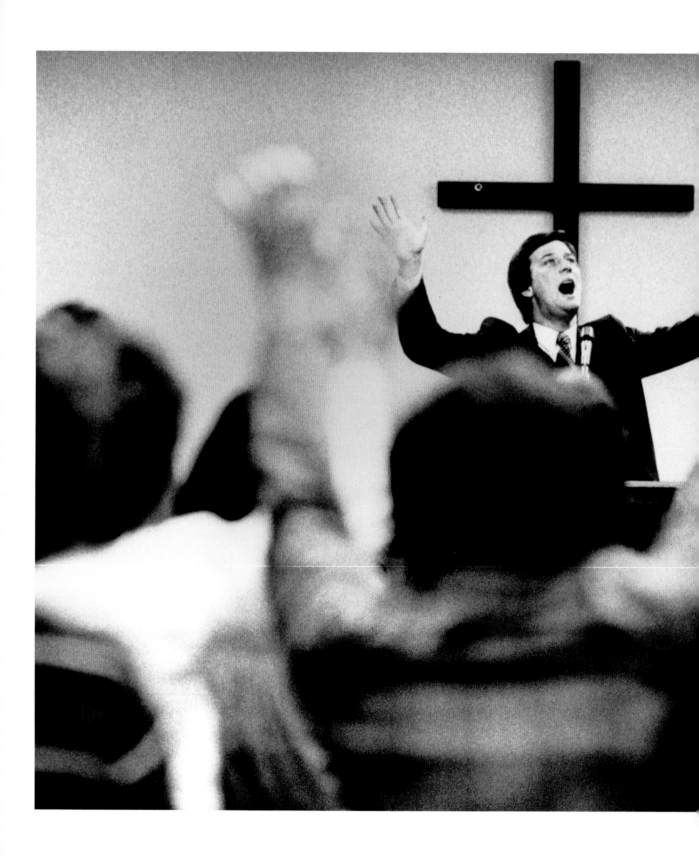

NEOSHO 1981

Burr Lewis

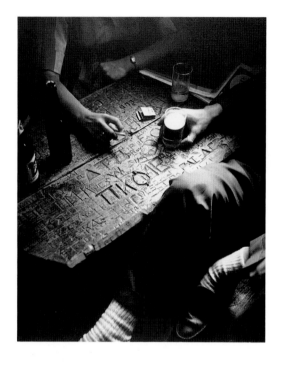

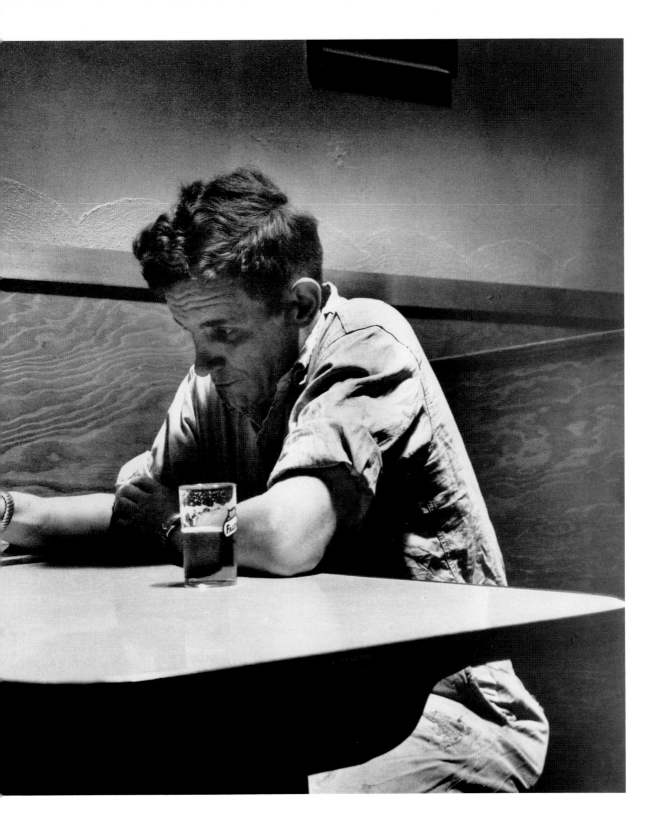

MEXICO 1954
Tom Abercrombie

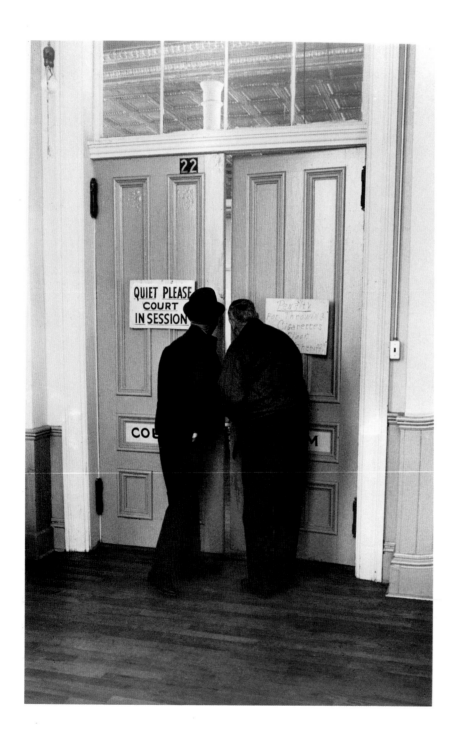

SALEM 1968

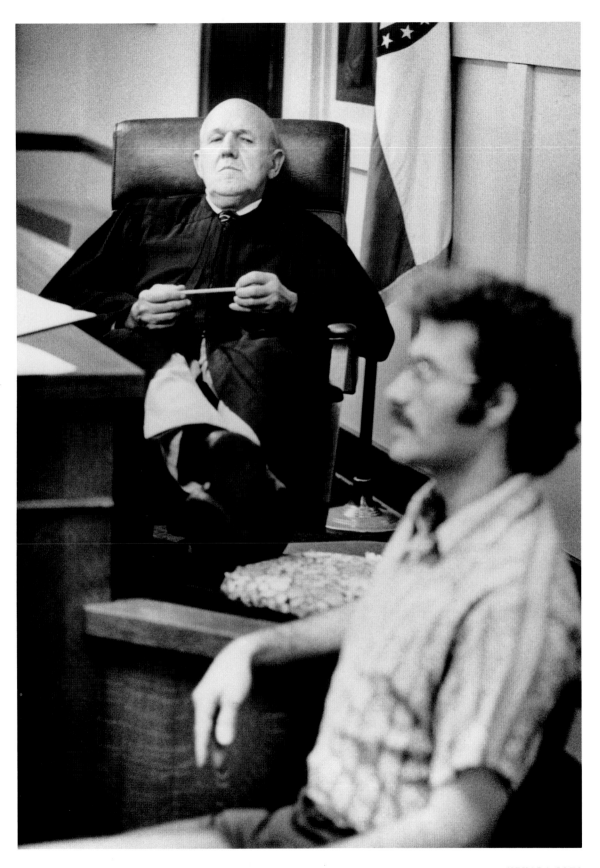

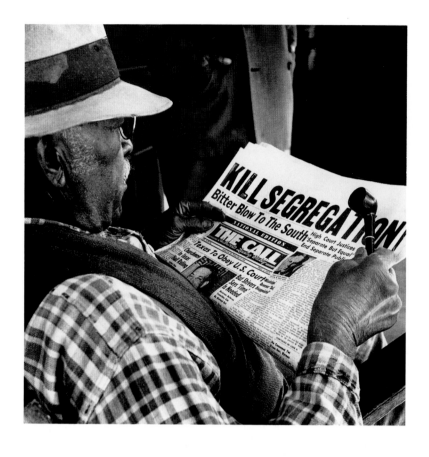

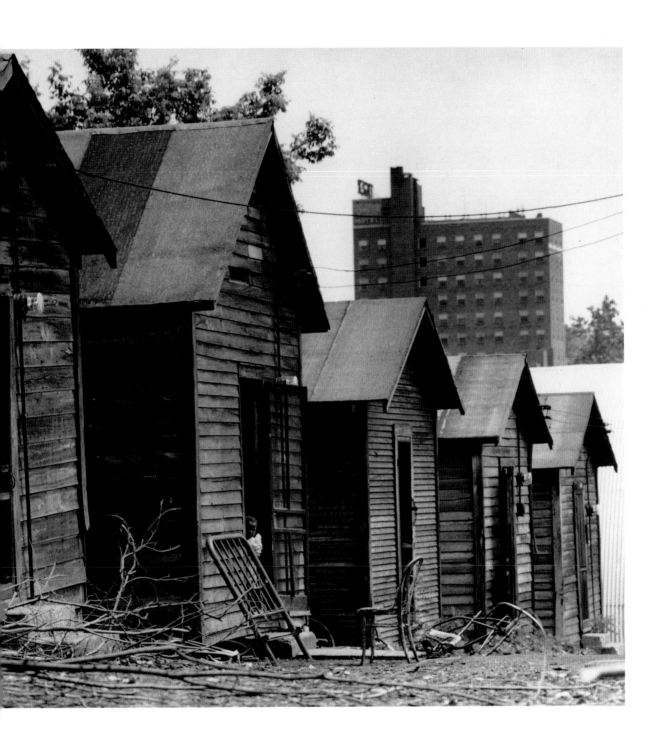

COLUMBIA 1949

Howard J. Sochurek

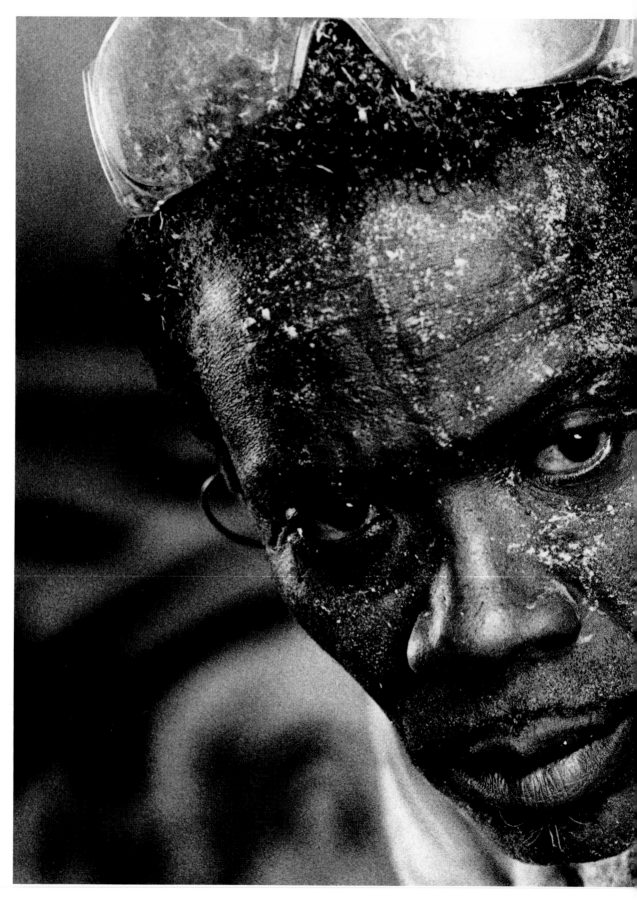

CARUTHERSVILLE 1987

Mary Kelley

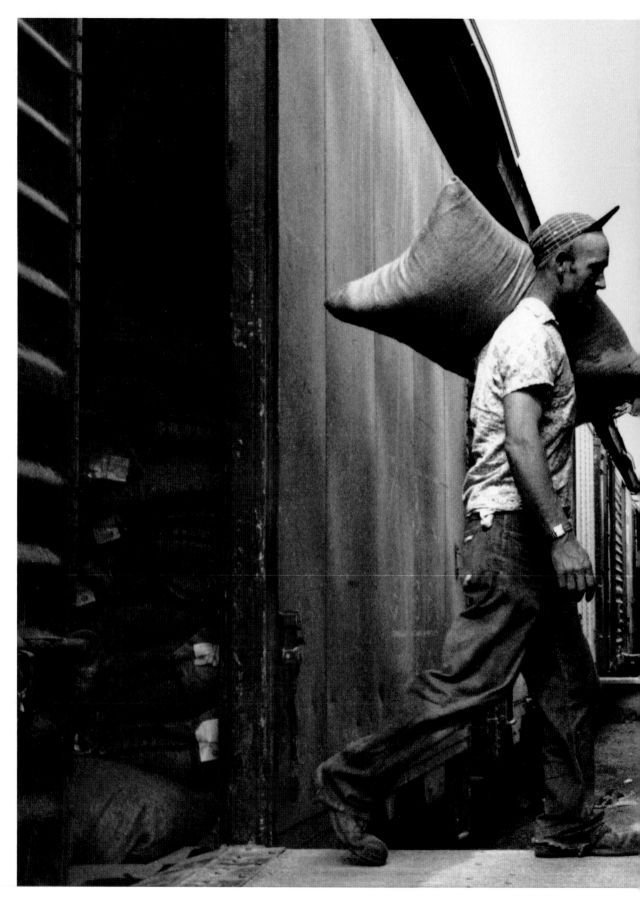

AURORA 1960

W. E. Eppridge

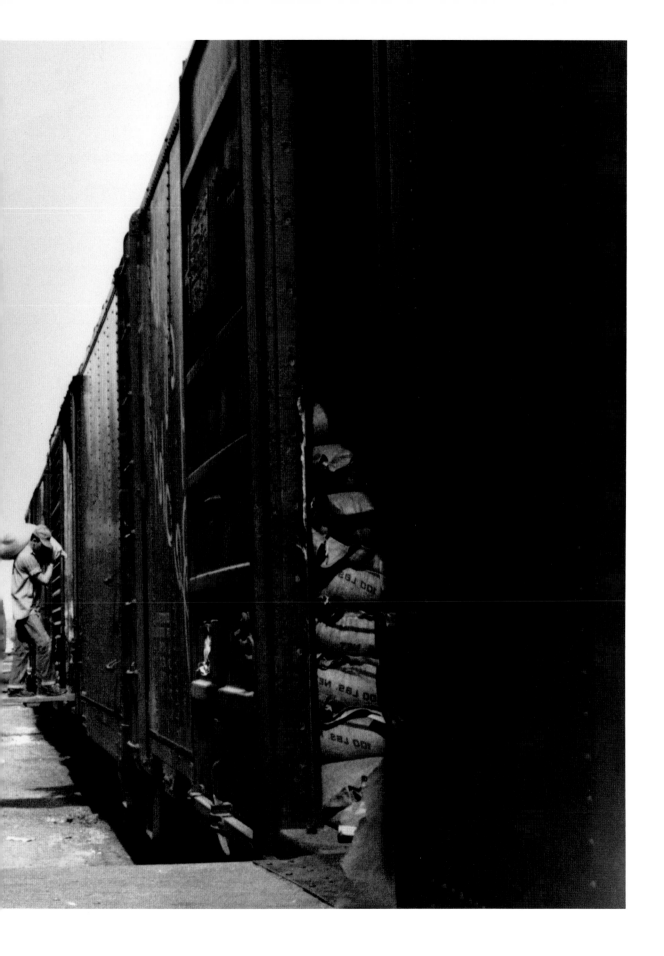

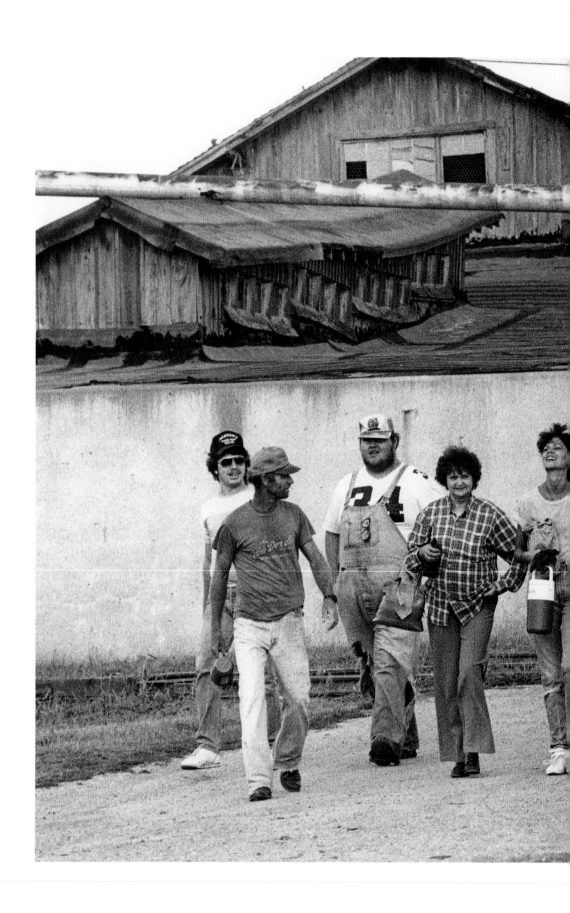

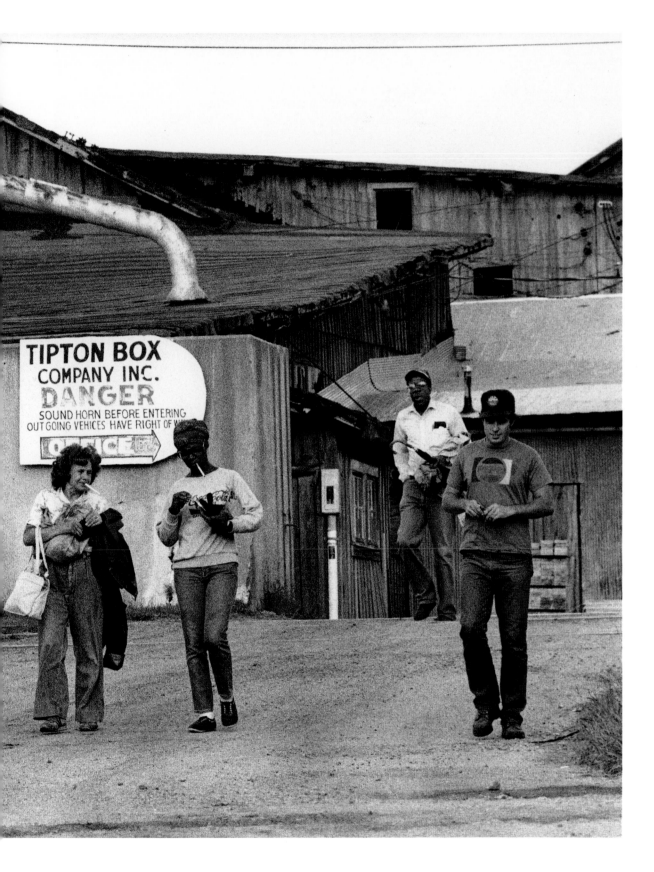

TIPTON BOX
COMPANY INC.
DANGER
SOUND HORN BEFORE ENTERING
OUT GOING VEHICES HAVE RIGHT OF W
OFFICE

CARUTHERSVILLE 1987
Mary Kelley

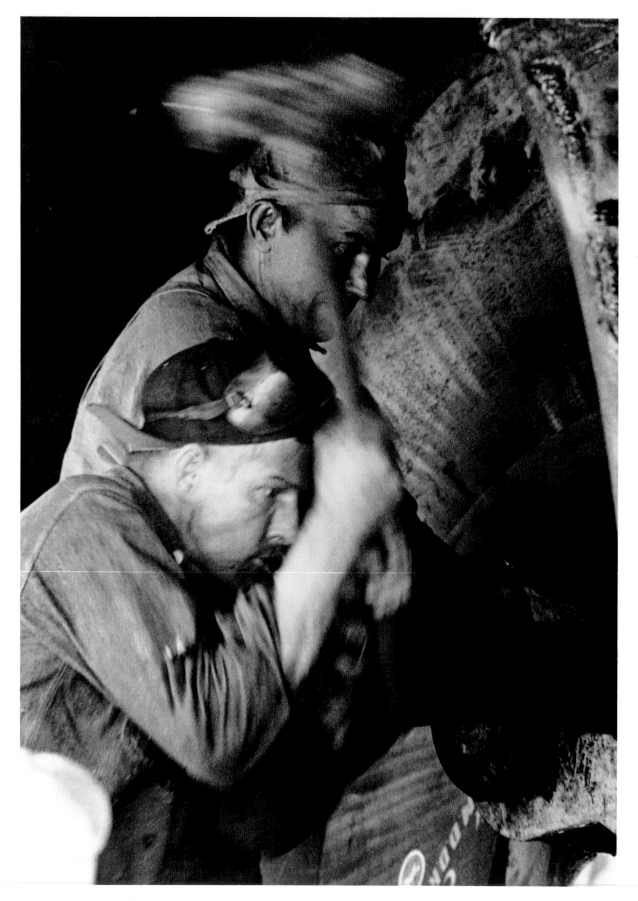

CAPE GIRARDEAU 1961

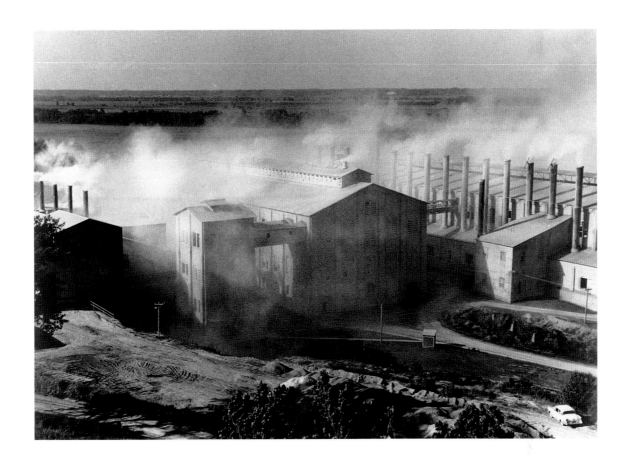

HANNIBAL 1957

Gilbert M. Grosvenor

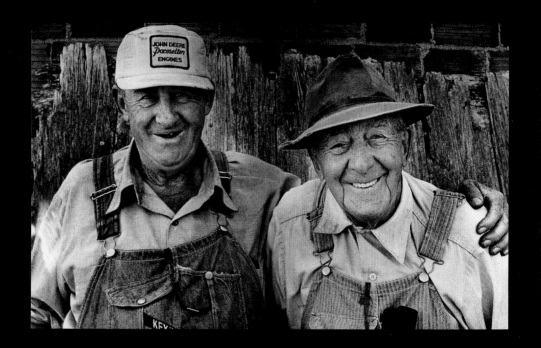

NEVADA 1975
James Mayo

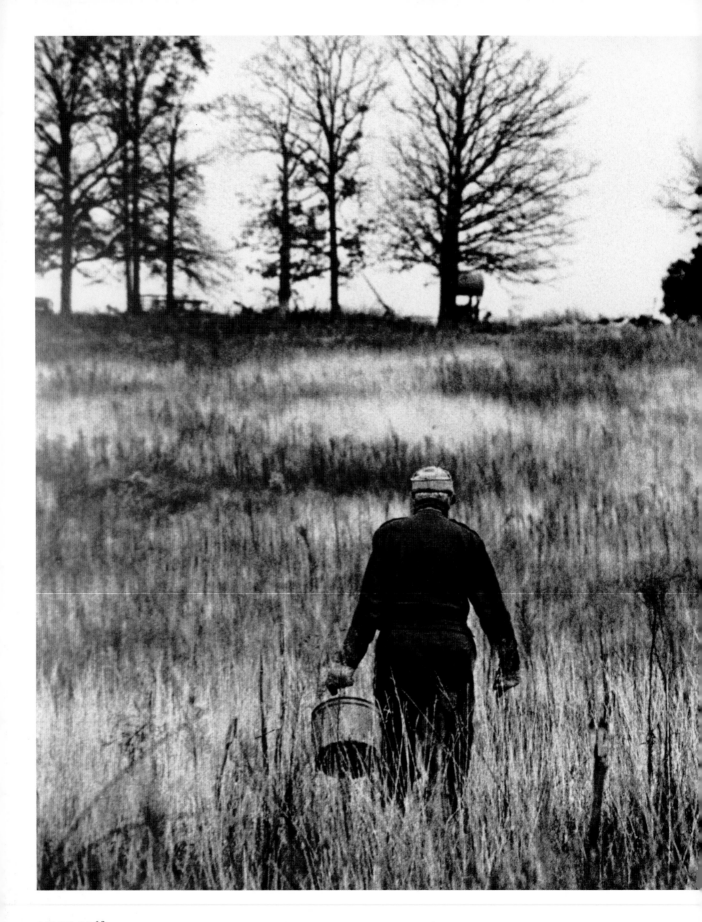

SALEM 1968

David A. Barnes

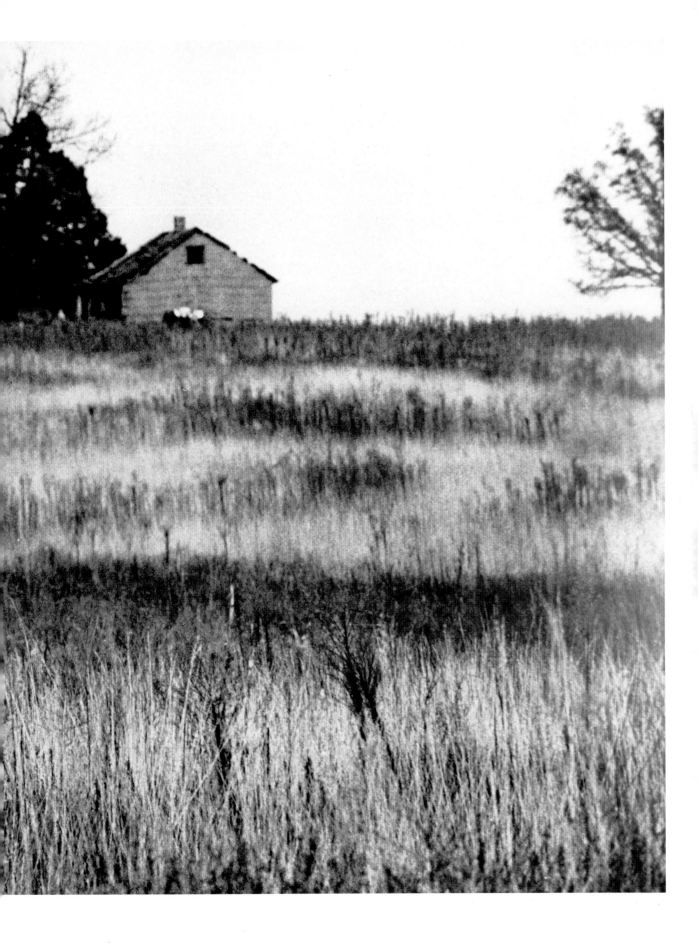

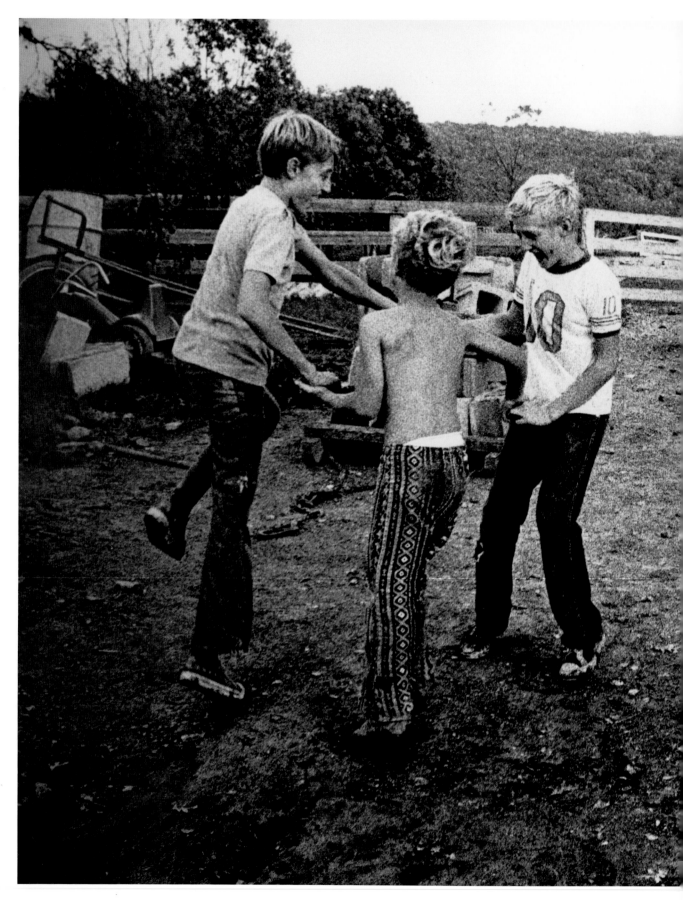

KIRKSVILLE 1973

Betsy Frampton

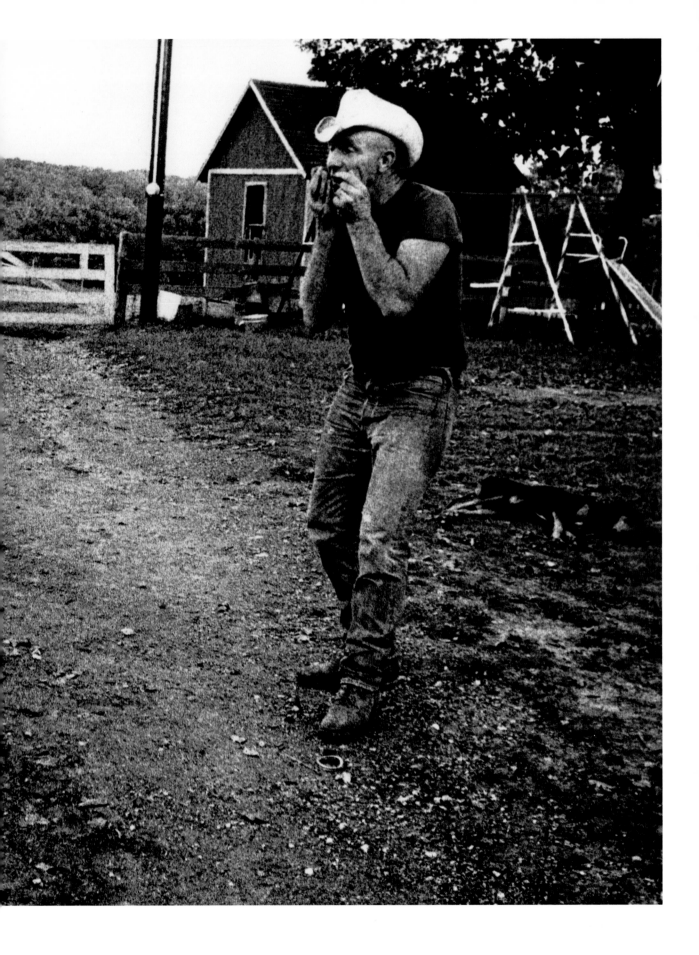

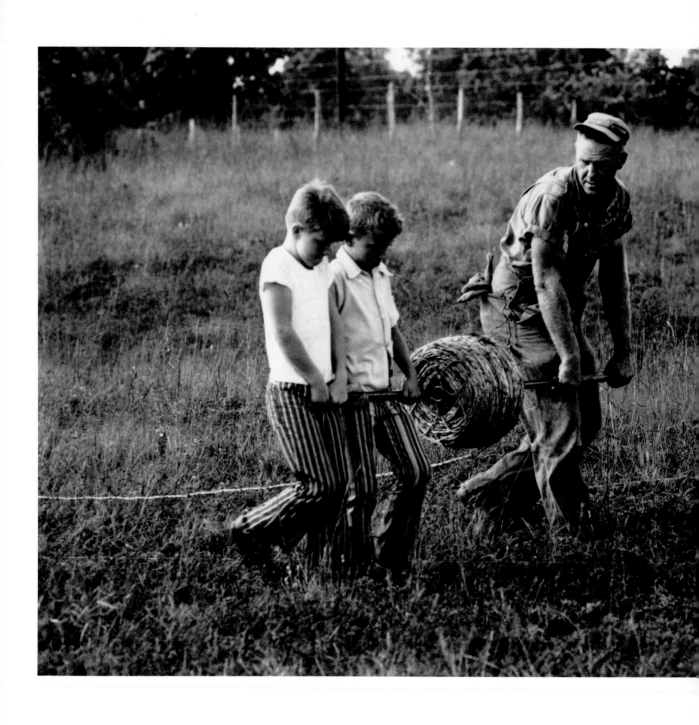

WEST PLAINS 1971

John A. Glover

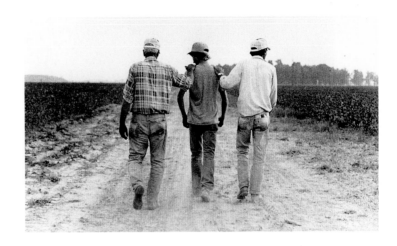

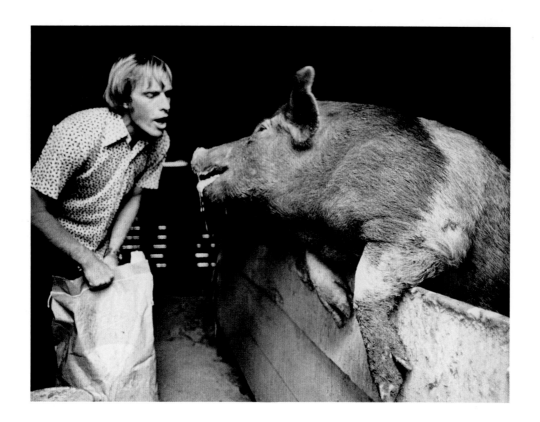

FORSYTH 1976

David Perdew

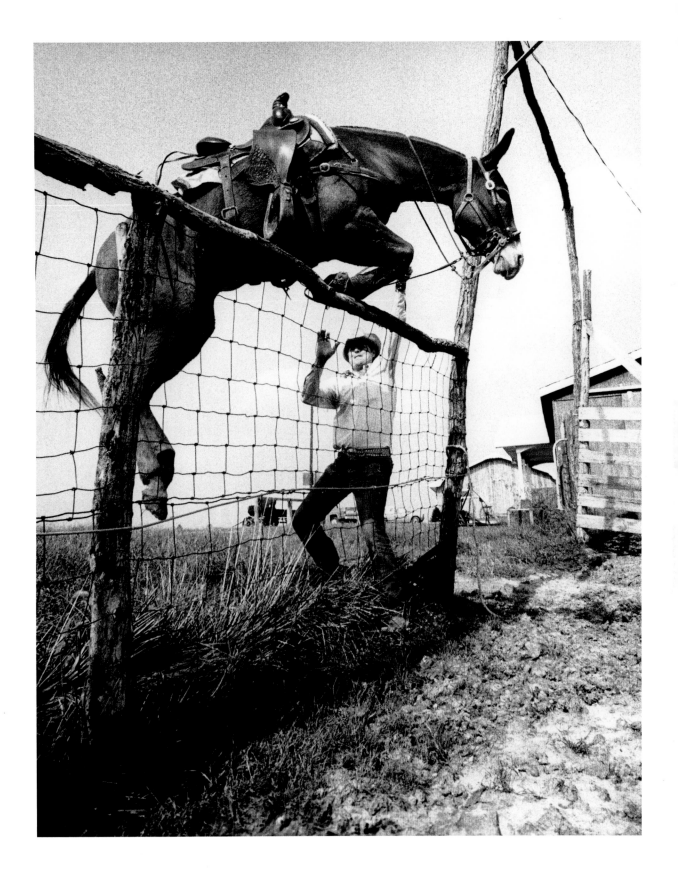

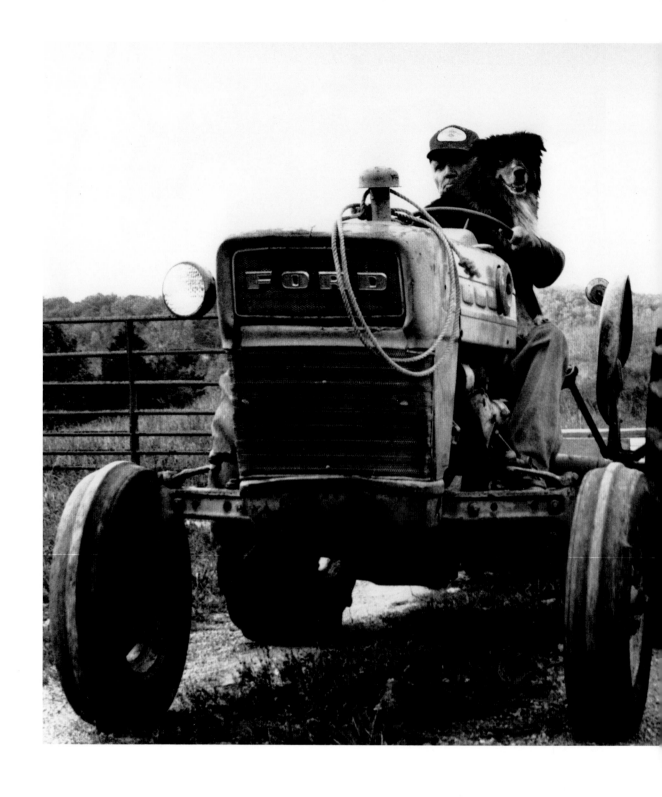

FORSYTH 1984

Kevin Grace

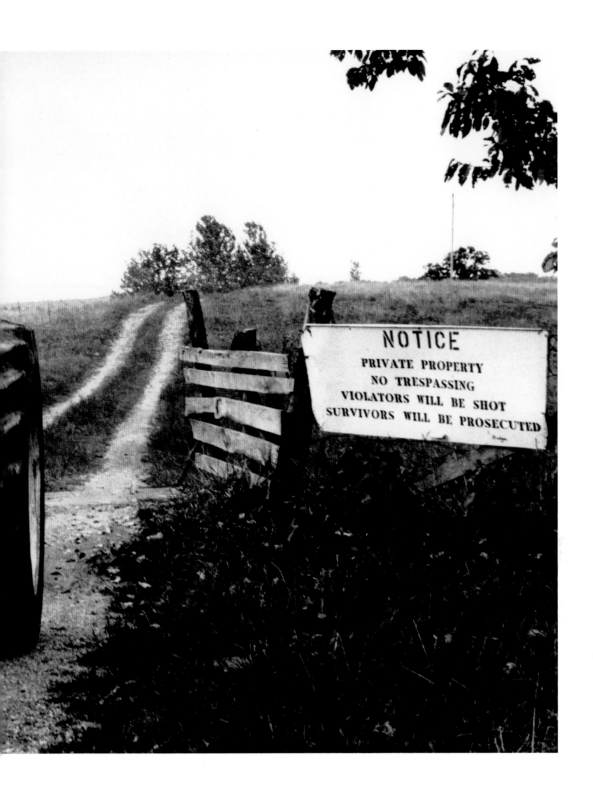

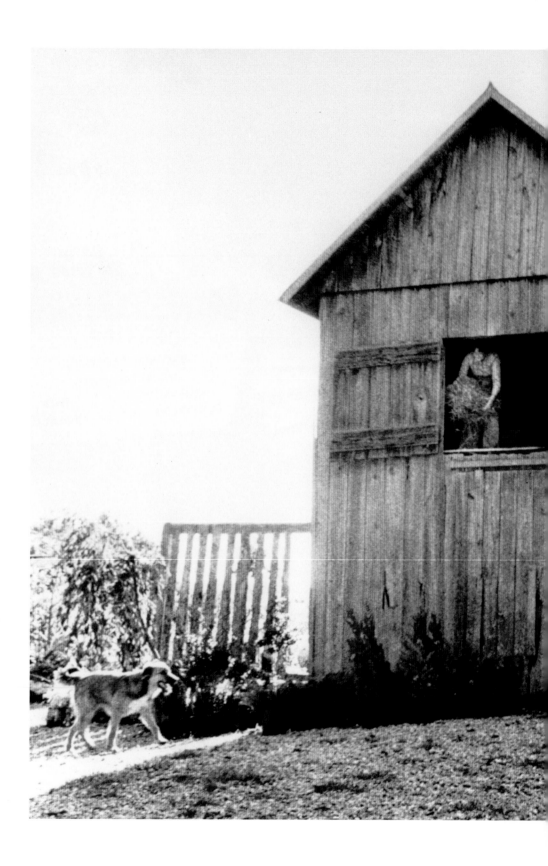

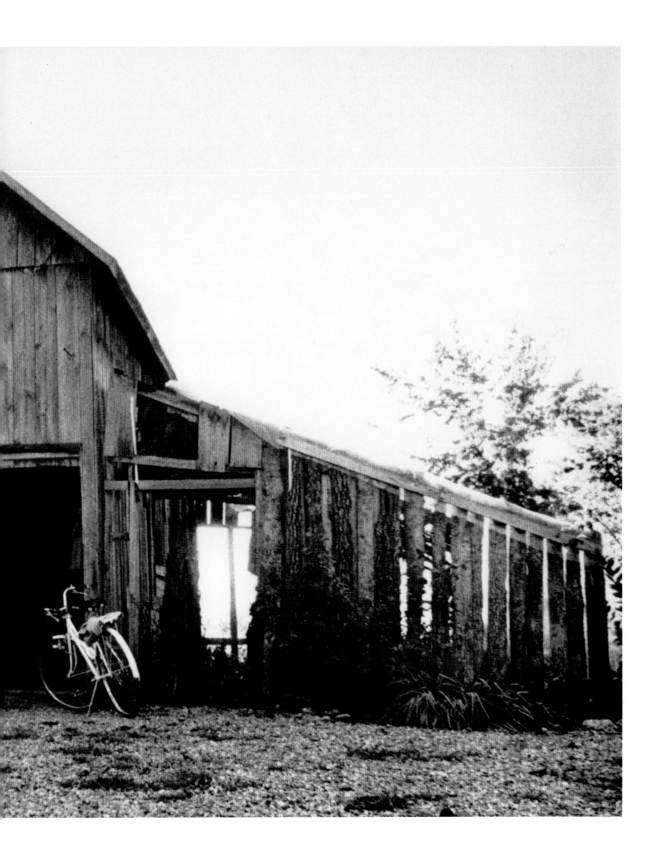

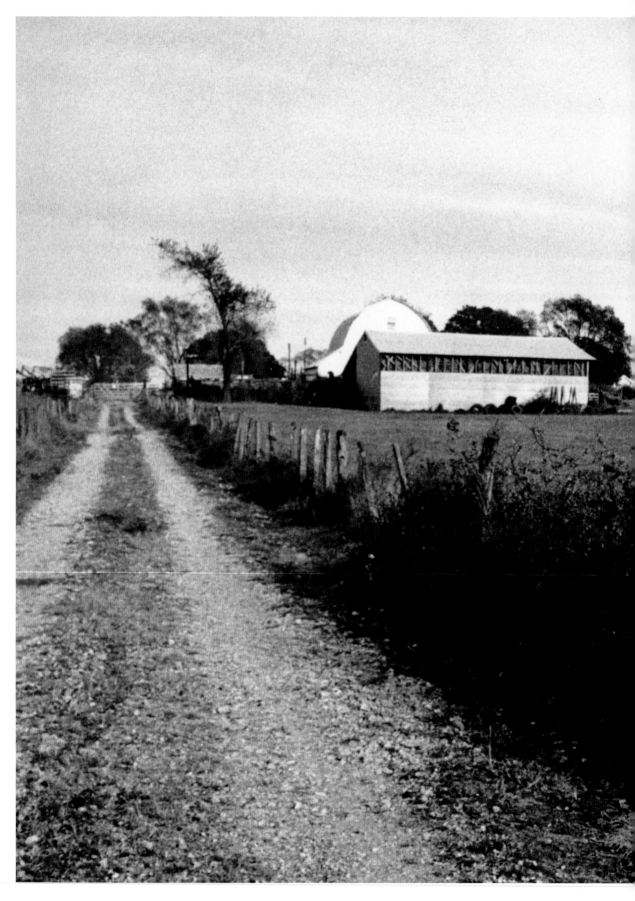

FORSYTH 1976

Hope Alexander Strode

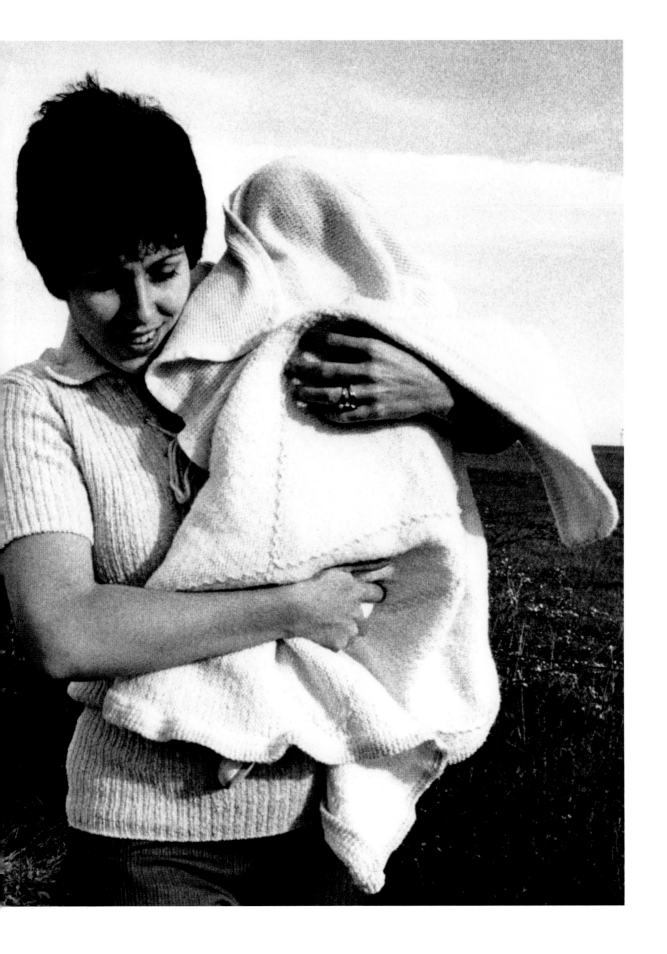

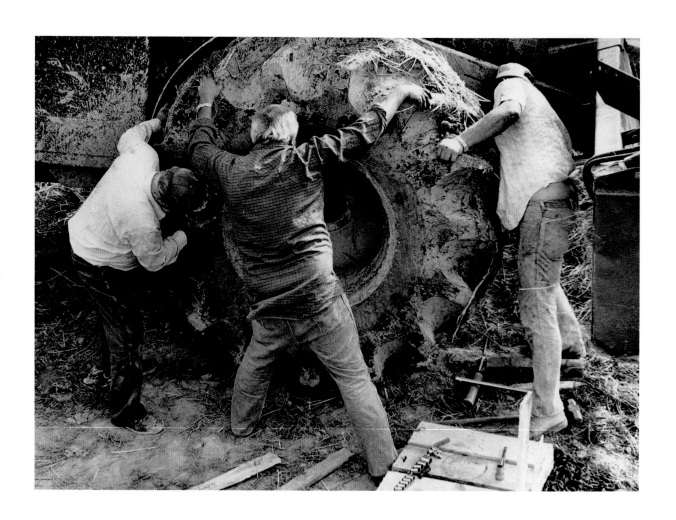

POPLAR BLUFF 1985

José Lopez, Jr.

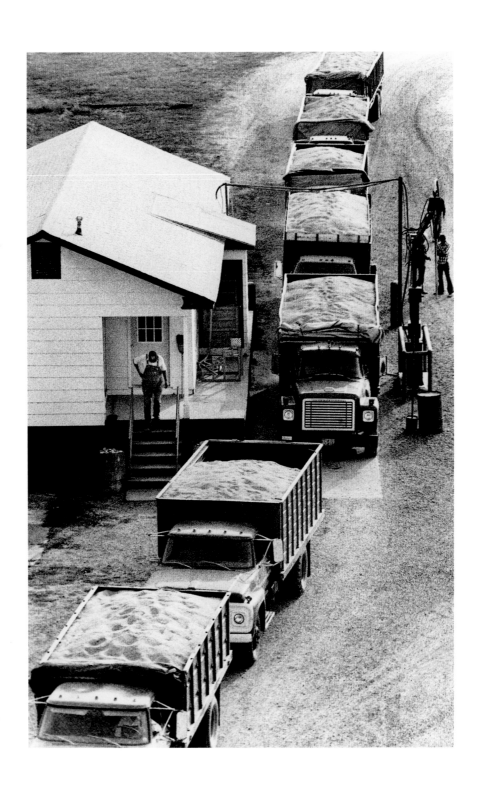

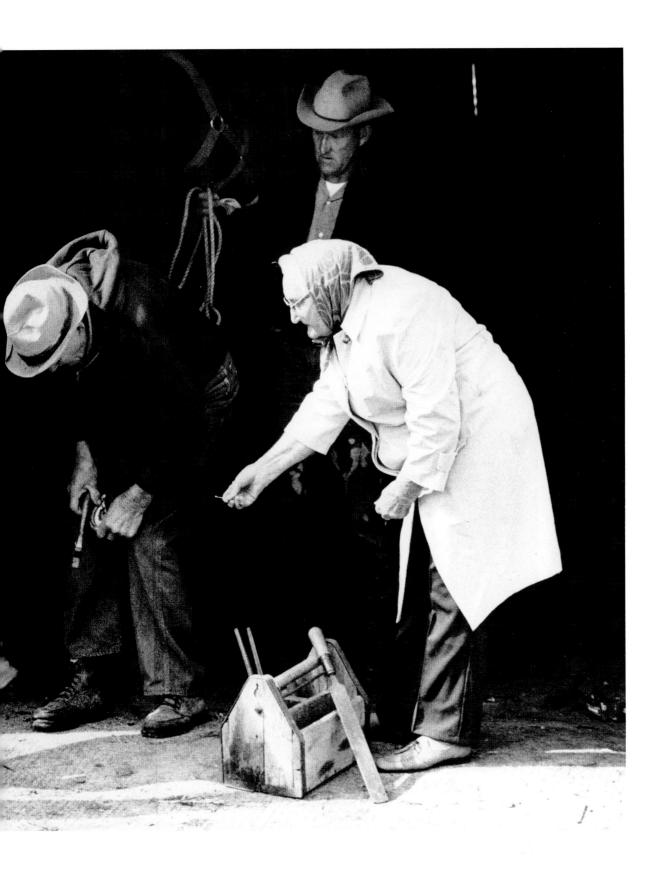

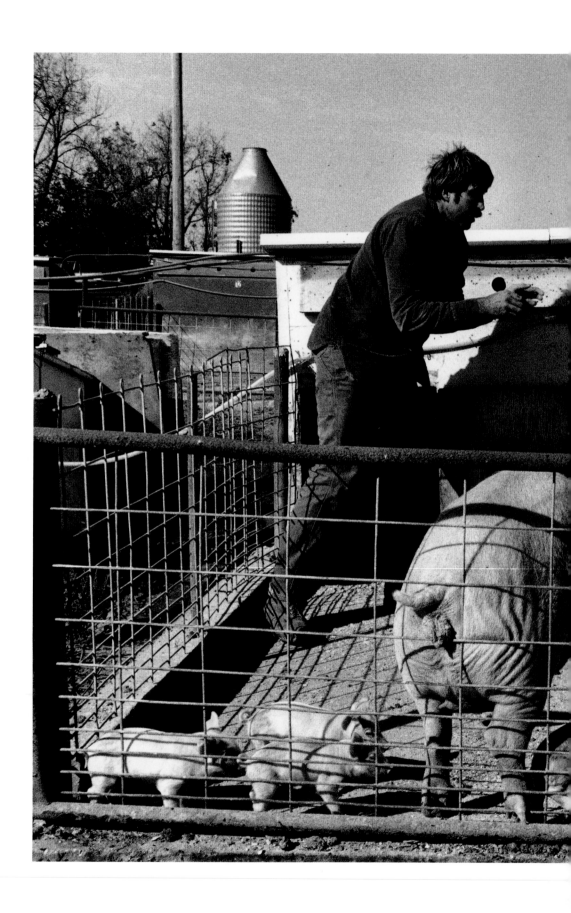

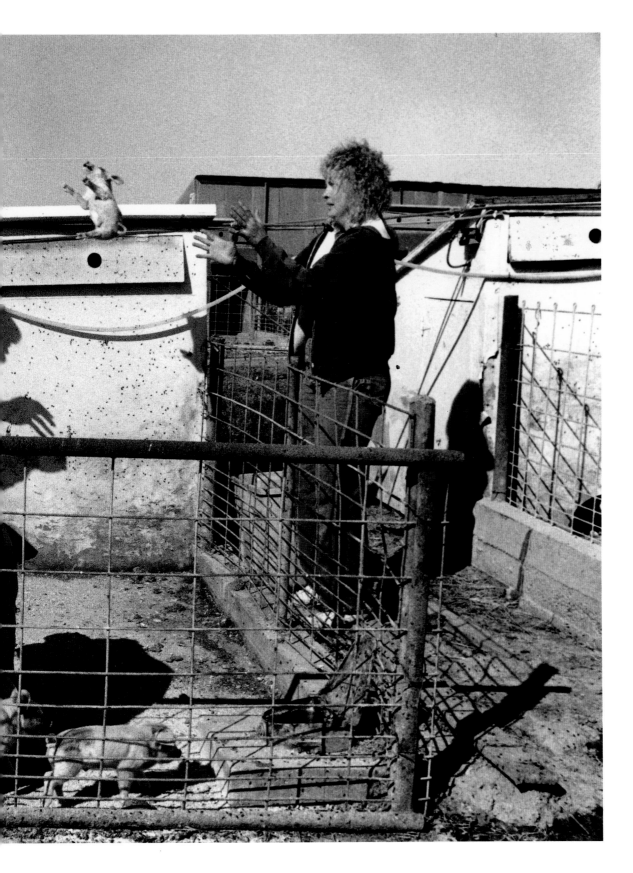

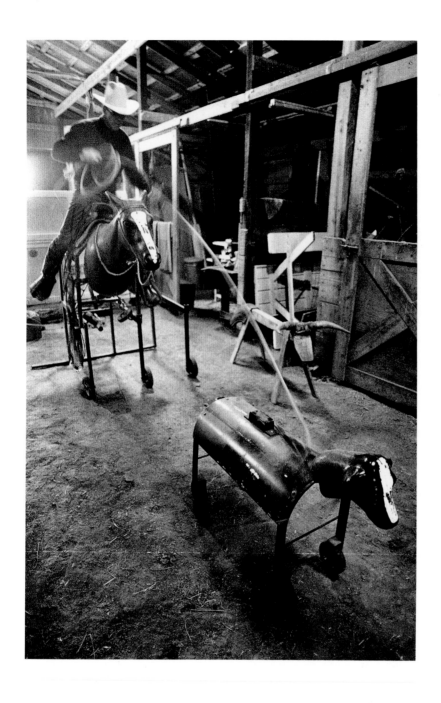

MARYVILLE 1989

Edward Kennedy

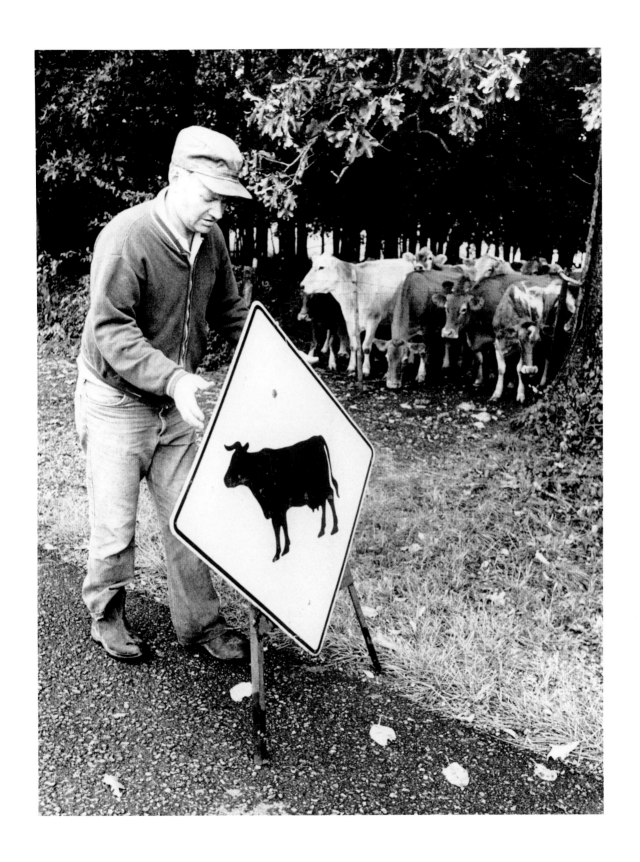

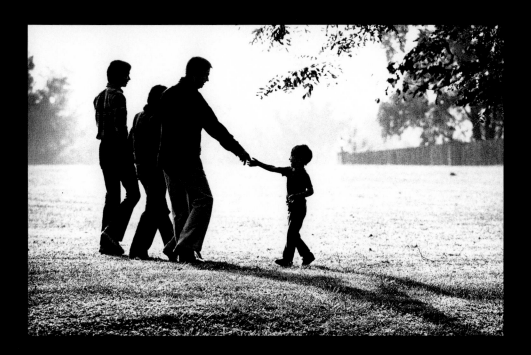

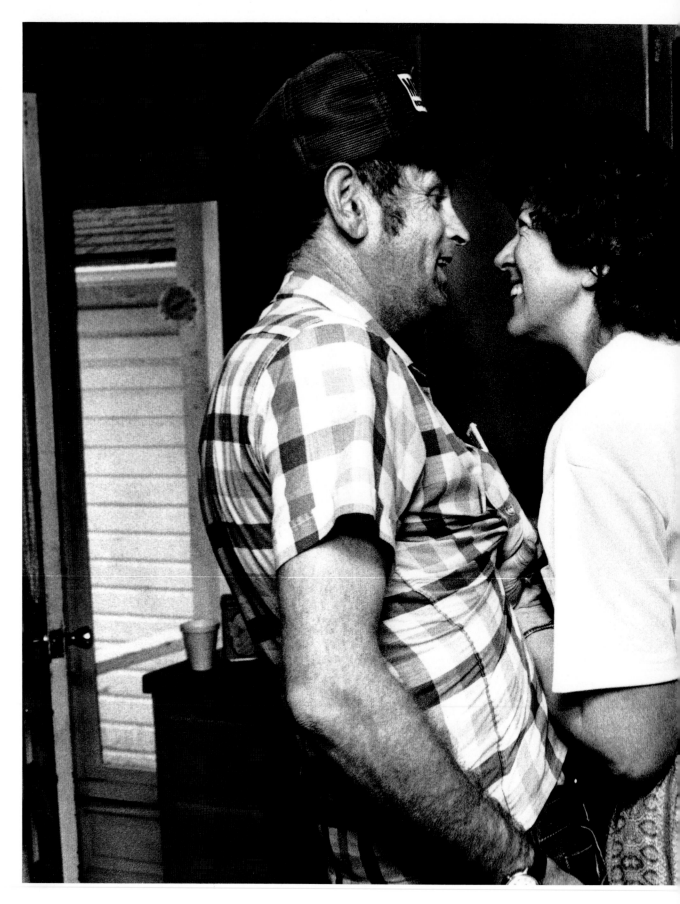

FORSYTH 1984

Paul Gero

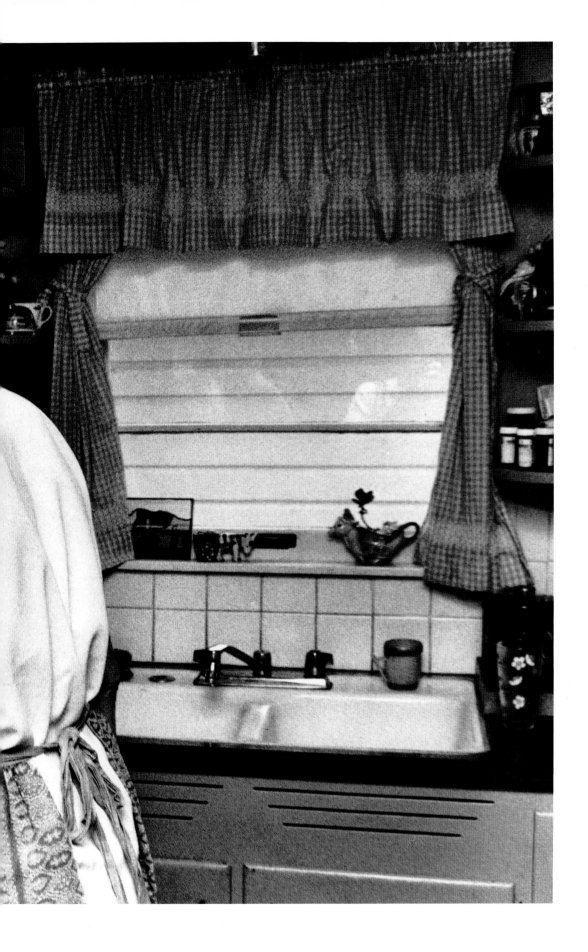

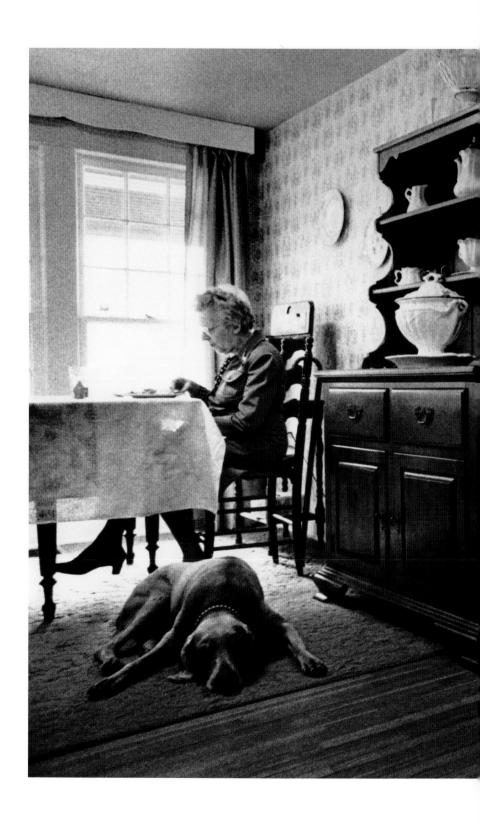

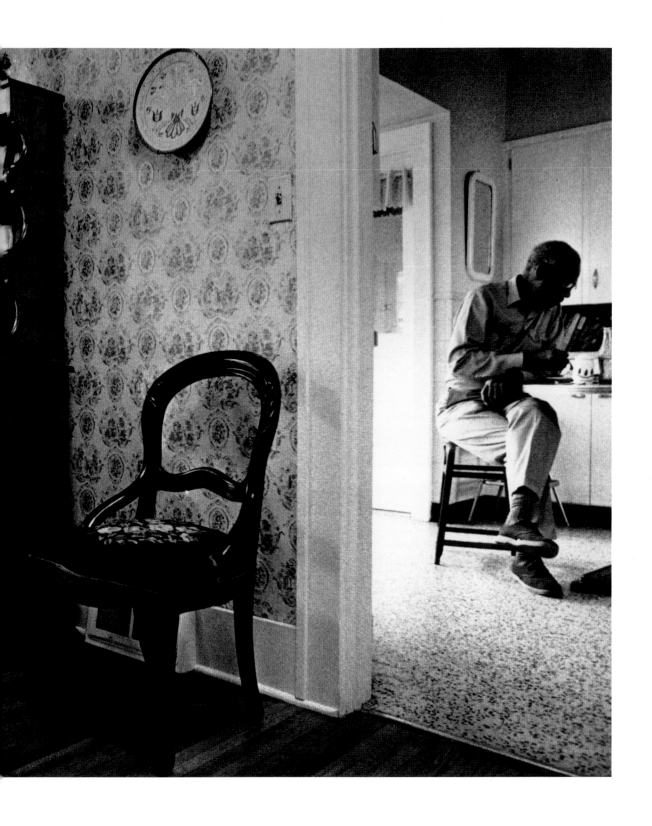

LEBANON 1978
William Janscha, Jr.

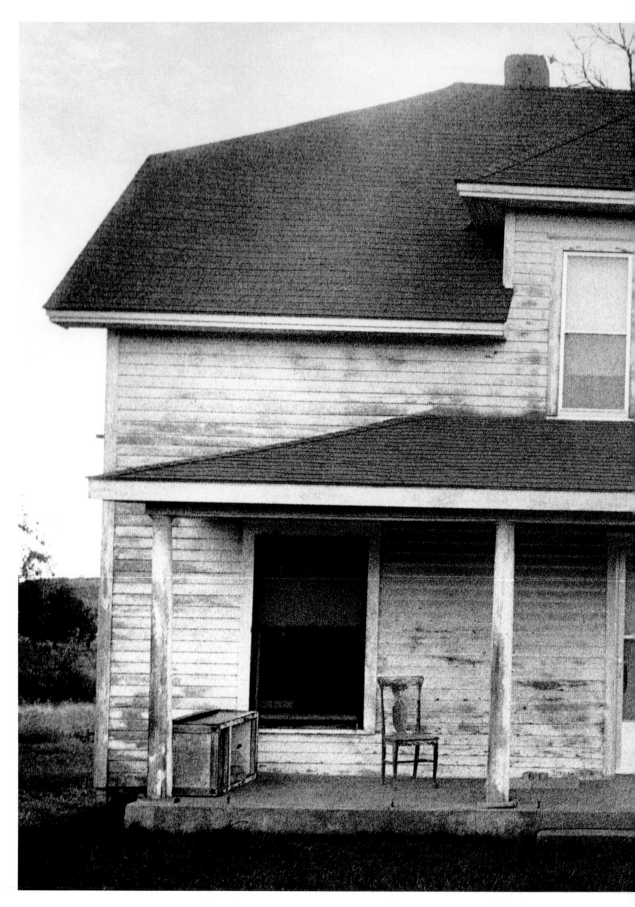

CASSVILLE 1977

Phil Schofield

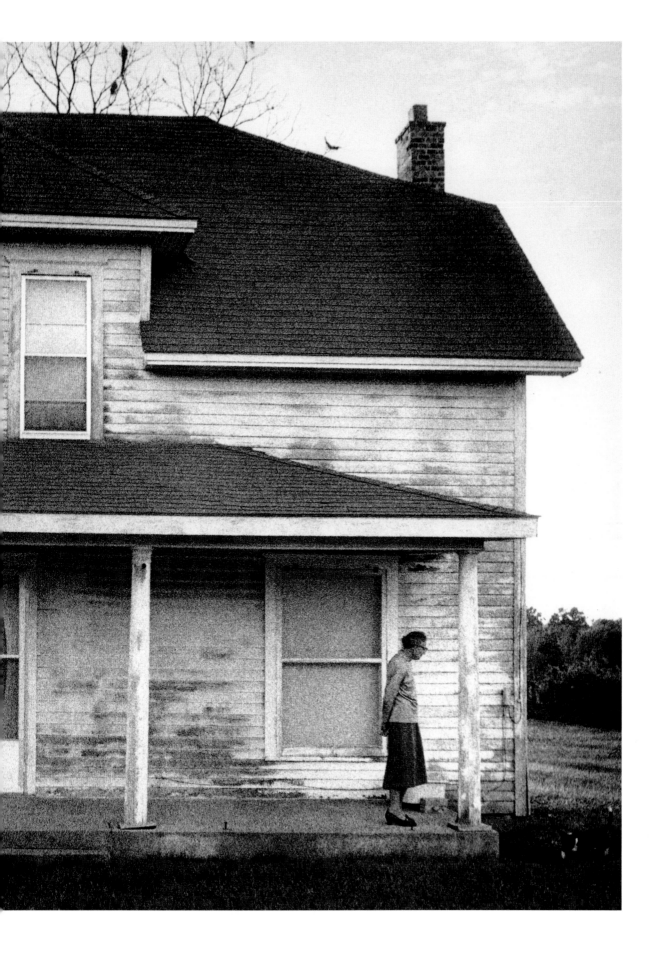

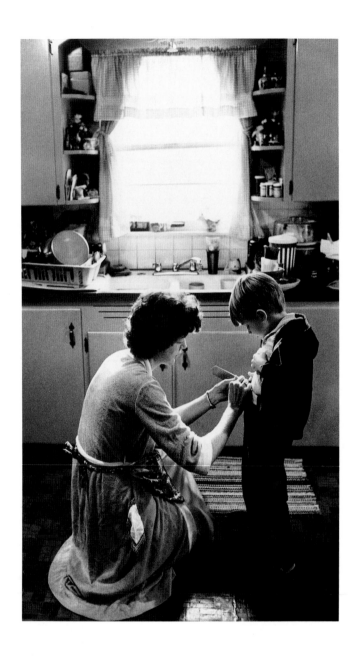

FORSYTH 1984

Paul Gero

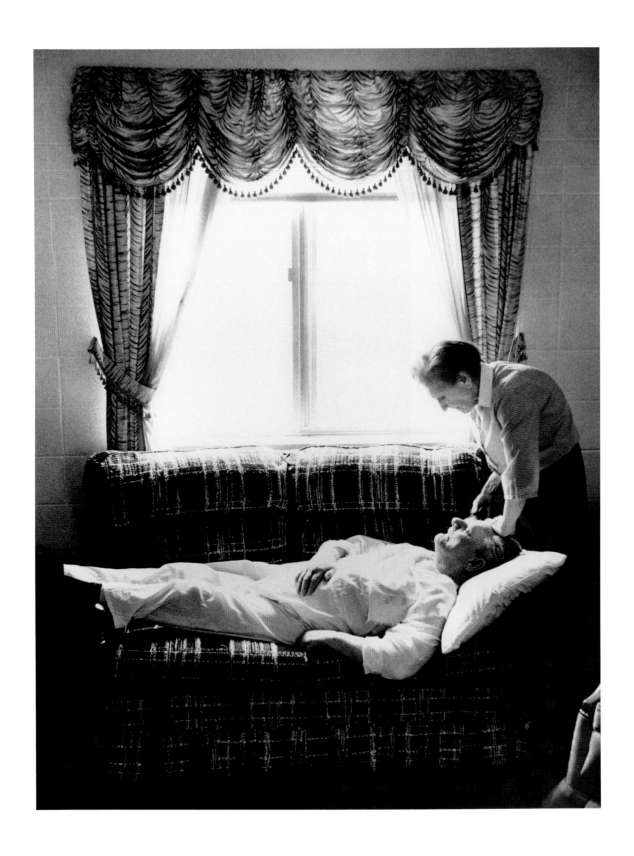

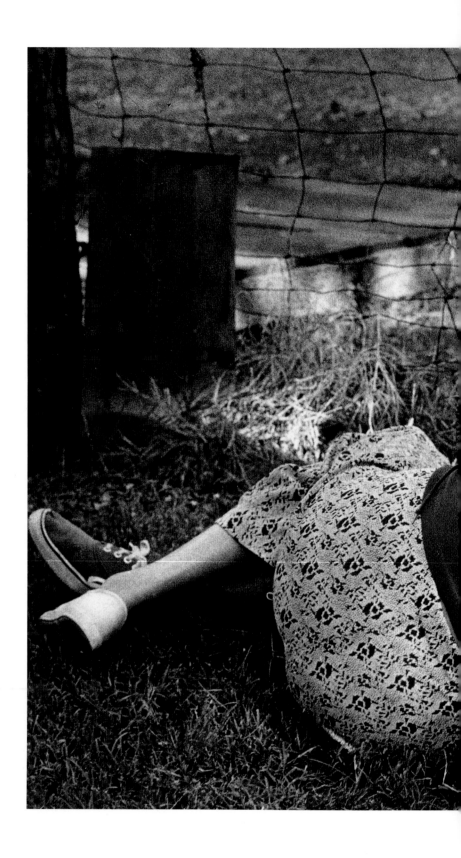

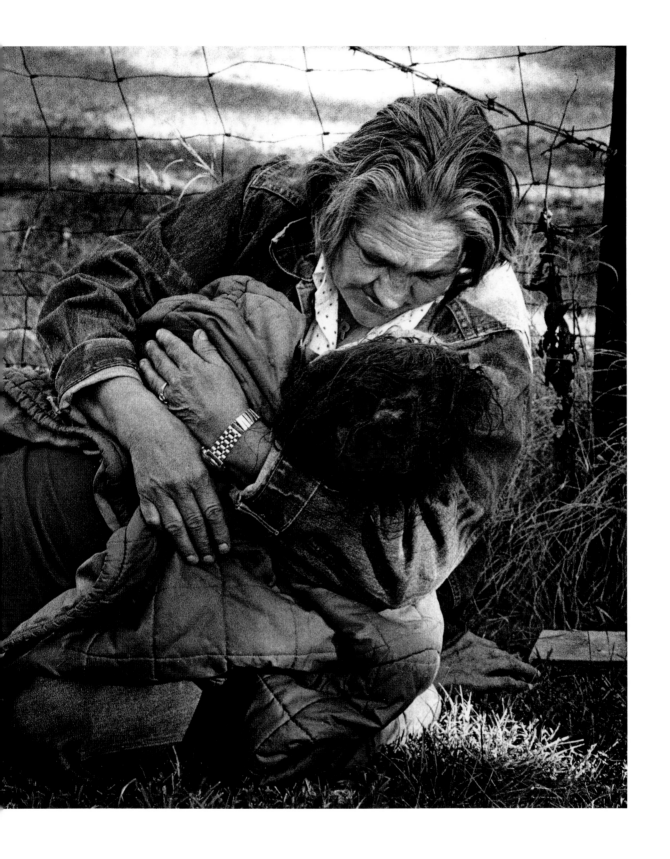

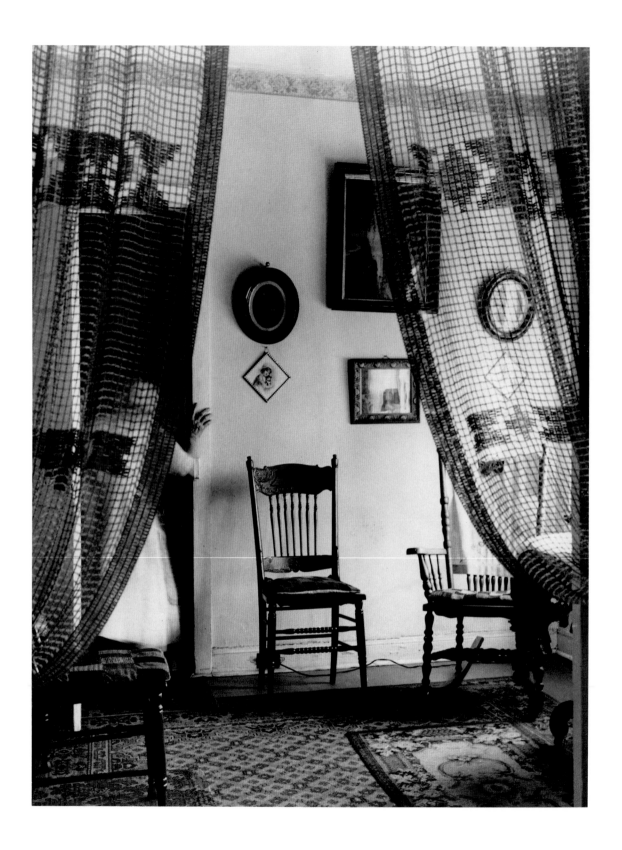

HERMANN 1951

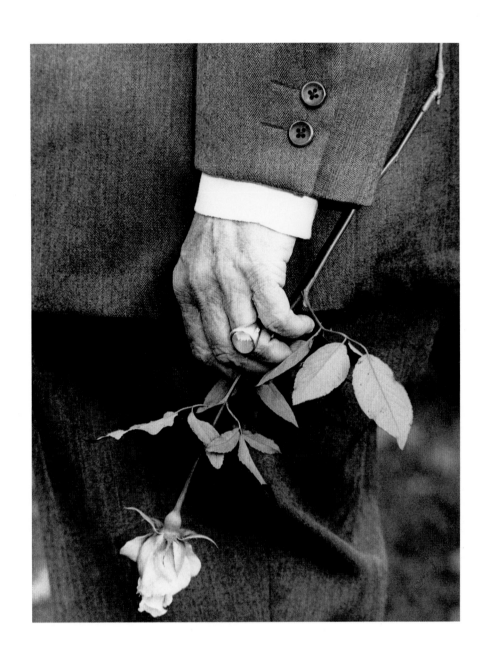

BOLIVAR 1970
Gary Gillum

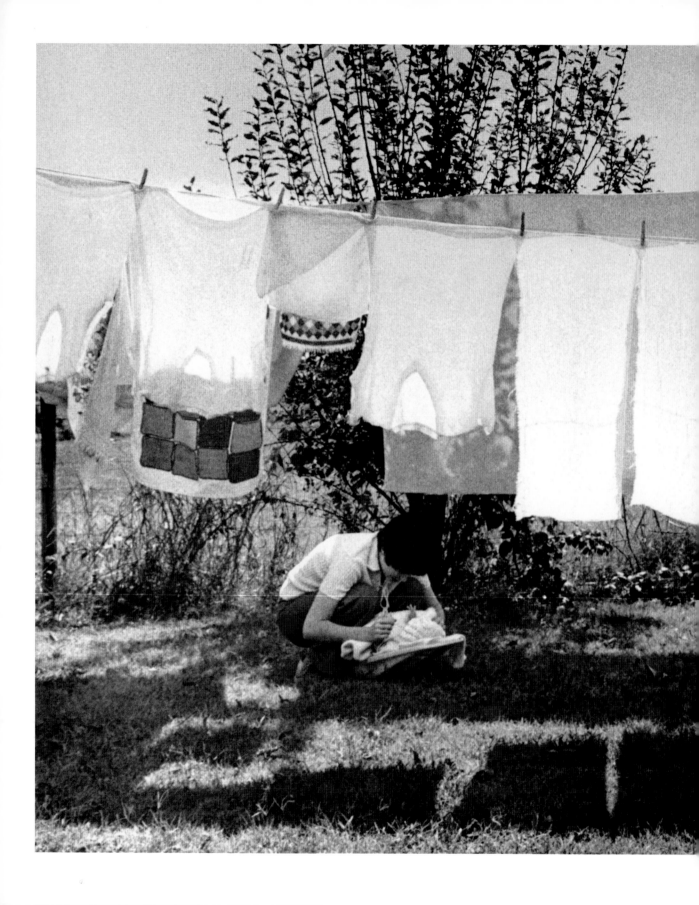

FORSYTH 1976

Hope Alexander Strode

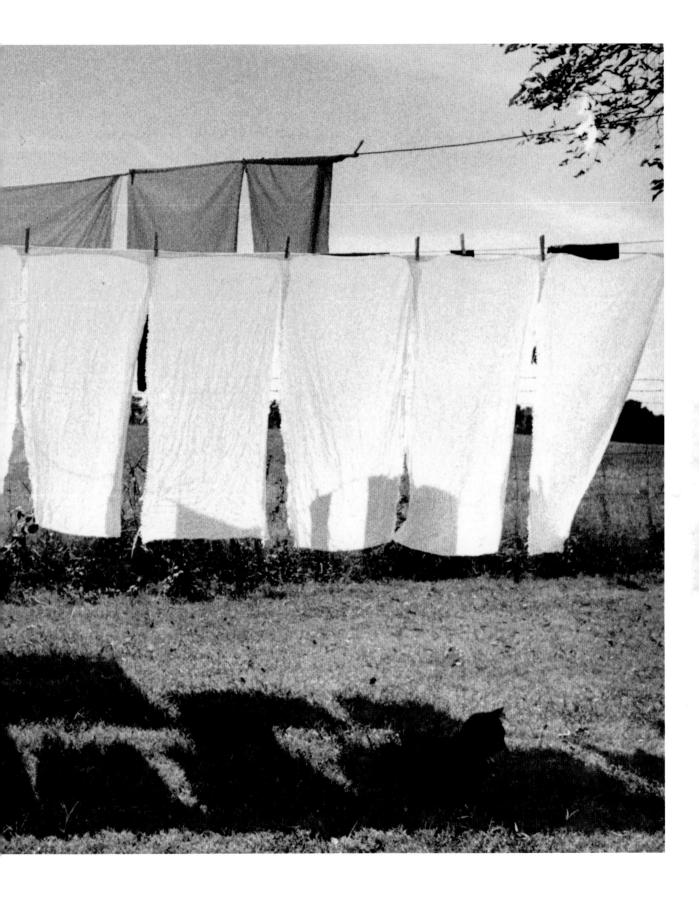

WASHINGTON 1972

Abigail Heyman

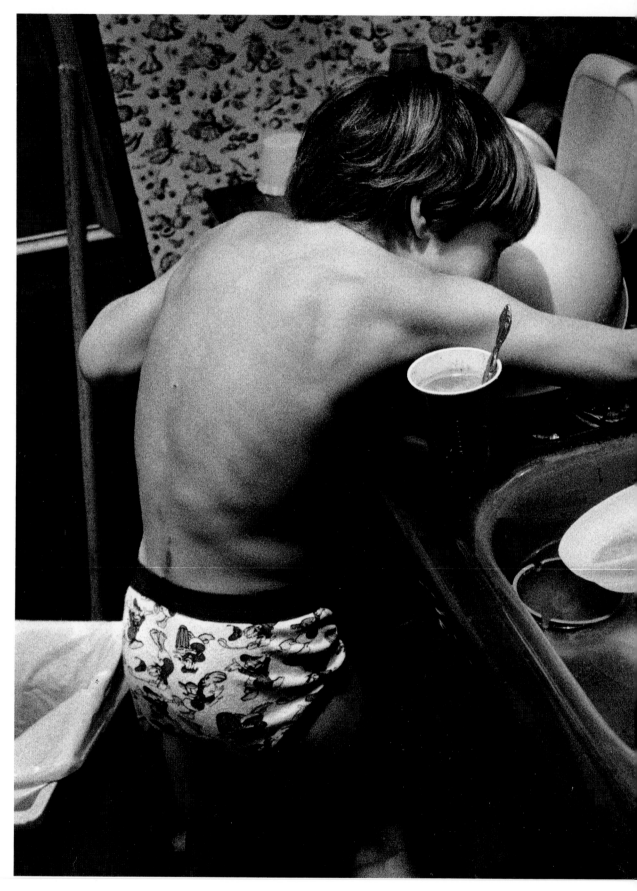

FORSYTH 1984

J. Kyle Keener

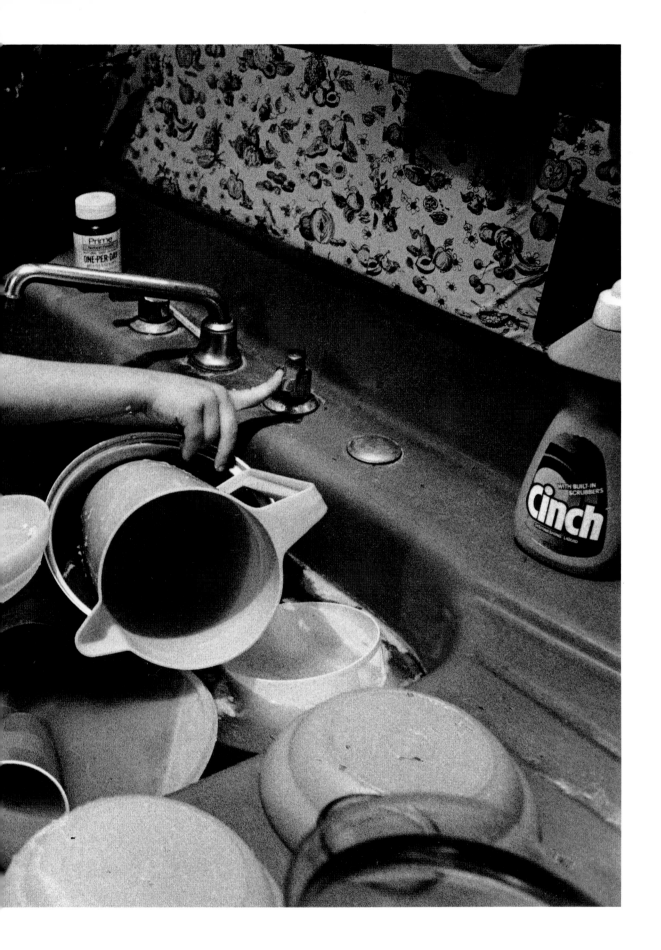

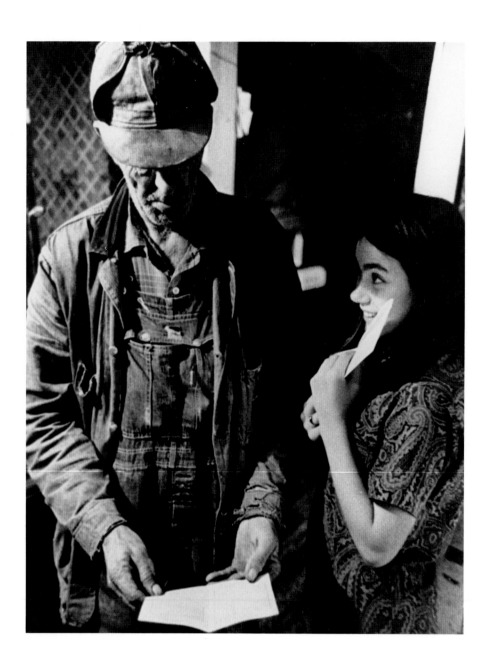

FORSYTH 1969

David Arnold

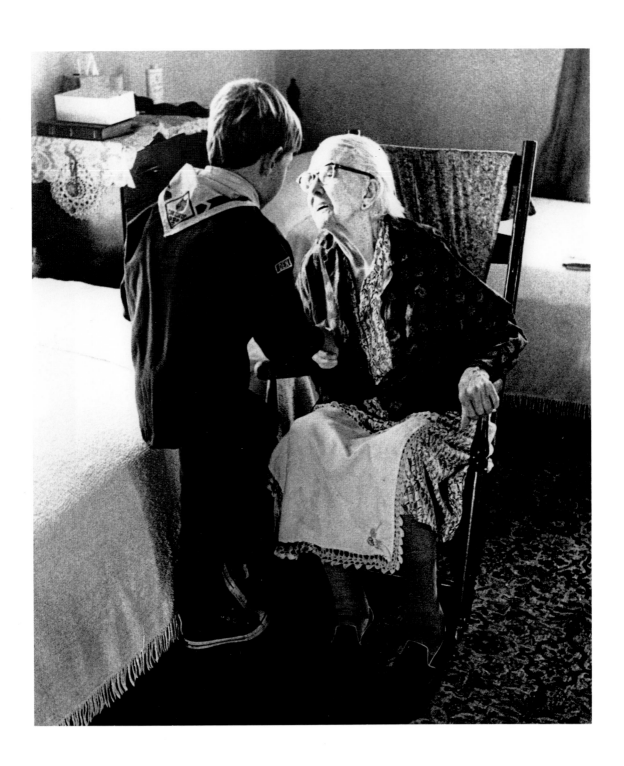

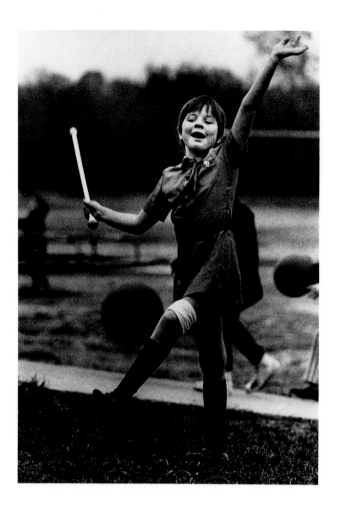

BOLIVAR 1970

Charles W. Luster

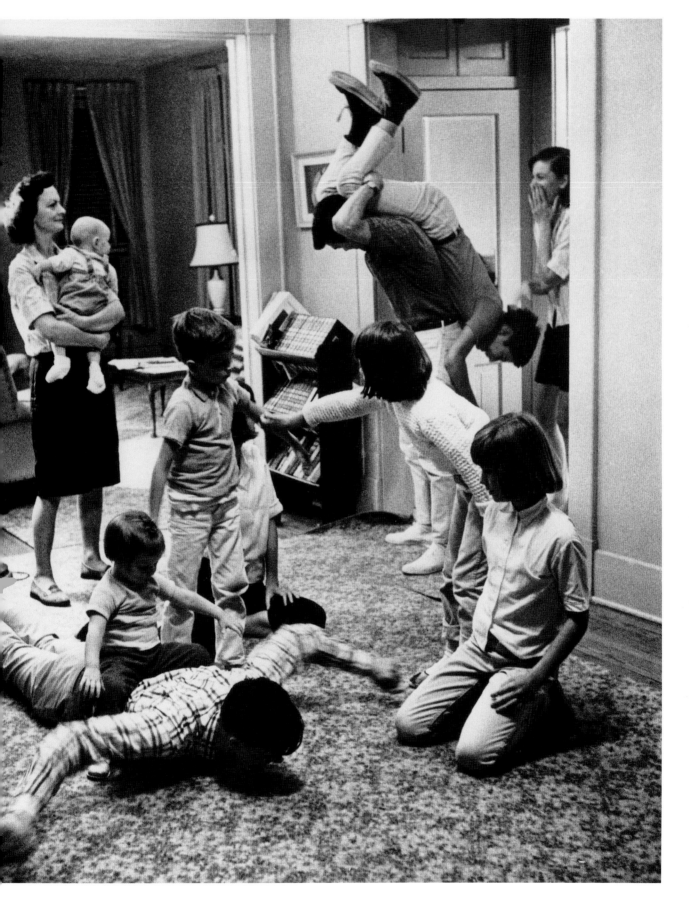

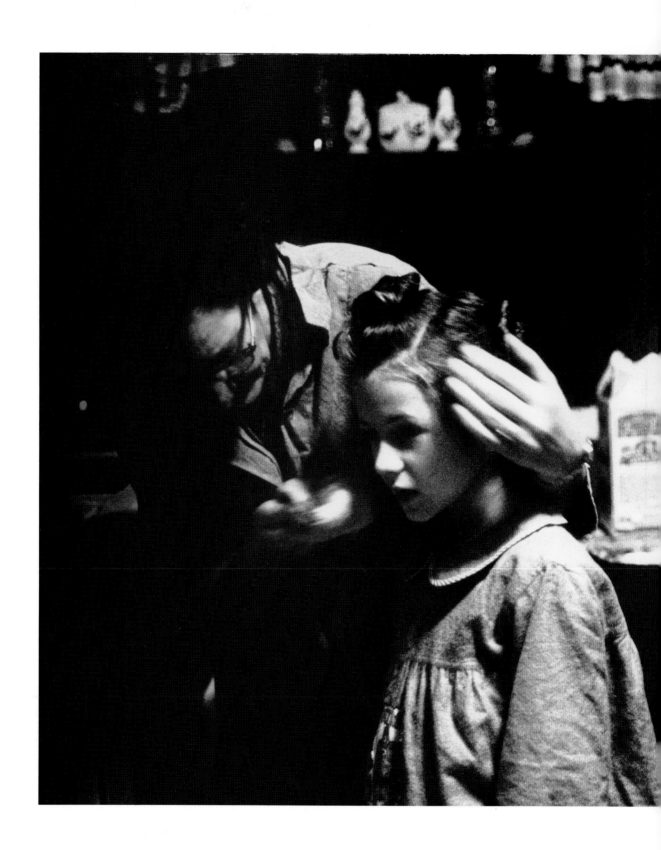

SALEM 1968

Howard Silvers

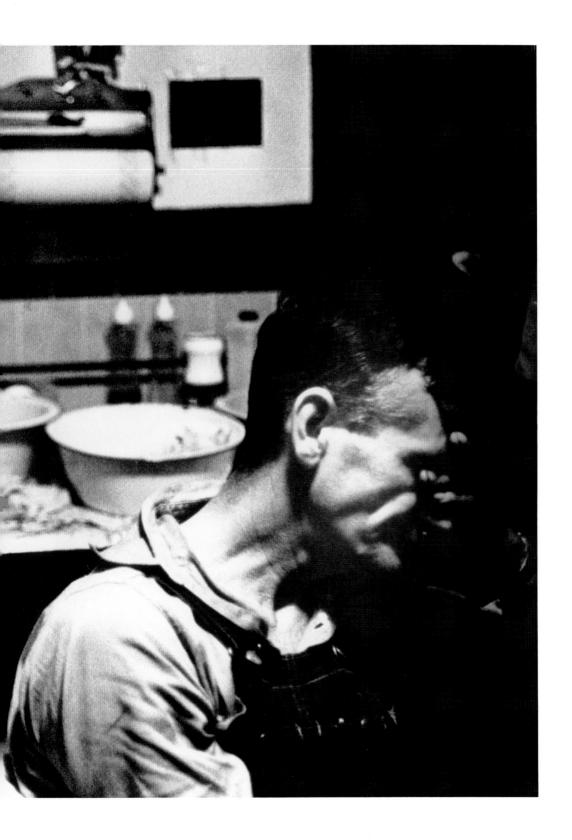

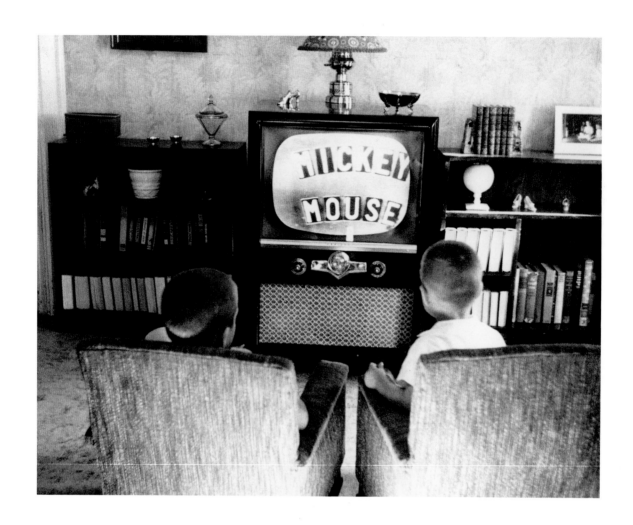

LEXINGTON 1956

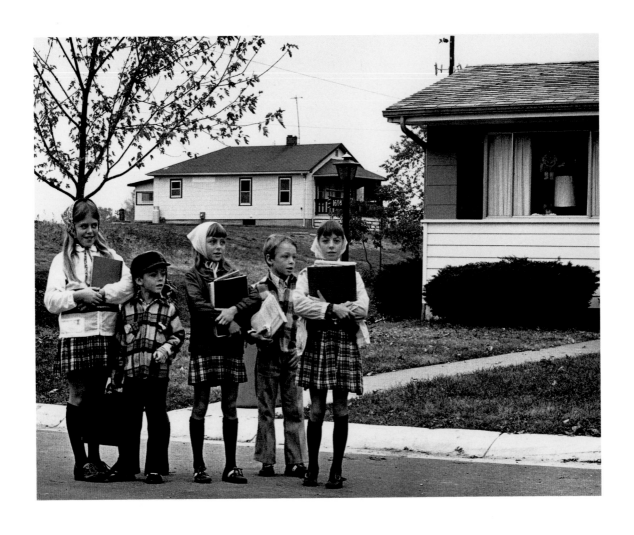

WASHINGTON 1972

Phyllis Fernandez Romero

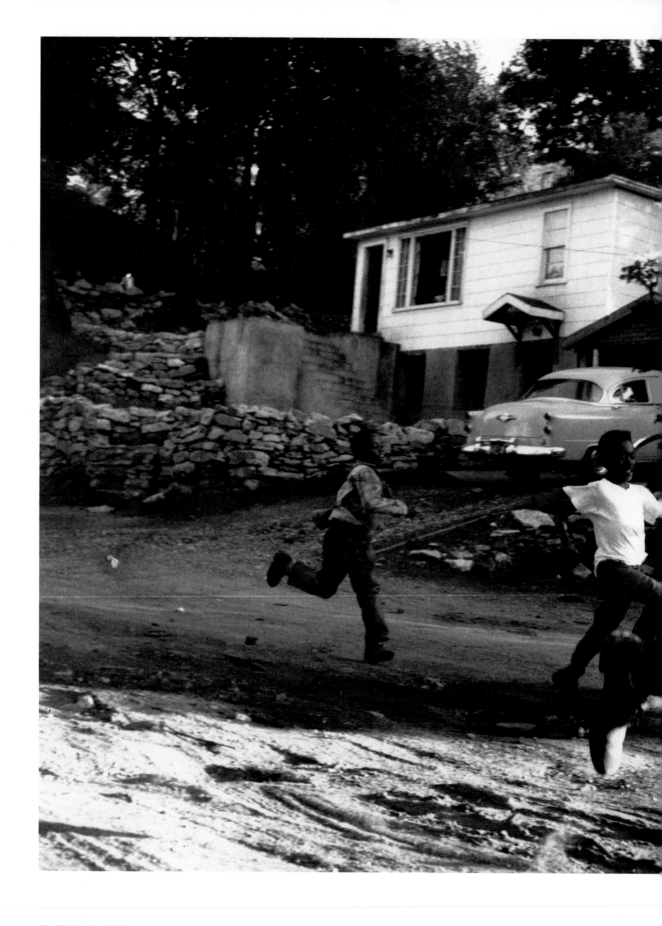

HANNIBAL 1957

Bill Ray

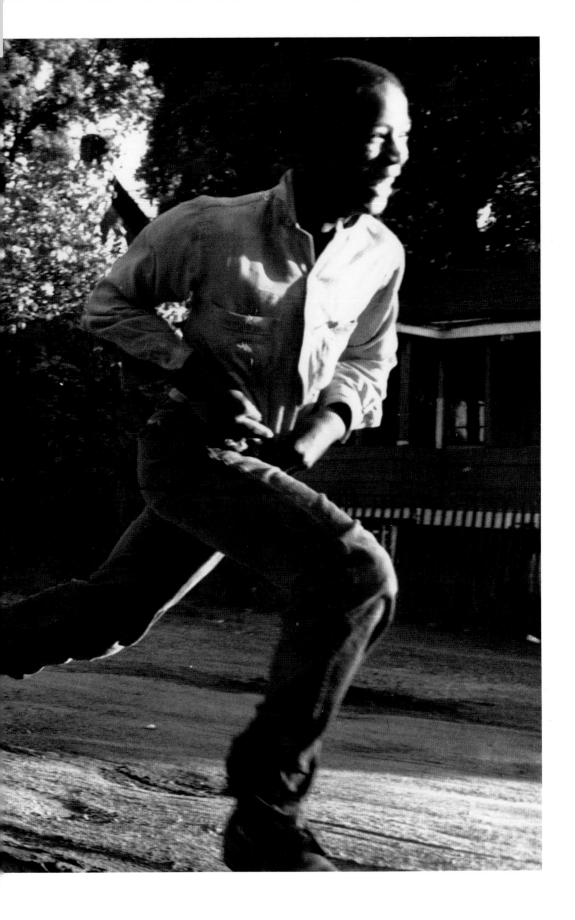

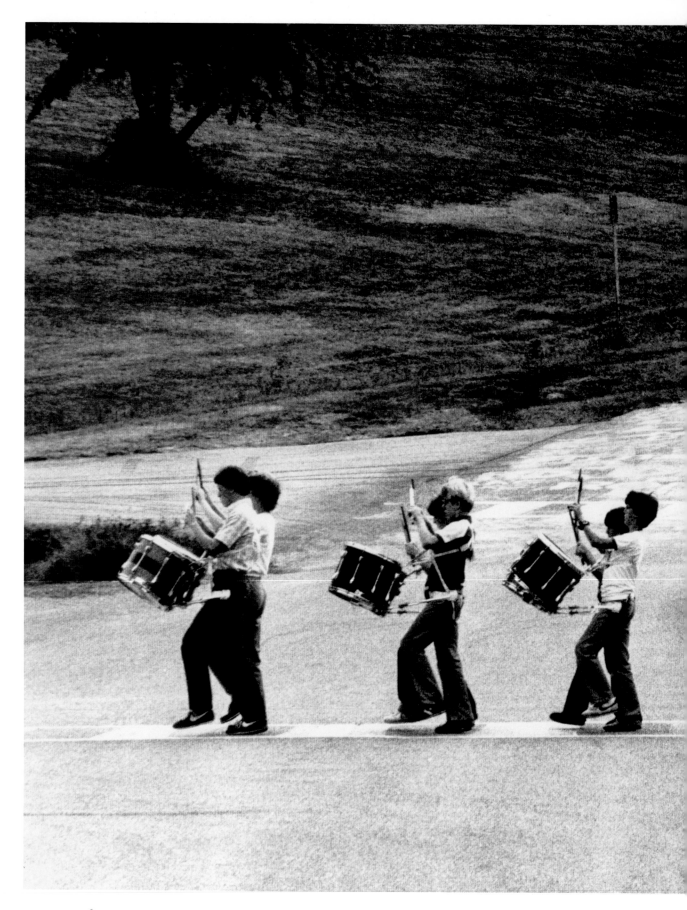

NEOSHO 1981

Judy Griesedieck

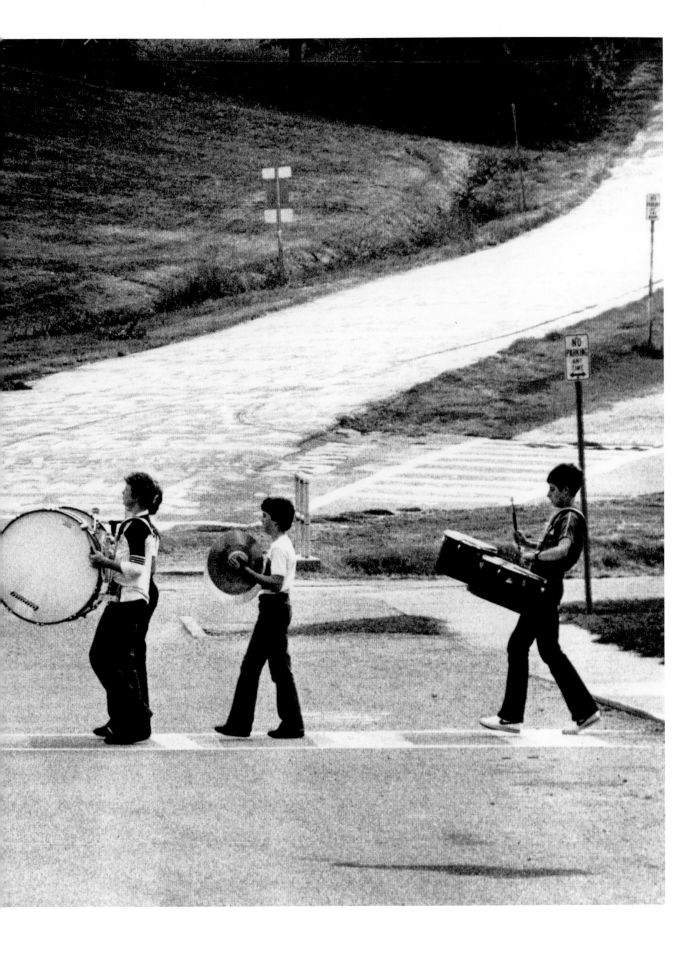

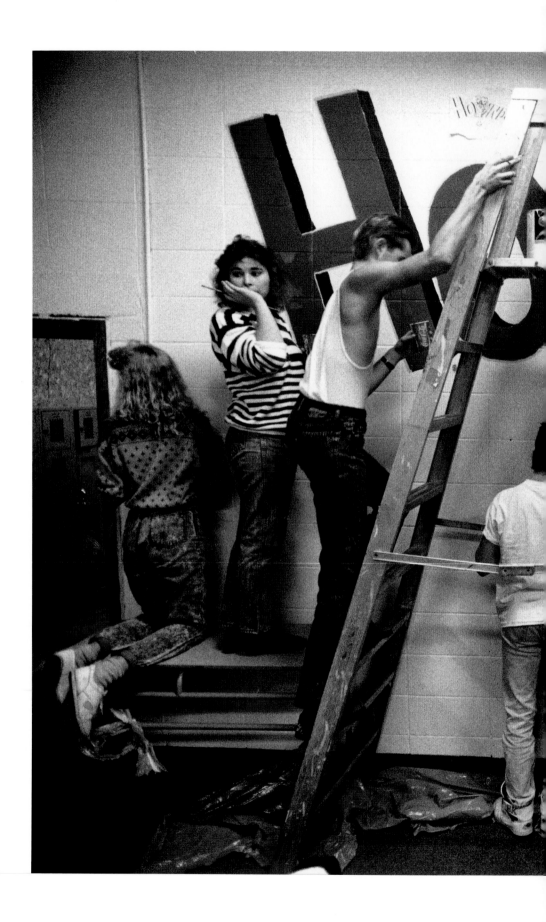

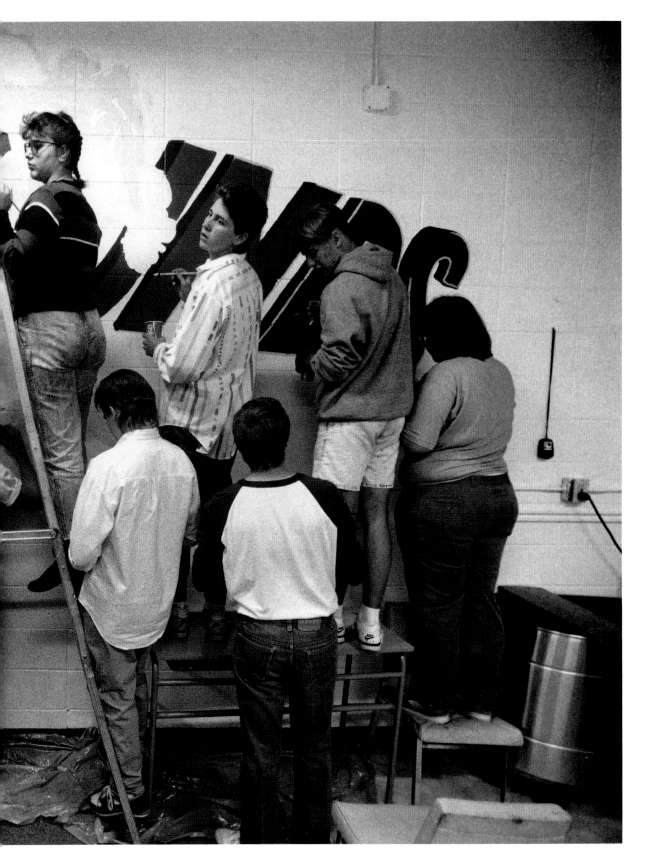

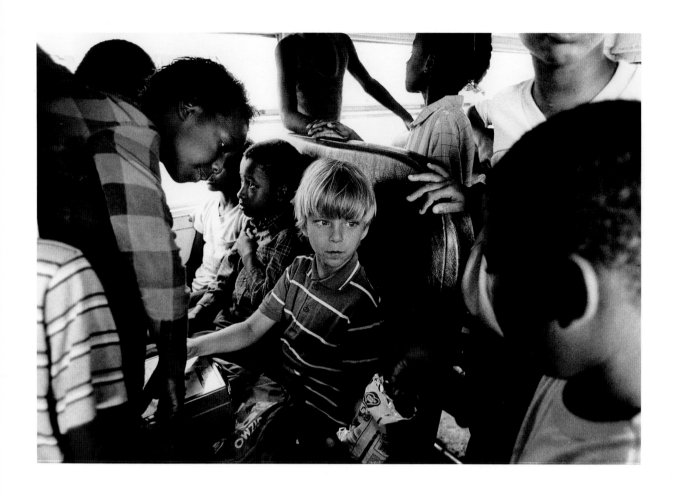

CARUTHERSVILLE 1987

Claro Cortes

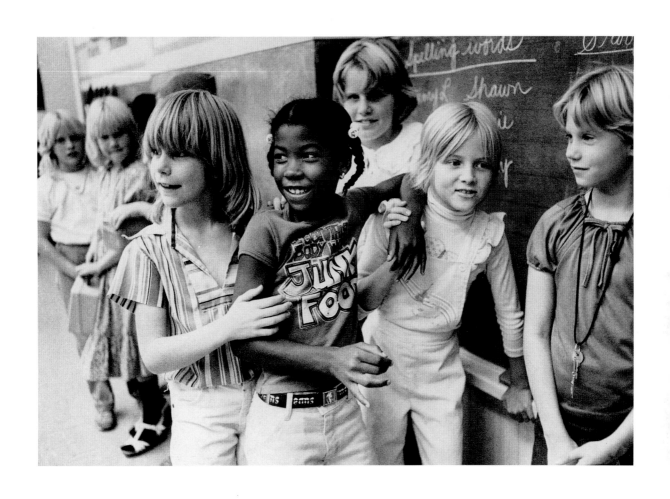

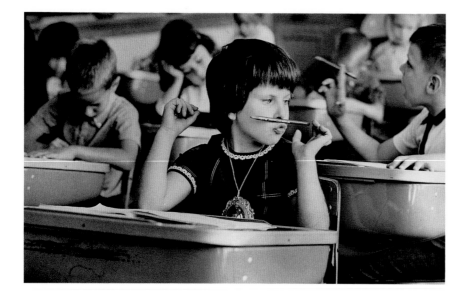

MARSHALL 1967

Charles Dresner

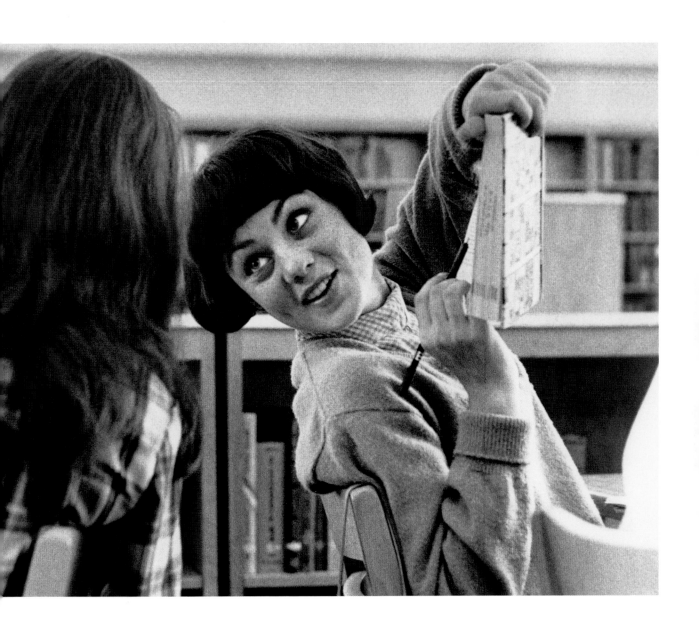

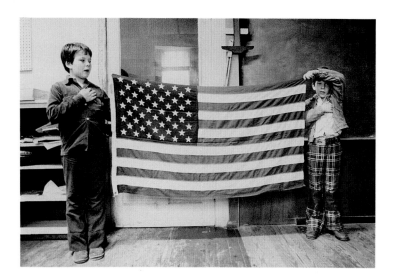

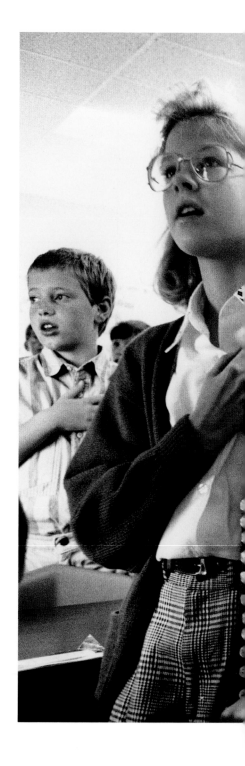

CASSVILLE 1977

Max Hirschfeld

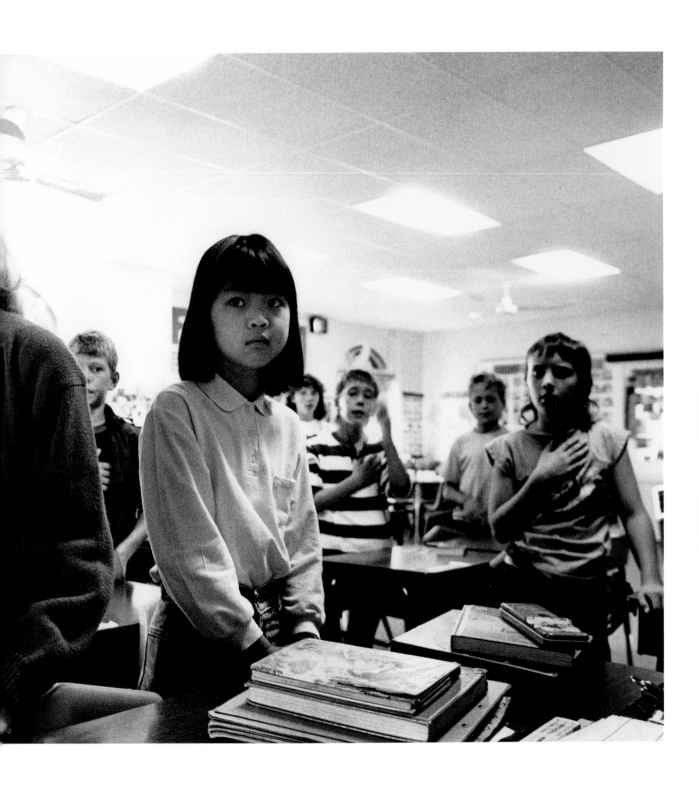

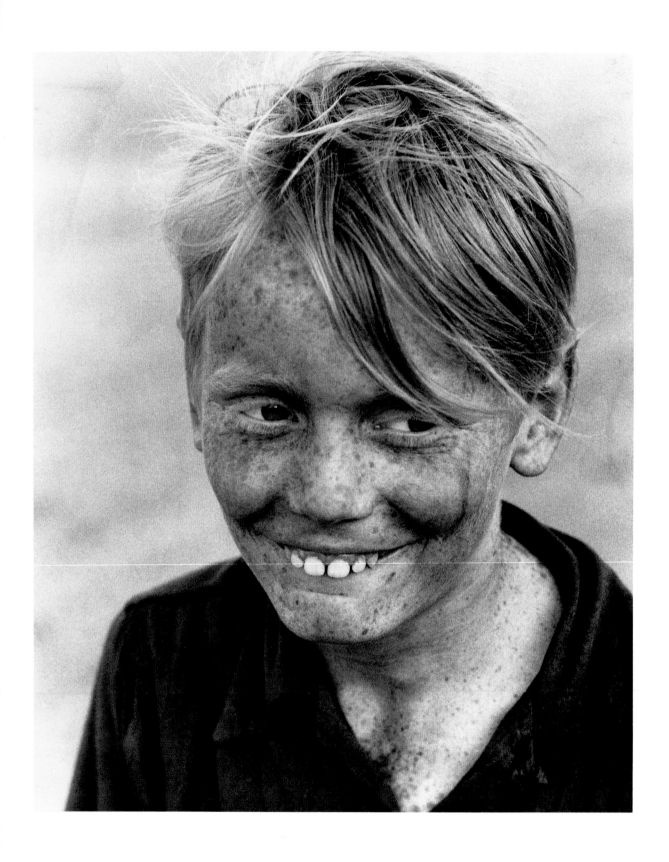

HANNIBAL 1957

Bill Ray

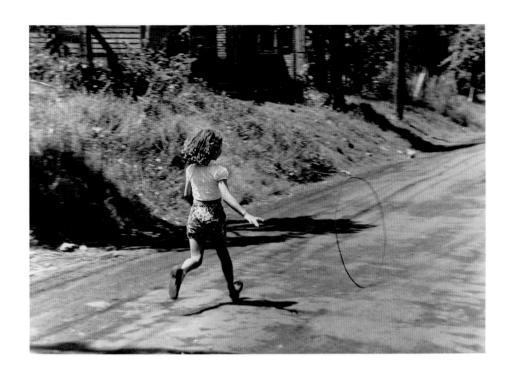

BOONVILLE 1953
Lillian Byrum

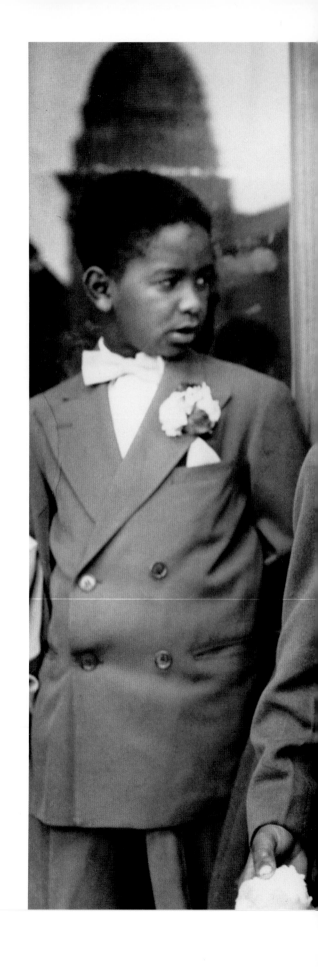

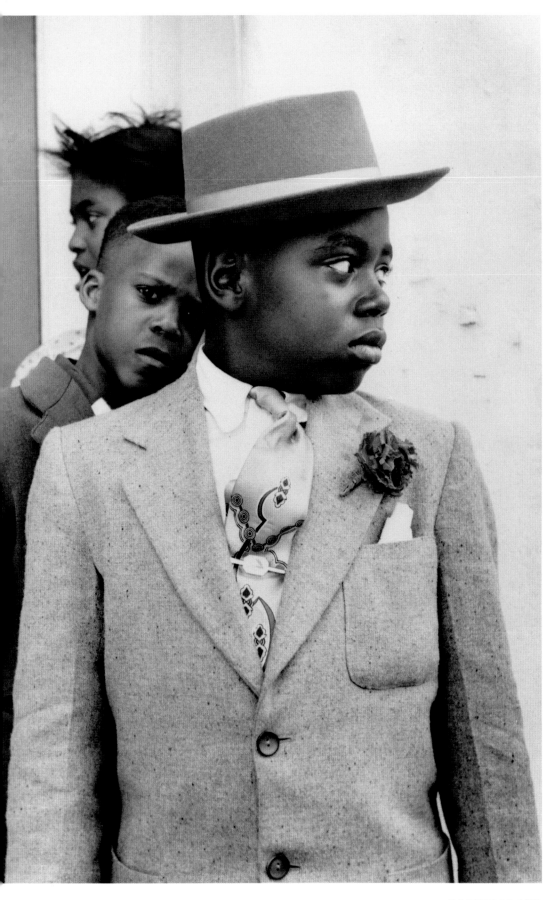

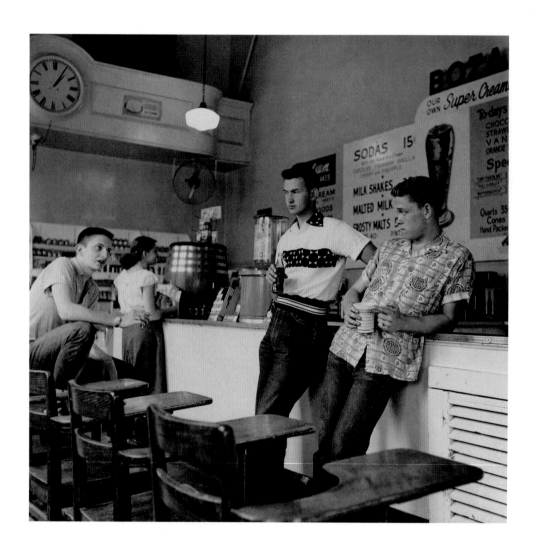

BOONVILLE 1953

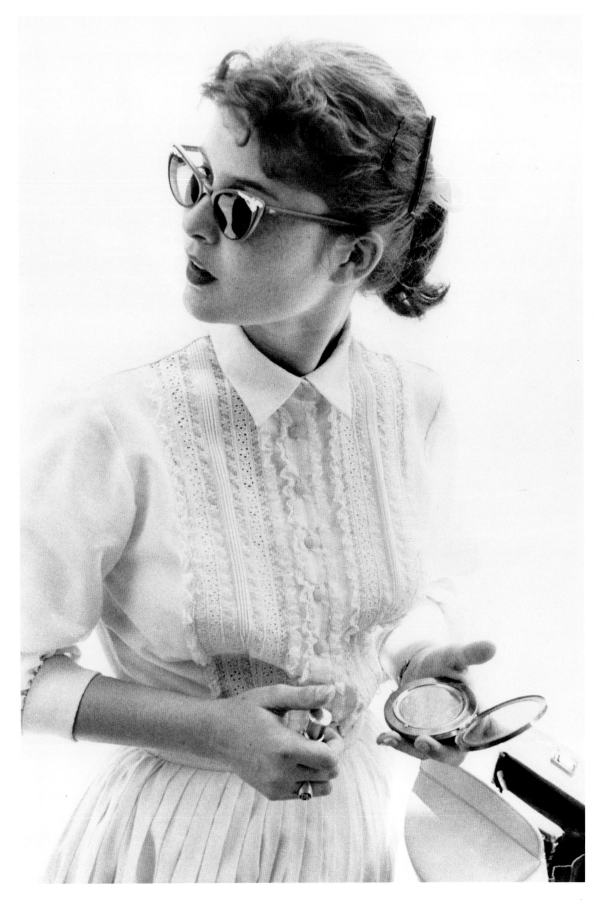

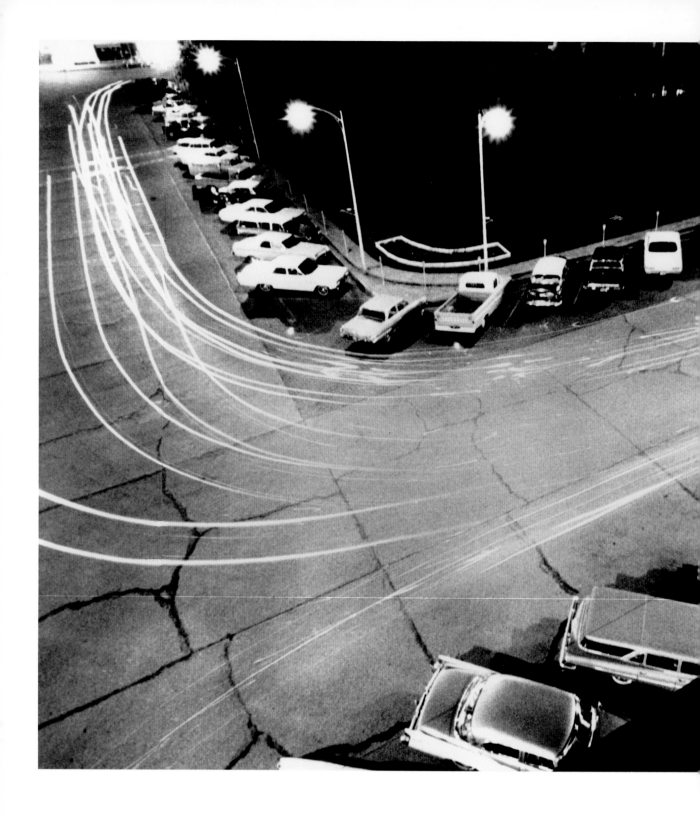

NEOSHO 1964

Owen Brewer

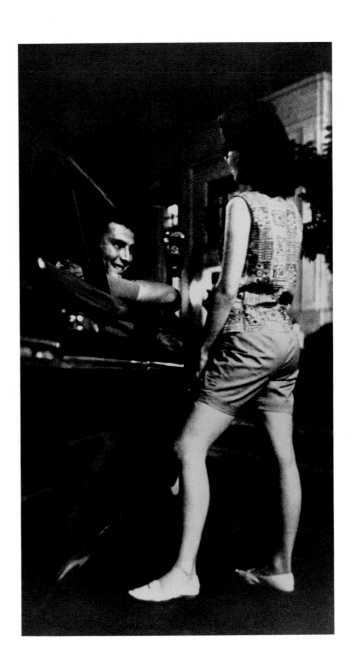

NEOSHO 1964

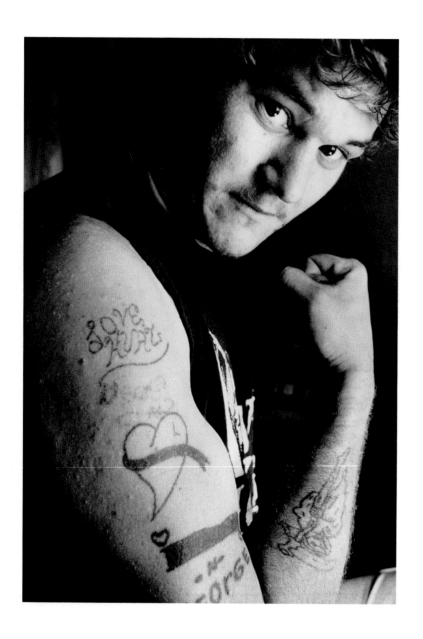

POPLAR BLUFF 1985

Don Ipock

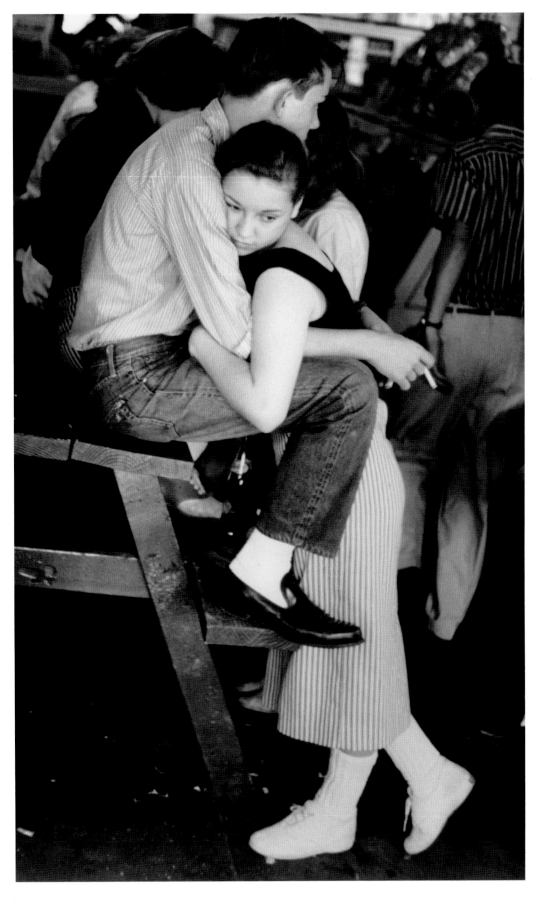

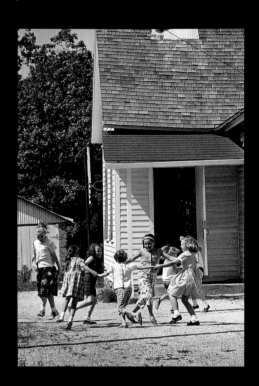

The Country School

By Bruce Dale

JOPLIN 1962

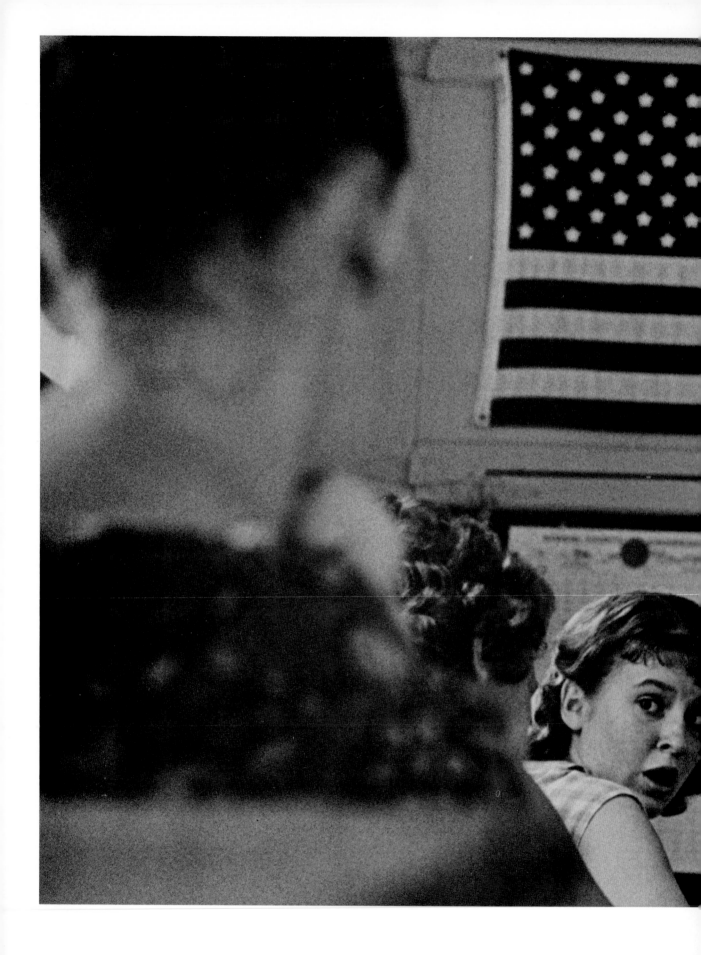

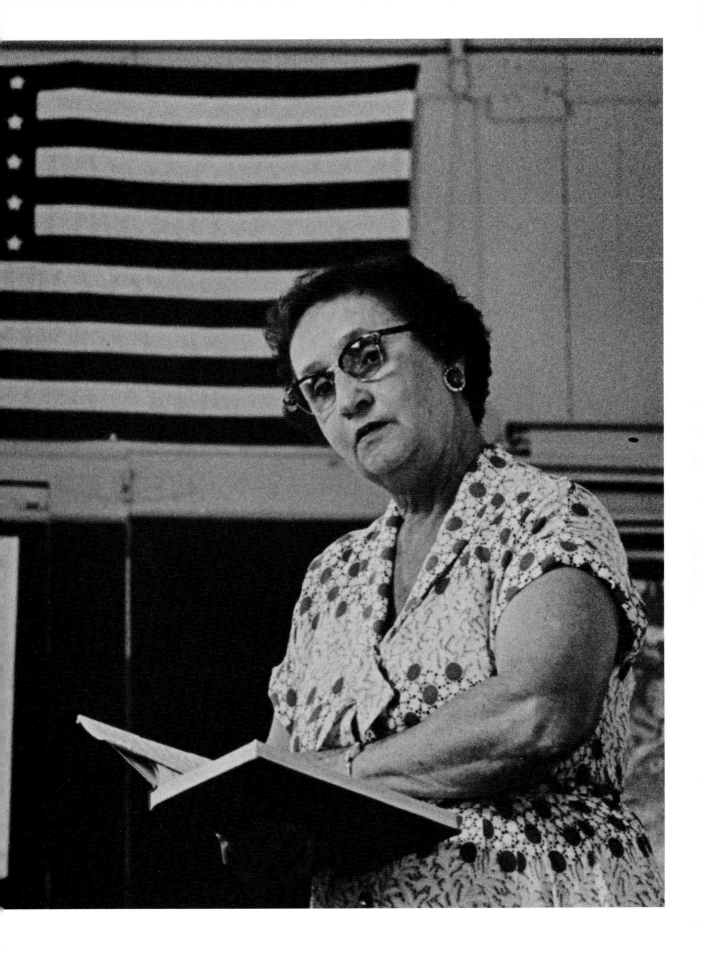

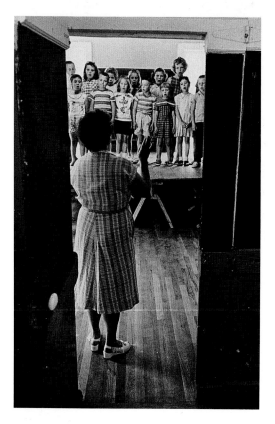

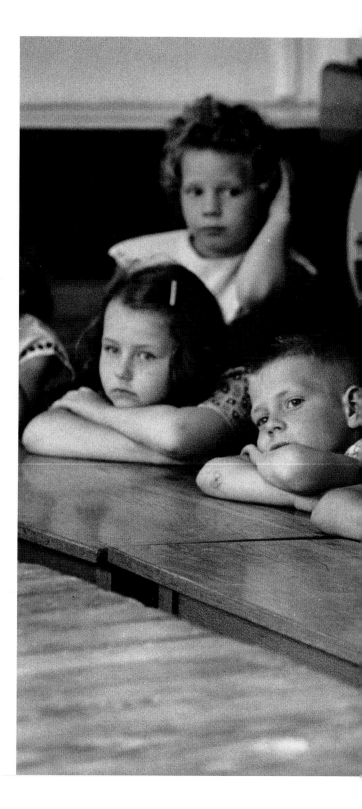

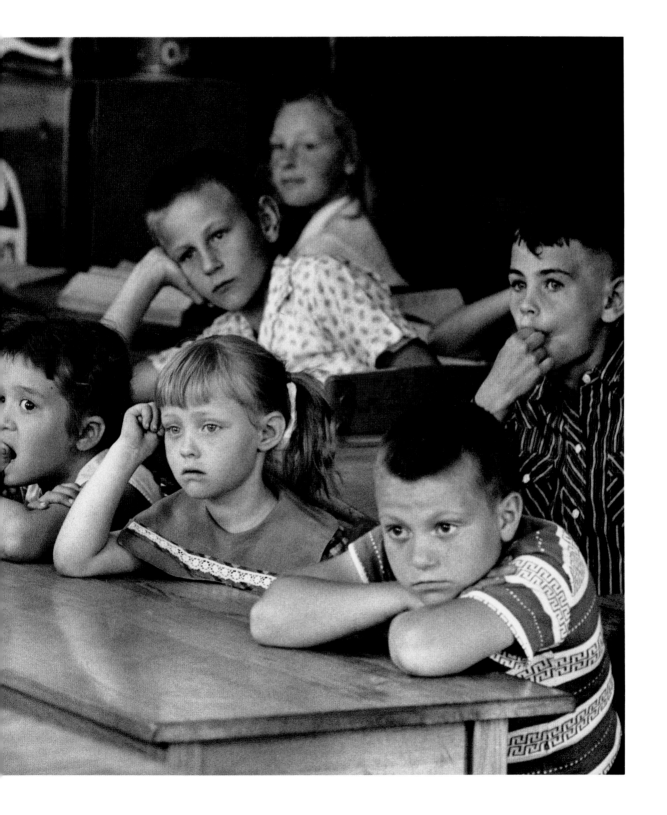

Home Is Where the Heart Is

By Jennifer Jecklin

NEOSHO 1981

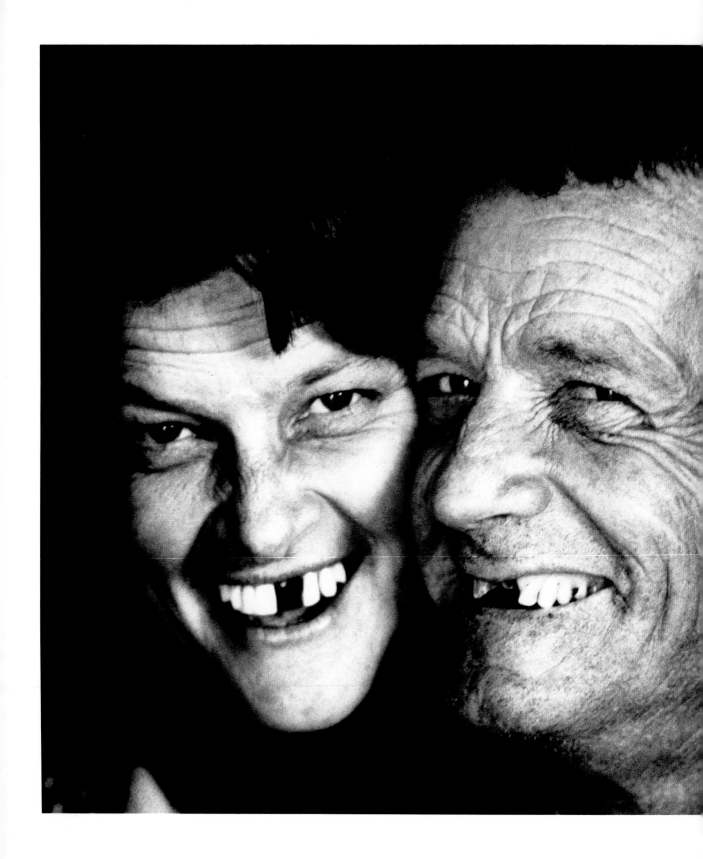

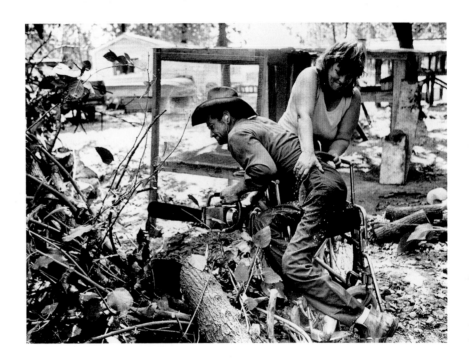

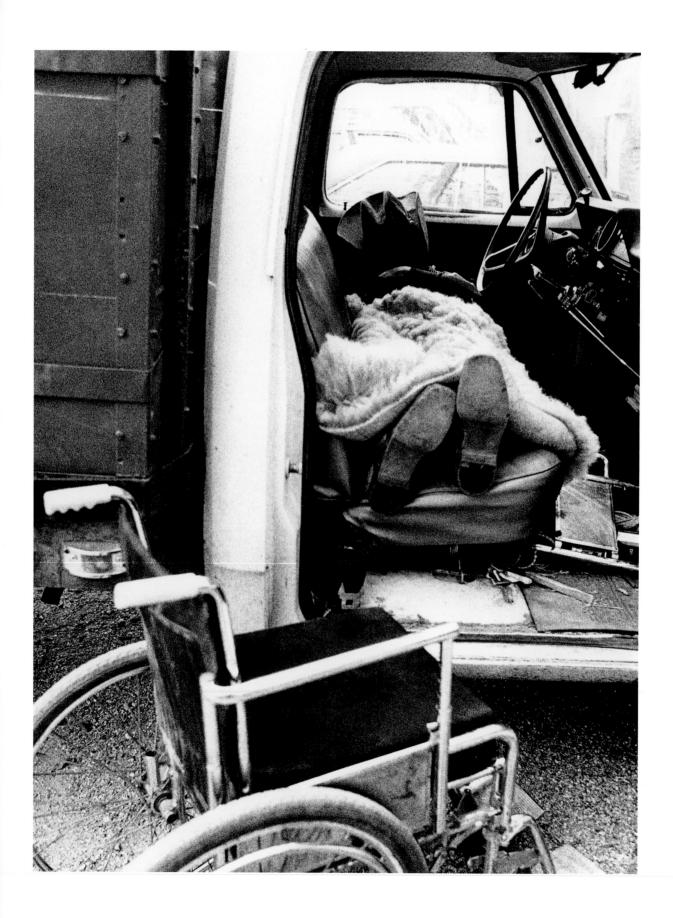

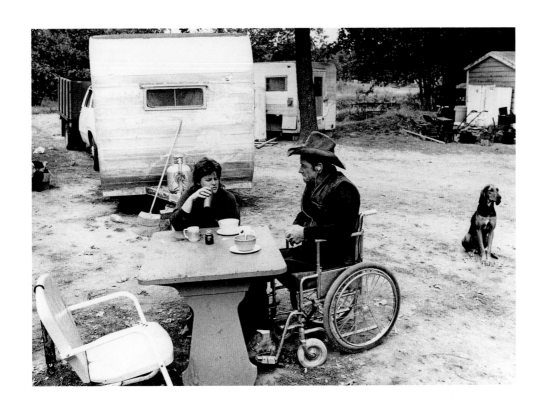

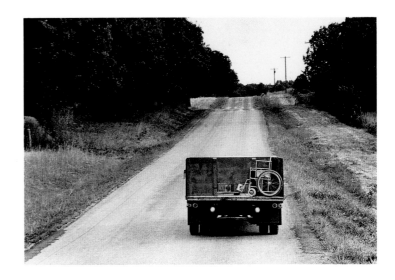

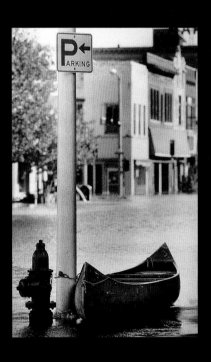

The 1986 Hannibal Flood

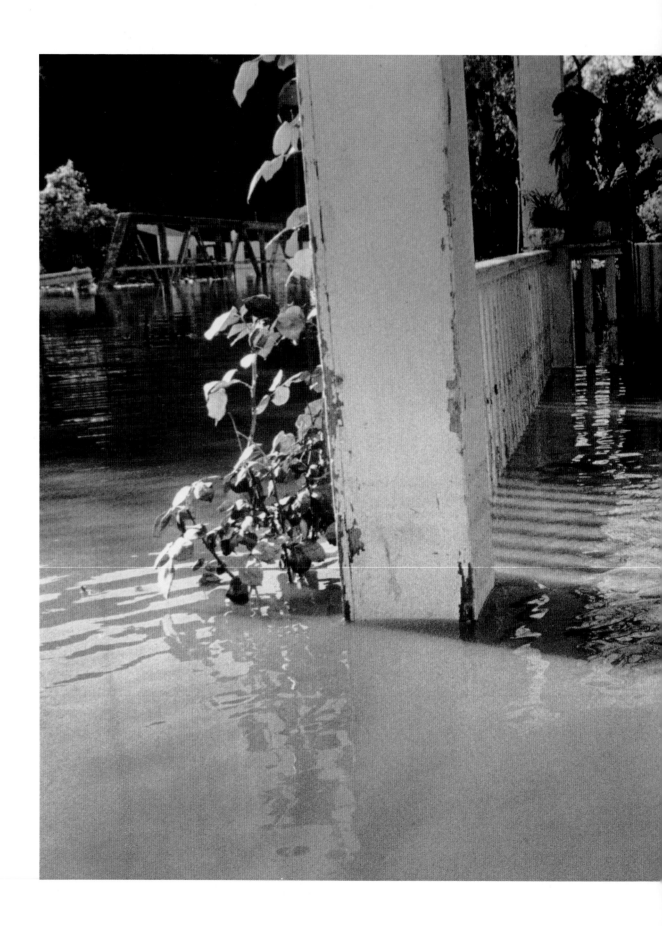

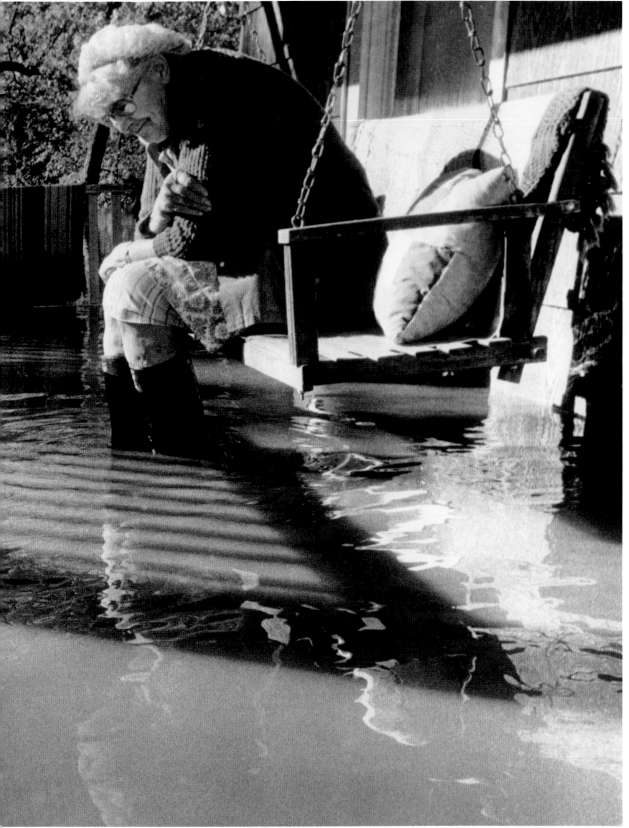

BEN HARRIS

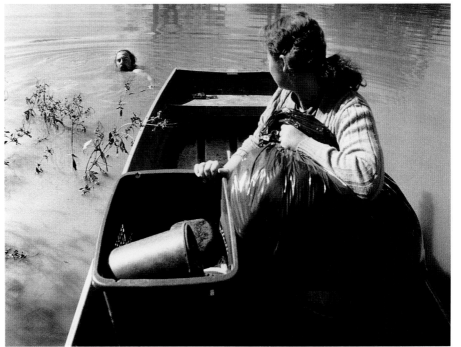

RICHARD GARDNER

BOB BREIDENBACH

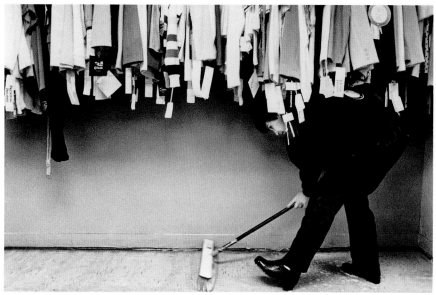

VICTOR FRASER

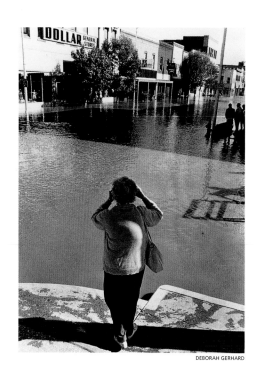

DEBORAH GERHARD

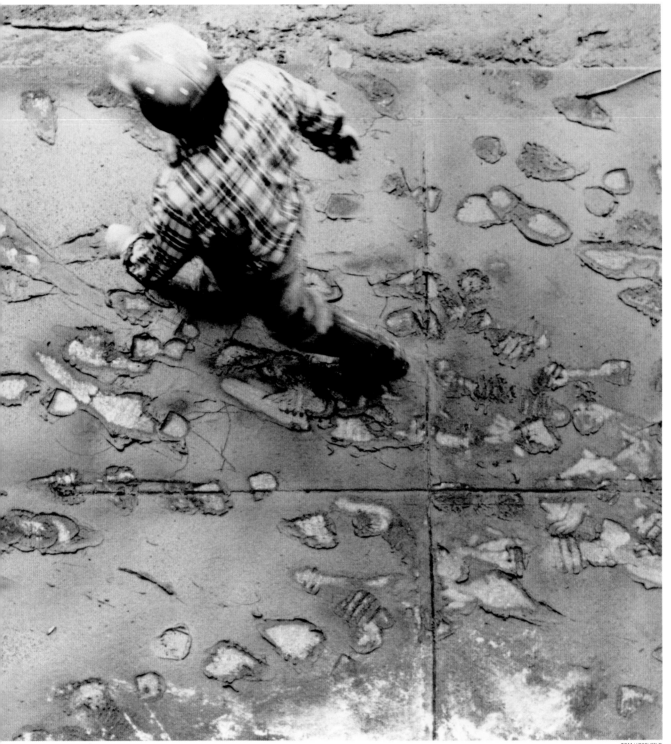

TOM HIRSCHFELD

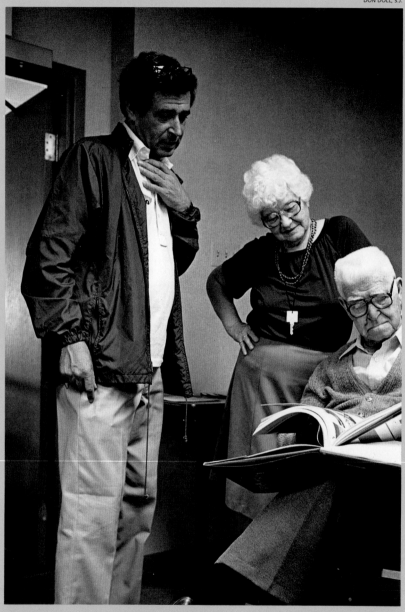

Cliff and Vi Edom look at
a 50th anniversary edition
of *Life* magazine with
Time/Life photographer Bill
Eppridge, a faculty member
after 19 workshops.

THROUGH THE BACK DOOR

*A Workshop History by Cliff Edom
and Verna Mae Edom Smith*

CLIFF EDOM: Bill Kuykendall, the newly appointed head of the photojournalism sequence at the University of Missouri's School of Journalism, decided to have a reunion following the 40th Missouri Photo Workshop at Jefferson City in 1988. During that happy occasion, I was asked, as the workshop's founder, to write a book covering the history of the workshop. I agreed but decided to include the entire family: my wife, Vi, and our daughter, Verna Mae. After all, all of us had a large part in the project, and each, I was sure, could contribute to the story. But before we started, we agreed there were other things that should be mentioned. For example, we needed to talk about the background of the School of Journalism and the events that led up to the workshop.

When acquaintances and friends of the Edom family learn we have invested a total of more than one hundred years in study and work in photojournalism, they ask, "How did you prepare to enter the profession, which has meant so much to all of you?" Rarely do they accept the answer, "We did nothing." The persistence of their questioning forced us to do a careful review of our preparation to be photojournalists. Much to our surprise, we learned that ours had been the best possible, the most direct route we could have taken at the time. First, we learned the printing trade; next, we were introduced to the photoengraving process; and finally, at the University of Missouri, we began to learn the elements of photographic reportage. When we looked at the way in which we began our work, we realized that we did not use a back-door approach.

In 1928, Vilia C. Patefield and I were married. The next year we moved to Edgar, Wisconsin, where we took over the weekly *Edgar News*. There our daughter was born. Vi not only had to run the typesetting machine and presses in the *News* printing shop but also had to care for our daughter. When we later sold the newspaper office, I became Linotype operator, proofreader, and photoengraver for the Wausau (Wisconsin) *Daily Record Herald*. But we weren't done moving yet. In 1935 we moved to Aurora, Missouri, where we worked with the Aurora School of Photo-Engraving. My job was to edit the *Tasopé News* and other monthly publications devoted to photography and photoengraving and also serve as educational director of the school. Vi, in the meantime, became administrative secretary, a job she held until we moved.

The next stage of my career, which consumed some thirty years, began in 1943 when we moved to Columbia, Missouri. Here I completed work on my bachelor of journalism degree in 1946 and became a full-fledged staff member of the School of Journalism. Although I never had the pleasure of meeting or working with the renowned Walter Williams, founder of the school, I found that my thinking harmonized with this great man's philosophy of combining work with classroom study.

When I started teaching photojournalism in Columbia, money was a big problem. Dean Frank Luther Mott did not have enough to run the photojournalism sequence, a problem not shared by many other schools. He had only a limited supply of film and photographic paper to use in the daily news-

paper, the *Columbia Missourian*. When we were out of one or the other of those products, there would be no more pictures for the paper until the next allotment. Our students did, however, quickly adjust. It all reminded me of the passage in John 21:24-25 when Peter said about Jesus' work, "This is the disciple which was bearing witness we know was true. But there are also many other things that Jesus did; were everyone of them to be written, I suppose the world itself could not contain all the books that

WORKING WITH PHOTOGRAPHIC GROUPS, WE FOUND

A COMMON GOAL AND MAINTAINED A STRONG TEAM,

A STRONG LOYALTY, AND A STRONG REASON FOR BEING.

would be written." The same is true for the vast amount of work done by the students who recognized the potential of photojournalism and the need for their commitment to the betterment of the profession; had everything the students did been reproduced in book form, "the world itself could not contain all the books that would be written."

Later I headed the photojournalism sequence, and Vi and I started the Pictures-of-the-Year Contest (POY), Kappa Alpha Mu (the photographic honorary society), and the Missouri Photo Workshop. Taking care of the department, POY, and the workshop during the last forty years has not been a bed of roses. There have been problems from time to time. But we would not have had it any other way. Inaugurating the programs and keeping them going has provided us great satisfaction. Working with photographic groups, we found a common goal and maintained a strong team, a strong loyalty, and a strong reason for being. This led to teamwork, to sincerity and dedication. It allowed us to do more than we could otherwise have done. The teamwork has paid dividends. If we were called again to do it

JEAN FLURKEY

Verna Mae Edom Smith

ten, fifteen, or twenty years from now, we would do it the same way, and we would have the same amount of successes.

Our daughter has carried on the family photographic tradition. Verna Mae, or Vme as her friends call her, began her college career at the University of Missouri in 1947. She earned a master's degree in sociology at George Washington University in 1965. Her thesis was "The Application of Photography to the Field of Sociology." She earned her Ph.D. at the University of Maryland in 1981. Her dissertation was a study of migrant children, the result of the influence of Farm Security Administration photographs in the 1930s. Her photographs have appeared on educational television and in several Department of Education, Head Start, and migrant education publications as well as in a number of books and exhibits throughout the country. She is the author of the book *Middleburg and Nearby* and is now a professor at the Northern Virginia Community College in Manassas. Let's let her tell the rest of the story.

VME EDOM SMITH: The reputation of the Missouri Photo Workshop is worldwide. Over two thousand photographers, picture editors, and students have participated in and contributed to its forty years of success. Not only have major publications employed workshop participants, but many newspapers and magazines including *National Geographic, Popular Photography, Modern Photography,* the *Ozark Mountaineer,* the *Missouri Alumni Magazine, Pageant,* and others have published stories on the workshop's successful approach to teaching picture thinking. Some who have attended the workshop have claimed it has changed the way they look at their personal lives and the way they see their profession—a profession that has never been merely a nine-to-five occupation, but always a twenty-four-hour challenge.

What is the Missouri Photo Workshop? How did it start? Who was responsible?

General Robert E. Lee is given credit for the idea of instruction in journalism in 1869, according to Sara

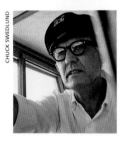

Charles S. Martz, **top**, and J. K. Burney, founded The Aurora School of Photo-Engraving in 1931. The Edoms credit the school with contributing to the development of photojournalism through improved methods of reproduction.

Lockwood Williams in her book Twenty Years of Education for Journalism. Williams quotes Dr. James Melvin Lee from a bulletin published in 1918 by the U.S. Bureau of Education as saying that Robert E. Lee, then president of Washington College (now Washington and Lee), was "seeking to train the youth of the South, not in the ways of war, but in those of peace." Lee was convinced that the press could help solve the problems of the South.

Shortly afterward instruction in journalism became available through English departments and apprenticeship programs around the country. Petitions from students requesting professional training in journalism and lobbying by the Missouri Press Association helped bring about the world's first School of Journalism in 1908 at the University of Missouri. The first courses in Newspaper Illustration offered at the University of Missouri in 1909 taught "pen and ink technique."

It was many years before photography was accepted as an appropriate part of journalism. Laura Vitray, Roscoe Ellard, and John Mills, Jr., in their book *Pictorial Journalism* state, "Any record other than the testimony of words was regarded as a concession to less literate readers." At a time when photographers were referred to as "reporters with their brains knocked out," training, if indeed there was any, often consisted of years of apprenticeship in the darkroom. Many schools refused to teach photography, and where it was taught, textbooks were usually how-to manuals published by manufacturers of photographic supplies or books such as the War Department's *Technical Manual: Basic Photography.*

Cliff Edom, newly appointed head of the photography sequence at the University of Missouri's School of Journalism, wanted photojournalism (a word he coined, according to Del Borer in *Kodak Data-Line,* June 1983) to reflect honesty, sensitivity, and intelligence. He wanted photojournalists to be able to feel and to think beyond the obvious. He wanted photojournalism to reflect professionalism with an academic approach.

Long before coming to Missouri, Cliff began his study of printing and journalism. In 1924 he worked for the *Pike County Times,* the *Pike County Democrat,* and the *Pike County Republican,* all weekly papers in Pittsfield, Illinois, while he attended high school. Following graduation, he attended the Milo Bennett Linotype School in Maumee, Ohio. Later he worked in the circulation department and as a feature writer for the *Quincy* (Illinois) *Herald.* While attending Western Illinois Teachers College at Macomb, he worked in the printery and on the college newspaper. To make ends meet, Cliff also scrubbed floors in the cafeteria and played drums in a theater for silent movies and in dance orchestras. After returning to Pittsfield to another stint with weekly newspapers, Cliff went to Chicago where he worked a year or so at R. R. Donnelley as a proofreader on such publications as *Time* and the *Encyclopaedia Britannica.* Vi was also employed at Donnelley as a proofreader.

Cliff has already described the period from his marriage to Vi until they arrived at the Aurora School of Photo-Engraving. Cliff credits Tasopé's improved method of reproducing engravings with greatly contributing to the development of photojournalism in the nation's small daily and weekly newspapers. Tasopé was founded by Charles S. Martz, who recognized Edom's expertise in education and publications. Both in photoengraving education and in equipment, Tasopé's role was growing nationally. Many small-town editors who purchased the company's equipment echoed the statement of Ainslie R. Davis, *Platte County Record,* Wheatland, Wyoming, who wrote that after installing Tasopé equipment in 1935, "Local pictures have helped us make a 50% increase in circulation."

However, Cliff was appalled at the pictures being used. Not only were many of them bad technically, but they were also awkwardly posed to represent or re-create an event. Print journalists and the general public often saw photographers as gadgeteers lacking in ability and sensitivity, who could illustrate other people's work only if told what to do. Cliff's concern for a better use of photography was evident in his conversations and letters with coworkers and friends.

THE SOUL OF A TOWN

■ IN THE LAST WEEK of May, 1949, Professor Clifton C. Edom of the University of Missouri's School of Journalism conducted one of the most exciting scholastic experiments of the year. Assembling 25 professional and amateur photog... from 10 states, he gave ...class assignment: to ... Columbia ... Uni-

CONTINUED
121

University of Missouri

Workshop In Photo-Journalism

Out in the 'Show Me' state, Cliff Edom and his instructors have been showing photographers how to "see" pictures

By RUSSELL LEE
Chairman of the Workshop Staff

Photographs by THOMAS ABERCROMBIE
Milwaukee Journal—Photographer of the Year

ONE OF the most interesting and unique experiments in photo-journalism for the past seven years has been the University of Missouri Photo Workshop. Photo-journalism is a difficult subject to teach for essentially it requires teaching the student to "see" pictures to ... story. The taking of pictures is ... of photo technique which can be ... most anyone given sufficient time, ... ment and a qualified instructor.

But, how do you teach a person ... do you teach a person to see pict... ject in such a manner that with on... he can tell a complete story to sa... or requirement? And, how do you t... with a camera to see a story in t... vidual yet related pictures, which... tell the full story and individuall... pertinent thought or part of the stor...

In May, 1949, Cliff Edom, Director... Journalism at the University of Mi... ceived the idea for the Workshop an... aid of famous photographers and... brought it into being. That first wor... held in Columbia, Mo., where the Univ... located. The idea behind it was to deve... actual interpretation, by means of photog... of life within a town or community.

The purpose of the workshop is to educ... practice and example; to teach the stud... produce pictures which have meaning, wh... something. It was reasoned that—by hav... students photograph a given subject w... geographically limited area, they could b... to see more clearly. The success of the... workshop in Columbia is a matter of r... duplicated successive years when another... souri town has been photographed in detai...

The workshop is limited to 30 students, ... of whom pays a $30 registration fee to cover... full week of instruction by top notch pict... editors and photographers, plus all of his ph... processing. Additional expenses borne by...

1

Betty Learns About Pictures

Dear Boss:

Because you so kindly consented to my last week's sojourn in the hills, I feel you should have a report of my doings—especially as I have come back empty handed with no pictures for you.

I honestly tried to get a picture story. I will have to explain what happened.

I went to the Photographic Workshop, arranged by Cliff Edom, head of the photo department of the University of Missouri. It was an invitation affair and I felt that it was the only workshop in the country which provided the working photographer with an opportunity to work with others and compare notes, and I was eager to attend.

The group gathered at Columbia on Saturday, May 19, and had a conference on the project and some explanations of the work done the year before. Six of the group of 15 were repeaters who were acquainted with the procedure.

Because of other commitments, I was unable to get there until Monday morning, which was a day and one half late. So I was a stranger among friends, so to speak.

* * *

I ARRIVED at the Ozark Beach hotel, a lovely secluded place, perfect for the meeting, since the season had not yet opened. The group had already

big time, doing magazine free lance work for Life, Pic and other big magazines, in addition to newspaper work.

They were all competent photographers, and I learned a great deal from their work.

Davis Gardner and John Sallis came from the Institute of Design in Chicago where they are majoring in photography.

Ruth Chipp and Clyde "Red"...

it, or could tell the students from the staff.

I studied the assignment of the project, and proceeded as I am accustomed to do on assignments from our paper.

I sorely missed my reporter, which you wisely sent with me, so I spent much of my time getting names and background material for my story.

By the end of my first shoot-

and tired, after driv... miles and having shot 12... and developing them... paper — but with nothin... to my poor showing of... tures from the day bef...

I felt that life was n... the struggle! However,... ned again on a full day... ing the next day to n... for my lack of pictures...

THURSDAY MORN... awoke to the gentle p... rain. I went out, deter... finish my job as best... in spite of it.

It was decided that w... have 15 pictures apiece... workshop presentation... tures would be project... screen and we would... story. Then the firework... as the staff made the... ments.

I shot five more p... some several times to ... sure I had them, and ... ed to the hotel to lea... the dark room was clos...

No more films could... cepted as they already ... many to process. Mr.... and Mr. Ghio did the... ing, and they did a w... job of getting out more t... shots into contact prints...

But I was stuck with... (desperately needed) ... The first presentation...

One of these friends was Dr. H. R. Long, a former editor of a weekly newspaper, the *Crane* (Missouri) *Chronicle*. Long had decided to return to the University of Missouri to earn his master's and Ph.D. degrees. He was the director of the Journalism Extension Service, manager of the Missouri Press Association, and also taught at the university. He encouraged Cliff and Vi to come to the university, where Vi became Long's secretary and Cliff studied journalism.

CLIFF WANTED TO BE ABLE TO QUESTION, CHALLENGE, AND BE CHALLENGED IN FACE-TO-FACE CONFRONTATIONS WITH THE BEST IN THE FIELD. ONE WAY TO DO THIS, HE FELT, WAS BY HONORING OUTSTANDING PHOTOGRAPHERS.

Within three months of Cliff and Vi's arrival at the university, Earl McPeak, the head of photography at the school, joined the navy. A new director was needed immediately. (Cliff had also volunteered for the navy while still living in Aurora, but he was rejected for medical reasons. He was drafted by the army while in Columbia, where again, in his middle thirties and weighing 108 pounds, he was rejected.) The position McPeak vacated involved teaching and making photoengravings for the school's daily newspaper, the *Columbia Missourian*. With fifteen years of experience in the printing and newspaper field, Cliff was qualified professionally, even though he did not meet the academic standard usually required for this position. Nonetheless, Cliff received the appointment, and with his characteristic determination and intensity, he balanced freshman English assignments with class preparations for his photography students, who had more academic credits than he.

Cliff always seemed to be running to catch up, to finish his bachelor's degree, to fulfill teaching requirements, and to find better ways to teach

photojournalism. He wanted to bring the most creative and best minds in the photographic profession to the Missouri campus so that he and his students could learn from them. Cliff wanted to be able to question, challenge, and be challenged in face-to-face confrontations with the best in the field. One way to do this, he felt, was by honoring outstanding photographers. This recognition would be a teaching tool for university students as well as a way to stimulate newspaper management and photographers to improve picture quality.

In 1943, the Pictures-of-the-Year (POY) contest was started. This national contest was open to all professional newspaper, magazine, and freelance photographers. Later, recognition was also given to picture editors. The juries of judges were chosen from outstanding photographers and editors in the field. Judges and the winners were brought to the campus where awards were presented. Thus began a parade of photojournalists to the University of Missouri that reads like a who's who of the profession. In recent years as many as two thousand photographers and editors have submitted forty thousand slides and tear sheets in a single contest. The judging, which used to take a few days, now takes two weeks.

In 1945, simultaneously with the POY contest, the Edoms began Kappa Alpha Mu, the only honorary fraternity of photography in the world. The goal of KAM was to give men and women their own organization to emphasize again the value of photojournalism. Advisory Council members of Kappa Alpha Mu included John R. Whiting, Murray Becker, Vincent S. Jones, Joe Costa, Wilson Hicks, George Ward, Arthur L. Witman, Art Rothstein, and Milton Freier. At one time there were approximately twenty college chapters, each of which pledged and initiated qualified students as well as professional and honorary members.

Cliff read about, met, and corresponded with as many of the leaders in the field of photography as he could. One of those leaders was Roy Stryker, then head of the Farm Security Administration (FSA).

Stryker and Edom were both passionately committed to the intelligent use of photographs. They wanted to encourage photographers to see, feel, and tell a story with truth and honesty. Both recognized the importance of diverse ideas and constantly questioned and provoked people to think.

Stryker believed that the tools of imagination, curiosity, and the will to think were more important than new gadgets and techniques. He urged photographers to educate themselves through the

STRYKER AND EDOM WERE BOTH PASSIONATELY COMMITTED TO THE INTELLIGENT USE OF PHOTOGRAPHS. THEY WANTED TO ENCOURAGE PHOTOGRAPHERS TO SEE, FEEL, AND TELL A STORY WITH TRUTH AND HONESTY.

study of sociology, anthropology, geography, and art. A former economics professor at Columbia University, Stryker involved his students in the real world by taking them to labor-union meetings where some actually walked the picket line.

Guy Rexford Tugwell, Stryker's mentor at Columbia University, was a member of the Brain Trust and an adviser to Franklin D. Roosevelt. He suggested Henry Wallace, a Republican newspaper editor from Iowa, as secretary of agriculture. Tugwell became assistant secretary of agriculture and was instrumental in bringing a number of people to Washington from Columbia University, including Stryker, his former student assistant. Stryker first worked with the Information Division in the Agricultural Adjustment Administration in 1934, which gave him access to the picture files of the Department of Agriculture. Then Stryker worked for the Resettlement Administration, later the Farm Security Administration.

At the time of the Depression of the 1930s, Stryker believed the country needed the impact of reality that could come from photographs. Author F.

Jack Hurley points out that "instead of merely focusing on poor farmers, the photographers working under Stryker's direction captured the relationship between rural poverty and improper land use, the decline of the small farming community, and the growth of urban blight during the depression." These FSA photographs documented the Dust Bowl era in a way that no previous time in our history had been covered. All America was made aware of the "drought refugees" in Texas, plantation owners in Mississippi, migrant families in California, and slum areas in Illinois. The FSA photographs were more widely published and exhibited than any other set of pictures in the United States up to that time. Only Edward Steichen's "Family of Man" series exceeded their breadth of circulation some twenty years later.

When the job was finished at FSA, Stryker became photo director at Standard Oil of New Jersey, where he again gathered photographers and artists to continue to document the American scene. The correspondence between Edom and Stryker at this time included discussions of the documentary work of the Missouri painter George Caleb Bingham, because Cliff had given Stryker one of Bingham's books. Stryker sent Cliff a copy of the April 1946 issue of *Coronet* magazine with the story "Oiltown USA" by Esther Bubley. At Cliff's suggestion, Stryker urged Bubley to submit her photographs to the POY contest. She did, and she became a winner.

Cliff continued to seek better ways to teach and communicate through pictures. He came up with the idea of the Missouri Photo Workshop, where a staff of photographic experts would guide photo students through the documentation of a small Missouri town during a one-week session. With the support of Frank Luther Mott, the dean of the School of Journalism, Robert Ghio, who was in charge of the darkroom, Dr. Long, and Kappa Alpha Mu as co-sponsor, the workshop became a reality.

The "Report on the First Annual Photo Workshop, May 1949," edited by Arlene Lawyer, refers to Cliff as the initiator of the workshop and the secretary of the

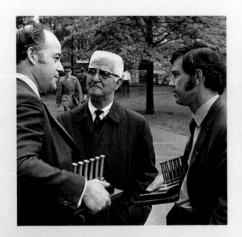

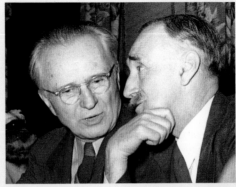

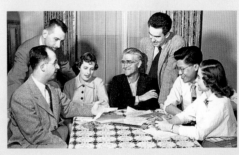

Far left: Cliff Edom with 1969 Magazine Photographer of the Year Bill Garrett and Newspaper Photographer of the Year Perry Riddle following a Pictures of the Year awards presentation.

Left: Edward Steichen of the Museum of Modern Art speaks with George Yates of the *Des Moines Register* at a 1947 Kappa Alpha Mu banquet.

Left: A Kappa Alpha Mu planning session in the Edom home in 1953.

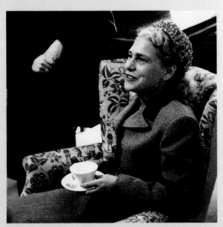

Above: Margaret Bourke-White was a guest of the University of Missouri photojournalism program in 1953.

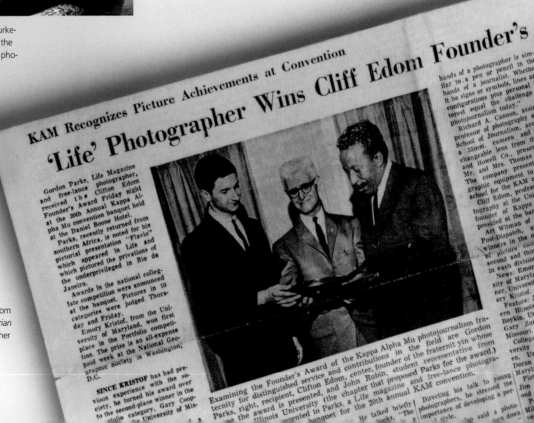

Right: A 1964 clip from the *Columbia Missourian* headlines photographer Gordon Parks.

KAM Recognizes Picture Achievements at Convention
'Life' Photographer Wins Cliff Edom Founder's

Gordon Parks, Life Magazine and free-lance photographer, received the Clifton Edom Founder's Award Friday night at the 20th Annual Kappa Alpha Mu convention banquet held at the Daniel Boone Hotel.

Parks, recently returned from southern Africa, is noted for his pictorial presentation "Flavio" which appeared in Life and which pictured the privations of the underprivileged in Rio de Janeiro.

Awards in the national collegiate competition were announced at the banquet. Pictures in 10 categories were judged Thursday and Friday.

Emory Kristof, from the University of Maryland, won first place in the Portfolio competition. The prize is an all-expense paid week at the National Geographic Society in Washington, D.C.

SINCE KRISTOF has had previous experience with the society, he turned his award over to the second-place winner in the portfolio category, Gary Cooper, University of Mis-

hands of a photographer is similar to a pen or pencil in the hands of a journalist. Whether it be signs or symbols, lines and configurations plus personal interest equal the challenge of photojournalism today."

Richard A. Cannon, assistant professor of photography at the School of Journalism, accepted a 35mm. camera and interchangeable lens from the Mr. and Mrs. Thomas and Howell Co., present The company presents graphic equipment to school for the KAM convention. Cliff Edom, professor of photography at the University founder of Kappa presided at the banquet. Art Witman of the Post-Dispatch, and winners in the other of picture competition second and third in each division News: Emory sity of Maryland ner, University ory Kristof. Feature. J ern Illinois Boykin, Un Gary Zum Missouri. College versity of en, Uni Doran Maryla Pi Jim on

Examining the Founder's Award of the Kappa Alpha Mu photojournalism fraternity for distinguished service and contributions in the field are Gordon Parks, right, recipient, Clifton Edom, center, founder of the fraternity yin whose Illinois University (the chapter that proposed Parks for the award.) presented to Parks, a Life magazine and free-lance photographer from banquet for the 20th annual KAM convention.

He talked briefly Directing his talk to young photographers, he stressed the importance of developing a per-

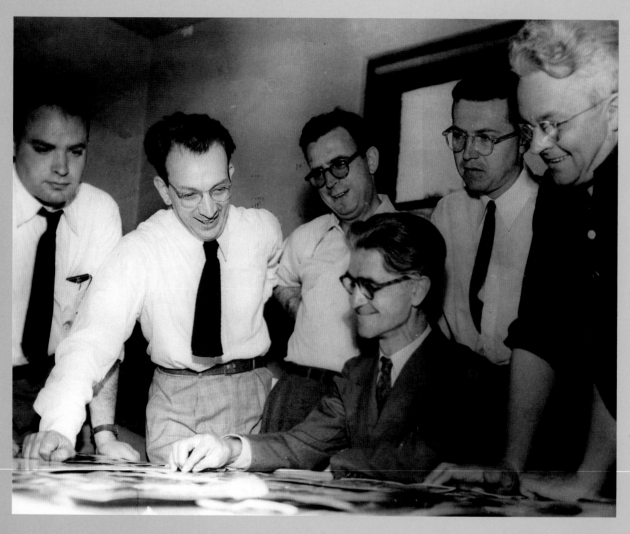

At the Missouri Photo Workshop in Columbia, 1949, were, **left to right:** Harold Corsini, Rus Arnold, Stanley E. Kalish, Cliff Edom, John Morris, and Roy E. Stryker.

"experiment." Cliff was able to recruit five of the world's best-known photojournalists to the workshop staff. They were Stryker, by then photo director of Standard Oil of New Jersey; John Morris, photo editor of the *Ladies' Home Journal;* Stanley Kalish, picture editor of the *Milwaukee Journal;* Rus Arnold, authority on flash photography; and Harold Corsini, magazine and freelance photographer.

Stryker was director of the workshop. In his article "Showing Them in Missouri," which appeared in *Popular Photography* in December 1983, Howard Chapnick recalled that at the beginning of the first workshop, Stryker threw up his hands and at one critical point asked John Morris, "What do we do now?" Without formal lectures, each of the twenty-three students was urged, encouraged, and challenged to shoot his interpretation of a picture story of Columbia. First they were to research the community itself for story ideas. They were to answer the questions, "What makes this community unique? What makes it universal?"

Otha Spencer, in "Photographers Seek Story of a Town in Pictures," published in *Quill* in August 1949, wrote: "Columbia, instead of being a simple college town, developed into an intricate mixture of educators, business men, students, farmers, traders, and the ordinary 'stand on the street' character common to every town. Columbia, upon close inspection, was a city with a race problem, and being situated right on top of the Mason Dixon line, the problem was more than ever evident. Columbia was a city with no industry, whose biggest business was education. It had little or no transportation facilities except for a bus line and an ancient branchline railroad. To complete the picture, local tempers were just beginning to cool off from a very bitter city charter campaign. There was plenty for a good story, but just how to put it into pictures was the problem."

University of Missouri School of Journalism Dean Frank Luther Mott presents a Journalism Medal to Wilson Hicks of *Life* magazine in 1948.

Lawyer and Edom write: "There was little time to rest during Workshop week. Best estimates are that at least 3,000 pictures were taken, processed and printed. Some stayed up all night to shoot pictures or work in the darkrooms. Some met with photographic disasters but refused to be stopped. A Canadian member had to leave his equipment in Chicago because of customs difficulties. The deficit was quickly abridged when a camera was loaned to him by his new friends. Another member shot 24 pictures from the top of the water tower, only to discover later that his holders were empty. Redfaced, he climbed back up the tower and shot all 24 again—this time with his 4x5 film holders loaded. Two photographers remained up until the 'wee small hours' to shoot pictures of the only train which leaves Columbia at night; two others lost plenty of sleep recording 'Early Morning in the City'."

The final work of the staff was to select seventy-five pictures that would tell the story of Columbia. What had been accomplished during the first workshop? Staff and students felt it had been a success. Participants believed they had learned a new way to think about taking pictures. Rus Arnold had warned before the workshop started that it should not be judged by the results of the last day. "The only fair way to judge," he said, "was to see what you have learned, what you have achieved a year, five years and ten years later." Later comments from students seemed to bear out Arnold's admonition.

Twenty-six pictures from the workshop in Columbia were published in Pageant magazine, along with a story on the workshop. Almost at once, this "experiment" was referred to as "The First Annual Workshop." Cliff directed thirty-eight annual workshops before turning over that responsibility to Bill Kuykendall, head of the photojournalism sequence at the University, and Duane Dailey, professor of extension education.

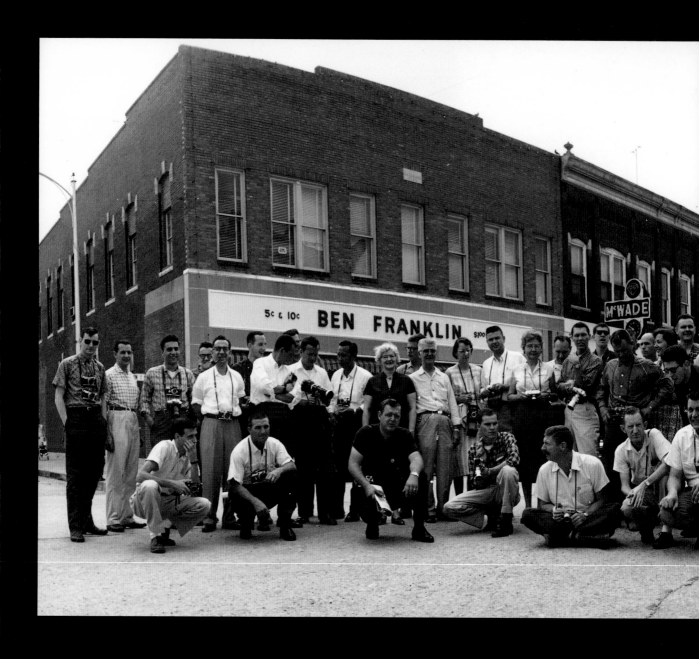

1960
**The workshop faculty
and staff on Main Street
in Aurora.**

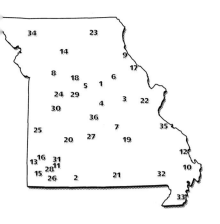

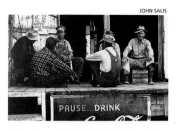

HAL POWER

1949
Columbia

JOHN SALIS

1950
Forsyth

workshop sites

1 Columbia
2 Forsyth
3 Hermann
4 Jefferson City
5 Boonville
6 Mexico
7 Rolla
8 Lexington
9 Hannibal
10 Sikeston
11 Aurora
12 Cape Girardeau
13 Joplin
14 Chillicothe
15 Neosho
16 Carthage
17 Louisiana
18 Marshall
19 Salem
20 Bolivar
21 West Plains
22 Washington
23 Kirksville
24 Warrensburg
25 Nevada
26 Cassville
27 Lebanon
28 Monett
29 Sedalia
30 Clinton
31 Mt. Vernon
32 Poplar Bluff
33 Caruthersville
34 Maryville
35 Osage Beach
36 Ste. Genevieve

faculty

RUS ARNOLD
Sylvania Light Company

HAROLD CORSINI
freelance

STANLEY E. KALISH
Milwaukee Journal

JOHN MORRIS
Ladies' Home Journal

ROY E. STRYKER
Standard Oil Company of New Jersey

▶ *Cliff Edom directed the Missouri Photo Workshops beginning in 1949 until 1986.*

faculty

WILLIAM F. BENNETT
U.S. State Department

ROBIN GARLAND
Graflex

TOWNSEND GODSEY
freelance

STANLEY E. KALISH
Milwaukee Journal

RUSSELL AND JEAN LEE
freelance, Austin

GEORGE YATES
Des Moines Register

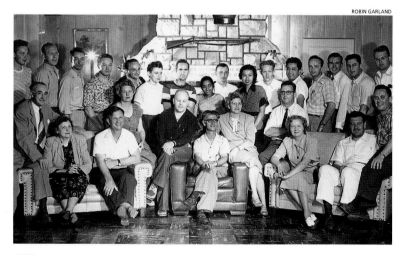

ROBIN GARLAND

1950

Staff and students assemble at the second workshop, in Forsyth. **Back row:** Clyde Hare, Angus McDougall, Don Peterson, Charles Shaw, John P. Salis, Arlene Lawyer, Louis Hendricks, Jaya Patel, Peter Marcus, Ruth Chinn, David Gardner, Tony Martinez, Otha Spencer, Clyde Hostetter, Hal Power, and Howard Sochurek. **Front row:** George Yates (faculty), Mrs. Yates, Russell and Jean Lee (faculty), William F. Bennett (faculty), Cliff and Vi Edom (faculty), Stanley Kalish (faculty), Betty Love, Bob Ghio, and Robin Garland (faculty).

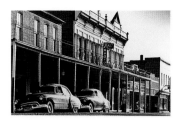

CLYDE HARE

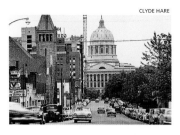

1951

Hermann

1952

Jefferson City

1953

Boonville

faculty

ROBIN GARLAND
Graflex

RUSSELL AND JEAN LEE
freelance, Austin

KURT SAFRANSKI
freelance, Black Star

ARTHUR SIEGEL
Chicago Institute of Design

faculty

ROBIN GARLAND
Graflex

TOWNSEND GODSEY
freelance

RUSSELL AND JEAN LEE
freelance, Austin

GERALD R. MASSIE
Missouri Department of Resources

ARTHUR SIEGEL
Chicago Institute of Design

HENRY SMITH
Indiana University

faculty

BARNEY COWHERD
Louisville Courier-Journal

ROBIN GARLAND
Graflex

CLYDE (RED) HARE
freelance, Pittsburgh

RUSSELL AND JEAN LEE
freelance, Austin

HAL POWER
Shell Oil Company

CLYDE HARE

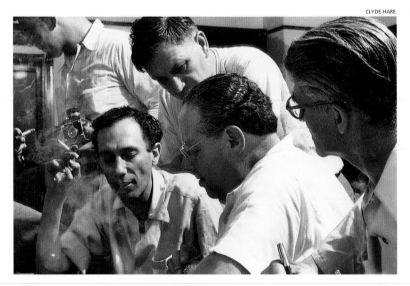

1951
Faculty in discussion in Hermann. **Seated from left:** Arthur Siegel,
Kurt Safranski, and Cliff Edom; **standing:** Russ Lee.

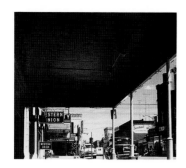

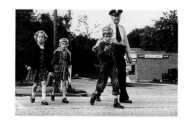

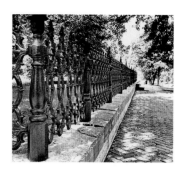

1954

Mexico

faculty

JACOB DESCHIN
New York Times

RUSSELL LEE
freelance, Austin

JOHN MORRIS
Magnum

ARTHUR ROTHSTEIN
Look magazine

1955

Rolla

faculty

ROBERT E. GILKA
Milwaukee Journal

RUSSELL AND JEAN LEE
freelance, Austin

ARTHUR ROTHSTEIN
Look magazine

1956

Lexington

faculty

ROBERT E. GILKA
Milwaukee Journal

RUSSELL LEE
freelance, Austin

ARTHUR ROTHSTEIN
Look magazine

EARL SEUBERT
Minneapolis Star Tribune

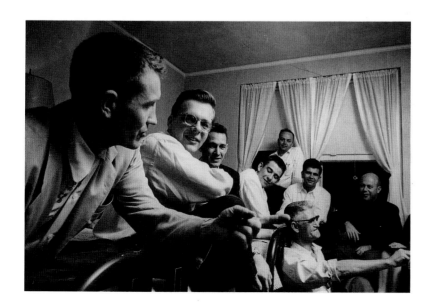

1955
Left: An informal workshop session
in Rolla with Bob Gilka, far left.
Above: Workshop student Lillian Byrum
from Commerce, Texas.

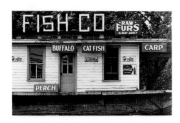

1957

Hannibal

1958

Sikeston

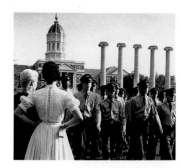

1959

Columbia

faculty

W. E. (BILL) GARRETT
National Geographic magazine

ROBERT E. GILKA
Milwaukee Journal

JAMES M. GODBOLD
Minneapolis Star Tribune

CLYDE (RED) HARE
freelance, Pittsburgh

YOICHI R. OKAMOTO
U.S. Press Service, Washington, D.C.

ROY E. STRYKER
Standard Oil Company of New Jersey

faculty

W. E. (BILL) GARRETT
National Geographic magazine

JAMES M. GODBOLD
Minneapolis Star Tribune

RUSSELL LEE
freelance, Austin

YOICHI R. OKAMOTO
USIA, Washington, D.C.

THOMAS R. SMITH
National Geographic magazine

faculty

ROBERT E. GILKA
National Geographic magazine

RUSSELL LEE
freelance, Austin

YOICHI R. OKAMOTO
USIA, Washington, D.C.

EARL SEUBERT
Minneapolis Star Tribune

THOMAS R. SMITH
National Geographic magazine

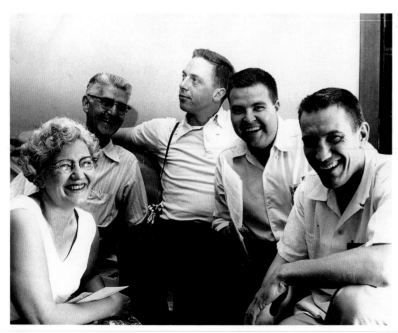

1956
Sharing a moment in Lexington: Vi Edom, Cliff Edom, Clyde "Red" Hare,
Tom Abercrombie, and Bob Gilka.

1960
Aurora

1961
Cape

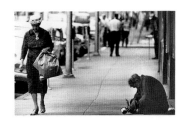

1962
Joplin

faculty

JAMES M. GODBOLD
National Geographic magazine

DON MOHLER
General Electric Company

YOICHI R. OKAMOTO
USIA, Washington, D.C.

EARL SEUBERT
Minneapolis Star Tribune

MAC SHAFFER
Ohio State University

faculty

JAMES M. GODBOLD
National Geographic magazine

RUSSELL LEE
freelance, Austin

ANGUS McDOUGALL
International Harvester World magazine

AL MOLDVAY
Denver Post

YOICHI R. OKAMOTO
USIA, Washington, D.C.

EARL SEUBERT
Minneapolis Star Tribune

faculty

RICH CLARKSON
Topeka Capital Journal

J. EYERMAN
Life magazine

ROBERT E. GILKA
National Geographic magazine

JAMES M. GODBOLD
National Geographic magazine

RUSSELL LEE
freelance, Austin

ANGUS McDOUGALL
International Harvester World magazine

EARL SEUBERT
Minneapolis Star Tribune

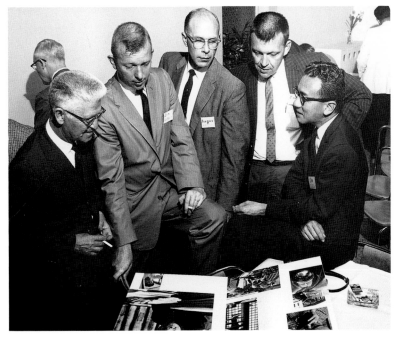

1961
Workshop faculty in Cape Girardeau: Cliff Edom, Jim Godbold, Angus McDougall,
Earl Seubert, and Yoichi Okamoto.

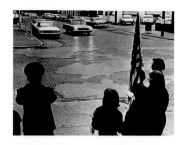

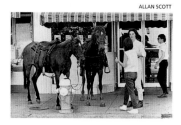

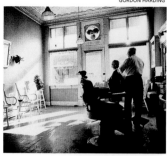

1963

Chillicothe

1964

Neosho

1965

Carthage

faculty

W. E. (BILL) GARRETT
National Geographic magazine

BRYAN HODGSON
Long Beach Press-Telegram

ROBERT HOSOKAWA
Honeywell, Minneapolis

RUSSELL LEE
freelance, Austin

ANGUS McDOUGALL
International Harvester World magazine

SOL MEDNICK
Philadelphia College of Art

EARL SEUBERT
Minneapolis Star Tribune

faculty

W. E. (BILL) EPPRIDGE
Life magazine

ROBERT E. GILKA
National Geographic magazine

RUSSELL LEE
freelance, Austin

ANGUS McDOUGALL
International Harvester World magazine

DON RUTLEDGE
Black Star

PEGGY SARGENT
Life magazine

EARL SEUBERT
Minneapolis Star Tribune

faculty

ROBERT E. GILKA
National Geographic magazine

GEORGE HONEYCUTT
Houston Chronicle

ANGUS McDOUGALL
International Harvester World magazine

CAROLYN PATTERSON
National Geographic magazine

PHELPS (FLIP) SCHULKE
freelance, Black Star

EARL SEUBERT
Minneapolis Star Tribune

BILL SUMITS
freelance, Garden City, New York

ARTHUR L. WITMAN
St. Louis Post-Dispatch

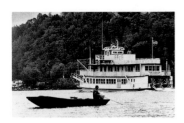

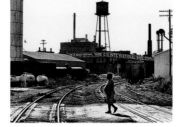

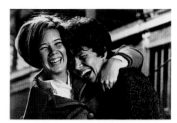

1966

Louisiana

1967

Marshall

1968

Salem

faculty

HOWARD CHAPNICK
Black Star

DECLAN HAUN
freelance, Black Star

DAVID LAWLOR
*Nazarene Publishing Company,
Kansas City*

ANGUS MCDOUGALL
International Harvester World magazine

PEGGY SARGENT
Life magazine

EARL SEUBERT
Minneapolis Star Tribune

THOMAS R. SMITH
National Geographic magazine

STAN WAYMAN
Life magazine

ARTHUR L. WITMAN
St. Louis Post-Dispatch

faculty

CLYDE (RED) HARE
freelance, Pittsburgh

DECLAN HAUN
freelance, Black Star

ANGUS MCDOUGALL
International Harvester World magazine

PEGGY SARGENT
Life magazine

EARL SEUBERT
Minneapolis Star Tribune

THOMAS R. SMITH
National Geographic magazine

WM. H. STRODE, III
Louisville Courier Journal

BILL SUMITS
freelance, Garden City, New York

STAN WAYMAN
Life magazine

ARTHUR L. WITMAN
St. Louis Post-Dispatch

faculty

BILL ALLARD
freelance, Silver Spring, Maryland

HOWARD CHAPNICK
Black Star

ROBIN GARLAND
Graflex

ROBERT GILKA
National Geographic magazine

DECLAN HAUN
freelance, Black Star

ANGUS MCDOUGALL
International Harvester World magazine

JOHN MORRIS
New York Times

EARL SEUBERT
Minneapolis Star Tribune

THOMAS R. SMITH
National Geographic magazine

WM. H. STRODE, III
Louisville Courier Journal

STAN WAYMAN
Life magazine

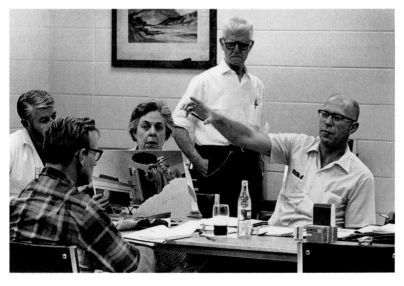

1967
Faculty discuss a story with a student in Marshall. **Facing camera at
table:** Stan Wayman, Peggy Sargent, Cliff Edom, and Angus McDougall.

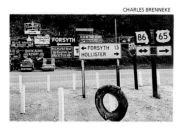

CHARLES BRENNEKE

1969

Forsyth

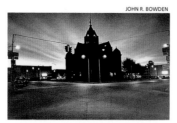

JOHN R. BOWDEN

1970

Bolivar

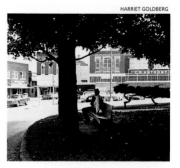

HARRIET GOLDBERG

1971

West Plains

faculty

J. BRUCE BAUMANN
Grand Rapids Press

HOWARD CHAPNICK
Black Star

W. E. (BILL) EPPRIDGE
Life magazine

DECLAN HAUN
freelance, Black Star

ROBIN GARLAND
Graflex

W. E. (BILL) GARRETT
National Geographic magazine

MORRIS GORDON
freelance, New York City

PERRY RIDDLE
Chicago Daily News

THOMAS R. SMITH
National Geographic magazine

WM. H. STRODE, III
Louisville Courier Journal

faculty

HOWARD CHAPNICK
Black Star

RICH CLARKSON
Topeka Capital Journal

W. E. (BILL) GARRETT
National Geographic magazine

ROBERT E. GILKA
National Geographic magazine

TOM KEANE
Wilmington News Journal

ANGUS MCDOUGALL
International Harvester World magazine

PEGGY SARGENT
Life magazine

GARY SETTLE
New York Times, Chicago bureau

EARL SEUBERT
Minneapolis Star Tribune

STAN WAYMAN
Life magazine

faculty

RICH CLARKSON
Topeka Capital Journal

W. E. (BILL) GARRETT
National Geographic magazine

STEVE GROER
freelance, Silver Spring, Maryland

DAVID ALLAN HARVEY
freelance, Richmond, Virginia

DECLAN HAUN
freelance, Black Star

BRIAN LANKER
Topeka Capital Journal

J. WINTON LEMEN
Eastman Kodak Company

ANGUS MCDOUGALL
International Harvester World magazine

IVAN MASSAR
freelance, Black Star

GEORGE SHIVERS
Eastman Kodak Company

WM. H. STRODE, III
Louisville Courier Journal

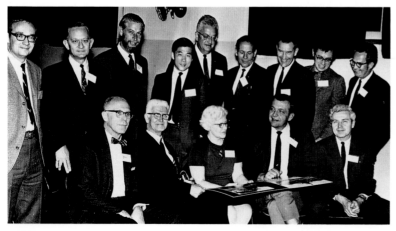

1968

A full-dress affair in Salem. **Back row:** Bill Strode, Howard Chapnick, Stan Wayman,
H. Edward Kim, Harald Baumann, Walter Heun, Robert E. Gilka, Declan Haun, and Thomas R. Smith.
Front row: Angus McDougall, Cliff Edom, Vi Edom, Earl Seubert, and John Morris.

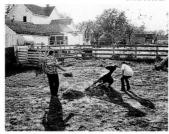

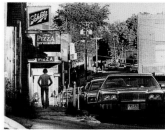

1972

Washington

faculty

J. Bruce Baumann
National Geographic magazine

Howard Chapnick
Black Star

Sterling Clarke
freelance, Richmond, Virginia

Rich Clarkson
Topeka Capital Journal

Robert E. Gilka
National Geographic magazine

Ken Heyman
freelance, New York City

Brian Lanker
Topeka Capital Journal

Robert Madden
National Geographic magazine

K. Kenneth Paik
Kansas City Times

Elie Rogers
National Geographic magazine

Earl Seubert
Minneapolis Star Tribune

Wm. H. Strode, III
Louisville Courier Journal

1973

Kirksville

faculty

Howard Chapnick
Black Star

Rich Clarkson
Topeka Capital Journal

W. E. (Bill) Garrett
National Geographic magazine

Robert E. Gilka
National Geographic magazine

David Allan Harvey
freelance, Richmond, Virginia

Jack Kenward
Farm Industries, Kansas City

Brian Lanker
Topeka Capital Journal

Earl Seubert
Minneapolis Star Tribune

George Shivers
Eastman Kodak Company

Wm. H. Strode, III
Louisville Courier Journal

1974

Warrensburg

faculty

Howard Chapnick
Black Star

Rich Clarkson
Topeka Capital Journal

Bruce Dale
National Geographic magazine

W. E. (Bill) Eppridge
LIFE Magazine

W. E. (Bill) Garrett
National Geographic magazine

Robert E. Gilka
National Geographic magazine

Larry Harper
Missouri Ruralist

Brian Lanker
Topeka Capital Journal

K. Kenneth Paik
Kansas City Times

George Shivers
Eastman Kodak Company

Wm. H. Strode, III
Louisville Courier Journal

1975

Nevada

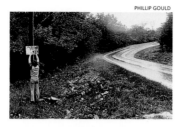

1976

Forsyth

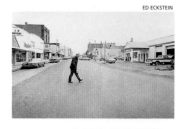

1977

Cassville

faculty

HOWARD CHAPNICK
Black Star

RICH CLARKSON
Topeka Capital Journal

SANDRA EISERT
The White House, Washington, D.C.

RICARDO FERRO
St. Petersburg Times

W. E. (BILL) GARRETT
National Geographic magazine

ROBERT E. GILKA
National Geographic magazine

CHIP MAURY
Associated Press, Boston

WAYNE MILLER
Magnum

K. KENNETH PAIK
Kansas City Times

EARL SEUBERT
Minneapolis Star Tribune

GEORGE SHIVERS
Eastman Kodak Company

WM. H. STRODE, III
Louisville Courier Journal

faculty

HOWARD CHAPNICK
Black Star

RICH CLARKSON
Topeka Capital Journal

SANDRA EISERT
The White House, Washington, D.C.

W. E. (BILL) EPPRIDGE
Life magazine

BRYAN HODGSON
National Geographic magazine

GERALD HOLLY
Nashville Tennessean

RUSSELL LEE
freelance, Austin

CHIP MAURY
Associated Press, Boston

LOU MAZZATENTA
National Geographic magazine

JOHN MORRIS
freelance, New York City

K. KENNETH PAIK
Kansas City Times

EARL SEUBERT
Minneapolis Star Tribune

GEORGE SHIVERS
Eastman Kodak Company

WM. H. STRODE, III
Louisville Courier Journal

faculty

BRUCE BISPING
Minneapolis Star Tribune

RICH CLARKSON
Topeka Capital Journal

JACK CORN
freelance, Goodlettsville, Tennessee

SANDRA EISERT
The Washington Post

W. E. (BILL) EPPRIDGE
Life magazine

W. E. (BILL) GARRETT
National Geographic magazine

JERRY GAY
Los Angeles Times

ROBERT E. GILKA
National Geographic magazine

RUSSELL LEE
freelance, Austin

ROBERT MADDEN
National Geographic magazine

CHIP MAURY
Associated Press, Boston

GEORGE SHIVERS
Eastman Kodak Company

WM. H. STRODE, III
freelance, Prospect, Kentucky

DON STURKEY
Charlotte Observer

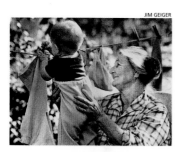

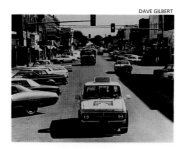

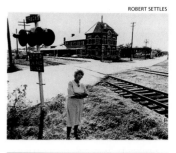

1978

Lebanon

1979

Monett

1980

Sedalia

faculty

HOWARD CHAPNICK
Black Star

RICH CLARKSON
Topeka Capital Journal

DON DOLL, S.J.
Creighton University, Omaha

SANDRA EISERT
The Washington Post

W. E. (BILL) EPPRIDGE
Life magazine

W. E. (BILL) GARRETT
National Geographic magazine

ROBERT E. GILKA
National Geographic magazine

DAVID ALLAN HARVEY
National Geographic magazine

KEN HEYMAN
freelance, New York City

BRIAN LANKER
The Register Guard, Eugene, Oregon

K. KENNETH PAIK
Kansas City Star & Times

EARL SEUBERT
Minneapolis Star Tribune

GEORGE SHIVERS
Eastman Kodak Company

WM. H. STRODE, III
freelance, Prospect, Kentucky

faculty

RICH CLARKSON
Topeka Capital Journal

DON DOLL, S.J.
Creighton University, Omaha

SANDRA EISERT
The Washington Post

W. E. (BILL) EPPRIDGE
Sports Illustrated

W. E. (BILL) GARRETT
National Geographic magazine

ROBERT E. GILKA
National Geographic magazine

CHRIS JOHNS
Topeka Capital Journal

K. KENNETH PAIK
Jacksonville Journal

CHARLES (CHUCK) SCOTT
Ohio University

EARL SEUBERT
Minneapolis Star Tribune

WM. H. STRODE, III
freelance, Prospect, Kentucky

JAMES SUGAR
National Geographic magazine

faculty

BRUCE BISPING
Minneapolis Star Tribune

RICH CLARKSON
Topeka Capital Journal

DON DOLL, S.J.
Creighton University, Omaha

JOHN DURNIAK
Movie magazine, New York City

SANDRA EISERT
Associated Press, Washington, D.C.

W. E. (BILL) EPPRIDGE
Sports Illustrated

W. E. (BILL) GARRETT
National Geographic magazine

ROBERT E. GILKA
National Geographic magazine

GARY SETTLE
Seattle Times

GEORGE SHIVERS
Eastman Kodak Company

RICH SHULMAN
Everett (Washington) Herald

DICK SRODA
Gannett Newspapers, Rochester

WM. H. STRODE, III
freelance, Prospect, Kentucky

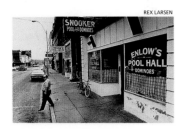

REX LARSEN

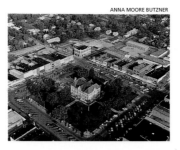

ANNA MOORE BUTZNER

RICK MANSFIELD

1981

Neosho

1982

Clinton

1983

Mt. Vernon

faculty

HOWARD CHAPNICK
Black Star Publishing

RICH CLARKSON
Topeka Capital Journal

JODI COBB
National Geographic magazine

SANDRA EISERT
San Jose Mercury News

W. E. (BILL) EPPRIDGE
Sports Illustrated

K. KENNETH PAIK
Jacksonville Journal

GARY SETTLE
Seattle Times

EARL SEUBERT
Minneapolis Tribune

GEORGE SHIVERS
Eastman Kodak Company

RICH SHULMAN
Everett (Washington) Herald

GEORGE WEDDING
San Jose Mercury News

faculty

HOWARD CHAPNICK
Black Star Publishing

RICH CLARKSON
Denver Post

RANDY COX
Allentown Morning Call

W. E. (BILL) EPPRIDGE
Sports Illustrated

ROBERT E. GILKA
National Geographic magazine

GEORGE LAUR
*Rural Missouri magazine,
Jefferson City*

ANGUS McDOUGALL
University of Missouri

K. KENNETH PAIK
Jacksonville Journal

GEORGE SHIVERS
Eastman Kodak Company

faculty

HOWARD CHAPNICK
Black Star Publishing

RICH CLARKSON
Denver Post

DON DOLL, S. J.
Creighton University, Omaha

SANDRA EISERT
San Jose Mercury News

W. E. (BILL) EPPRIDGE
Sports Illustrated

W. E. (BILL) GARRETT
National Geographic magazine

ROBERT E. GILKA
National Geographic magazine

ANGUS McDOUGALL
University of Missouri

K. KENNETH PAIK
Baltimore Sun

GARY SETTLE
Seattle Times

EARL SEUBERT
Minneapolis Tribune

WILLIAM H. STRODE, III
freelance, Prospect, Kentucky

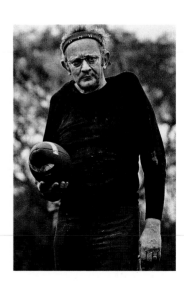

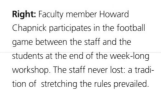

Right: Faculty member Howard Chapnick participates in the football game between the staff and the students at the end of the week-long workshop. The staff never lost: a tradition of stretching the rules prevailed.

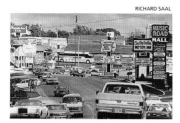

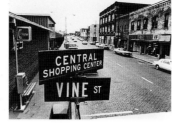

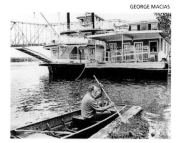

1984

Forsyth

1985

Poplar Bluff

1986

Hannibal

faculty

RANDY COX
Hartford Courant

SANDRA EISERT
San Jose Mercury News

W. E. (BILL) EPPRIDGE
Sports Illustrated

W. E. (BILL) GARRETT
National Geographic magazine

ROBERT E. GILKA
National Geographic magazine

SARAH LEEN
Philadelphia Inquirer

BOB LINDER
Springfield (Missouri) News Leader

ANGUS McDOUGALL
University of Missouri

K. KENNETH PAIK
Baltimore Sun

CHARLES "CHUCK" SCOTT
Ohio University

GEORGE SHIVERS
Eastman Kodak Company

TOM STRONGMAN
Kansas City Star

faculty

RICH CLARKSON
National Geographic magazine

RANDY COX
Hartford Courant

DON DOLL, S.J.
Creighton University, Omaha

SANDRA EISERT
San Jose Mercury News

W. E. (BILL) EPPRIDGE
Sports Illustrated

THOMAS HARDIN
Louisville Courier Journal

SARAH LEEN
Philadelphia Inquirer

BOB LINDER
Springfield (Missouri) News Leader

ANGUS McDOUGALL
University of Missouri

DARLENE PFISTER
Minneapolis Star Tribune

GARY SETTLE
Seattle Times

GEORGE SHIVERS
Eastman Kodak Company

faculty

RICH CLARKSON
National Geographic magazine

JODI COBB
National Geographic magazine

DUANE DAILEY
University of Missouri

DON DOLL, S.J.
Creighton University, Omaha

W. E. (BILL) EPPRIDGE
Sports Illustrated

THOMAS HARDIN
Louisville Courier Journal

BILL KUYKENDALL
University of Missouri

SARAH LEEN
Philadelphia Inquirer

ANGUS McDOUGALL
University of Missouri

RON MANN
*Orange County Register,
Santa Ana, California*

K. KENNETH PAIK
Baltimore Sun

PERRY RIDDLE
Los Angeles Times

GEORGE SHIVERS
Eastman Kodak Company

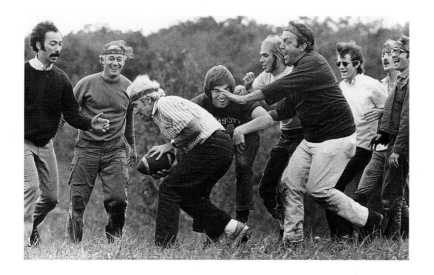

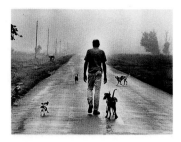

1987

Caruthersville

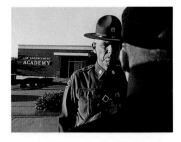

1988

Jefferson City

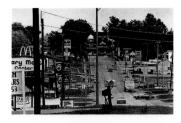

1989

Maryville

faculty

RICH CLARKSON
Clarkson and Associates, Denver

W. E. (BILL) EPPRIDGE
Sports Illustrated

MELISSA FARLOW
Pittsburgh Press

JUDY GRIESEDIECK
San Jose Mercury News

ABIGAIL HEYMAN
*International Center of Photography,
New York City*

JOSÉ LOPEZ
New York Times, Washington, D.C.

BOB LYNN
Virginia Pilot & Ledger Star

ANGUS MCDOUGALL
University of Missouri

K. KENNETH PAIK
Baltimore Sun

GARY SETTLE
Seattle Times

faculty

SAM ABELL
freelance

ALAN BERNER
Seattle Times

HOWARD CHAPNICK
Black Star Publishing

RICH CLARKSON
Clarkson and Associates, Denver

W. E. (BILL) EPPRIDGE
Sports Illustrated

MELISSA FARLOW
Pittsburgh Press

ROBERT E. GILKA
National Geographic magazine, retired

CHRIS JOHNS
freelance, Seattle

SARAH LEEN
freelance, Philadelphia

ANGUS MCDOUGALL
University of Missouri, retired

K. KENNETH PAIK
Baltimore Sun

GEORGE SHIVERS
Eastman Kodak Company

faculty

FRED BLOCHER
Kansas City Times

RICH CLARKSON
Clarkson and Associates, Denver

JAN COLBERT
University of Missouri

DON DOLL, S. J.
Creighton University, Omaha

SANDRA EISERT
San Jose Mercury News

BILL EPPRIDGE
Sports Illustrated

MELISSA FARLOW
Pittsburgh Press

STORMI GREENER
Minneapolis Star Tribune

KENT KOBERSTEEN
National Geographic magazine

JIM RICHARDSON
freelance, Denver

GARY SETTLE
Seattle Times

PAMELA SPAULDING
Louisville Courier Journal

▶ *Bill Kuykendall* and *Duane Dailey,*
both of the University of Missouri, have
codirected the workshops from 1987
to the present.

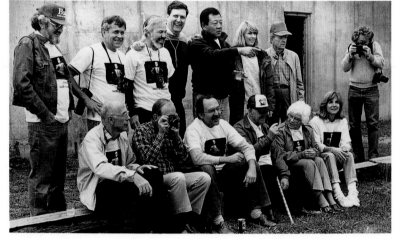

1986
Staff from the last workshop directed by Cliff and Vi Edom, in Hannibal. **Back row:** Duane Dailey, Don Doll, S.J., Perry Riddle, Thomas Hardin, K. Kenneth Paik, Sarah Leen, and George Shivers. **Front row:** Angus McDougall, Rich Clarkson, Bill Kuykendall, Cliff Edom, Vi Edom, and Jodi Cobb.

RICK LOOMIS

1990

Osage Beach

KAY-CHIN TAY

1991

Ste. Genevieve

faculty

RICH CLARKSON
Clarkson and Associates, Denver

SANDRA EISERT
San Jose Mercury News

W. E. (BILL) EPPRIDGE
Sports Illustrated

ROBERT E. GILKA
National Geographic Magazine, retired

STORMI GREENER
Minneapolis Star Tribune

ANGUS MCDOUGALL
University of Missouri, retired

RANDY OLSON
Pittsburgh Press

K. KENNETH PAIK
Baltimore Sun

LOIS RAIMONDO
freelance, New York City

ELI REED
Magnum, New York City

GARY SETTLE
Seattle Times

PAVEL STECHA
Prague School of Fine Art

faculty

RICH CLARKSON
Clarkson and Associates, Denver

DON DOLL, S.J.
Creighton University, Omaha

JOHN DURNIAK
New York Times

SANDRA EISERT
San Jose Mercury News

W. E. (BILL) EPPRIDGE
freelance, Wilmington, Delaware

STORMI GREENER
Minneapolis Star Tribune

CHERYL MAGAZINE
U. S. News and World Report

RANDY MILLER
Detroit Free Press

LOIS RAIMONDO
freelance, New York City

ELI REED
Magnum, New York City

GARY SETTLE
Seattle Times

ZOE SMITH
University of Missouri

MAGGIE STEBER
freelance, New York City

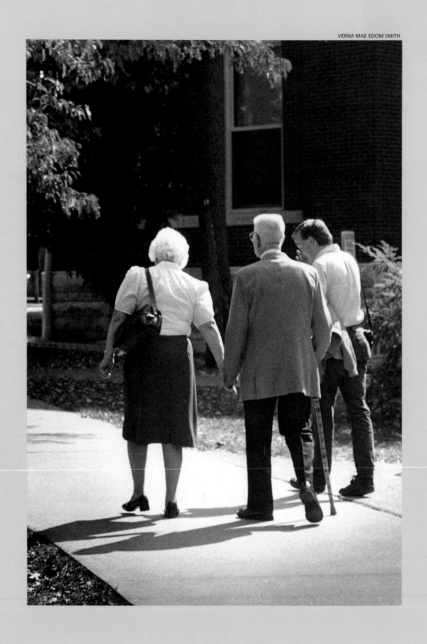

For the past ten years, members of the faculty who have met in these wonderful Missouri towns have talked of those pictures from all the years of the Missouri Workshops. Always, someone would say what a wonderful book they would make.

It was in 1988 that Bill Garrett, then editor of *National Geographic* magazine, suggested that all of us who had taught (and learned) at those workshops needed to pull the pictures together to do a book for Cliff and Vi. As the catalyst, Garrett embarked on a story for the *Geographic* about small towns—with pictures from the Missouri Workshop archives. Cliff and Vi helped the *Geographic* staff by going though the prints, making copy negatives, and researching the material. As director of photography at the *Geographic* at the time, I began thinking about how the material might also be used for a book and an exhibition of prints.

Cliff and Vi weren't just thinking about the possibilities though; they were already working on a compilation of the pictures and had begun writing the history of the Workshops. As the *Geographic* research progressed and Cliff and Vi's book began taking form, it became obvious that a unique and rich trove of Americana had emerged from those Workshop "classrooms."

The Edoms produced a book dummy from their files, calling on their daughter Vme's perspective and Vi's amazing memory. At that point, a small core of Workshop graduates and faculty members joined in to expand upon the book Cliff envisioned. Our hope was to produce something that not only would stand as a record of the Workshop's contribution to American documentary photography but would also be a lasting tribute to the Edoms. Cliff and Vi's modesty didn't allow them to talk of their influence on American photojournalism. In fact, they may not have realized how influential they had been.

While work on the funding, the editing, and the publishing progressed, Cliff passed away. Following his death on January 30, 1991, it was with renewed resolve that Vi, Vme, and the "staff" kept the project moving. Although he never saw this much-anticipated record of the Workshops, all who knew and studied with him can predict what he would have said: "Well, that's pretty good . . ."

And the implication would be that it could have been a little better. Which was exactly the lesson he taught us all at those Missouri Workshops.

— Rich Clarkson

Having a great deal of respect for books and the advantages they give photojournalists, Cliff Edom always recommended that early in their careers photojournalists begin to build a good library. He believed this was as important as buying darkroom and/or camera equipment. The following list was compiled by Cliff before his death and has been supplemented by his daughter, Verna Mae Edom Smith.

Abbott, Berenice. *A Guide to Better Photography*. New York: Crown Publications, 1941.

———. *Photographs: Faces of the Twenties*. New York: Horizon Press, 1970.

Adams, Ansel. *Born Free and Equal*. New York: U.S. Camera Books, 1944.

———. *Yosemite and the Range*. Boston: Little, Brown and Co., 1979.

Adams, Ansel, and Nancy Newhall. *Death Valley*. San Francisco: 5 Associates, 1954.

Anderson, Sherwood. *Home Town*. New York: Alliance Book Corporation, 1940.

Baynes, Ken. *Scoop, Scandal and Strife: A Study of Photography in Newspapers*. New York: Hastings House, 1971.

Beaton, Cecil. *Photobiography*. Garden City, N.Y.: Doubleday and Co., 1951.

———. *Time Exposure*. New York: Charles Scribner's Sons, 1941.

Bischof, Werner. *Japan*. New York: Simon and Schuster, 1955.

Bischof, Werner, et al. *The Concerned Photographer*. New York: Grossman, 1968.

Bluem, A. William. *Documentary in American Television*. New York: Hastings House, 1965.

Bourke-White, Margaret. *The Photographs of Margaret Bourke-White*. Greenwich, Conn.: New York Graphic Society Books, 1972.

———. *Portrait of Myself*. New York: Simon and Schuster, 1963.

Bry, Doris. *Alfred Stieglitz, Photographer*. Greenwich, Conn.: Museum of Fine Arts, Boston, 1965.

Burrows, Larry. *Compassionate Photographer*. New York: Time-Life Books, 1972.

Caldwell, Erskine, and Margaret Bourke-White. *Say, Is This the U.S.A.?* New York: Duell, Sloan and Pearce, 1941.

Capa, Cornell. *The Concerned Photographer 2*. New York: Grossman Publishers, 1972.

Capa, Robert. *Images of War*. New York: Grossman Publishers, 1964.

———. *Slightly Out of Focus*. New York: Henry Holt and Co., 1947.

Caputo, Kim Zorn. *Pictures of Peace*. New York: Alfred A. Knopf, 1991.

Cartier-Bresson, Henri. *The Decisive Moment*. New York: Simon and Schuster, 1952.

———. *The World of Henri Cartier-Bresson*. New York: Viking Press, 1952.

Clark, Joe. *I Remember*. N.p.: Tennessee Squire Association, 1969.

Coles, Robert, and Therese Heyman. *Photographs of a Lifetime / Dorothea Lange*. Millerton, N.Y.: Aperture, Viking, Penguin, 1982.

Cookman, Claude. *A Voice Is Born*. Durham, N.C.: National Press Photographers Association, 1985.

Costa, Joe. *The Complete Book of Press Photography*. New York: National Press Photographers Association, 1950.

Davis, Phil. *Photography*. Dubuque, Iowa: William C. Brown Co., 1972.

Doisneau, Robert. *Paris*. New York: Simon and Schuster, 1956.

Doll, Don, S.J. *Crying for a Vision*. Dobbs Ferry, N.Y.: Morgan and Morgan, 1976.

Duncan, David Douglas. *Self Portrait: U.S.A.* New York: Harry N. Abrams, 1969.

———. *War without Heroes*. New York: Harper and Row, 1970.

———. *Yankee Nomad*. New York: Holt, Rinehart and Winston, 1966.

Edey, Maitland. *Great Photographic Essays from LIFE*. Greenwich, Conn.: New York Graphic Society Books, 1978.

Edgerton, Harold E., and James R. Killian, Jr. *Flash: Seeing the Unseen by Ultra-High Speed Photography*. Boston: Hall, Cushman and Flint, 1939.

Edom, Clifton C. *The Great Pictures 1948*. New York: Garden City Publishing Co., 1948.

———. *Photojournalism, Principles and Practices*. Dubuque, Iowa: William C. Brown Co., 1976, 1980.

Eisenstaedt, Alfred. *Eisenstaedt's Album*. New York: Viking Press, 1976.

———. *People*. New York: Viking Press, 1973.

———. *Witness to Our Time*. New York: Viking Press, 1966.

Emmet, Herman Leroy. *Fruit Tramps*. Albuquerque: University of New Mexico Press, 1989.

Erwitt, Elliott. *Recent Developments*. Visual Books, 1978.

Evans, Harold. *Pictures on a Page*. New York: Holt, Rinehart and Winston, 1978.

Evans, Walker. *American Photographer*. New York: Museum of Modern Art, 1938.

—. *Message from the Interior*. New York: Eakins Press, 1966.

Evans, Walker, and James Agee. *Let Us Now Praise Famous Men*. New York: Houghton, Mifflin Co., 1936.

Frank, Robert, and Jack Kerouac. *The Americans*. Millerton, N.Y.: Aperture, 1969.

Garrett, W. E. *Photojournalism/76*. Louisville, Ky.: National Press Photographers Association, 1977.

Gernsheim, Helmut and Alison. *The Recording Eye: A Hundred Years of Great Events as Seen by the Camera, 1839-1939*. New York: G. P. Putnam, 1960.

Gidal, Tim M. *Modern Photojournalism, 1910-1933*. New York: Macmillan Publishing Co., 1973.

Goldsmith, Arthur. *The Eye of Eisenstaedt as Told to Arthur Goldsmith*. New York: Viking Press, 1969.

Haas, Joseph, and Gene Lovitz. *Carl Sandburg: A Pictorial Biography*. New York: G. P. Putnam's Sons, 1967.

Hare, Clyde. *Luke Swank*. Pittsburgh: Carnegie Institute, 1980.

Heyman, Ken. *The Color of Man*. New York: Random House, 1968.

Hicks, Wilson. *Words and Pictures*. New York: Harper and Brothers, 1952, Arno Press, 1972.

Holme, Bryan, and Thomas Forman. *Poet's Camera: Selection of Photographs*. New York and London: Studio Publications, 1946.

Horan, James B. *Mathew Brady: Historian with a Camera*. New York: Crown Publishers, 1955.

Hubbard, Jim. *Shooting Back: A Photographic View in Time by Homeless Children*. San Francisco: Chronicle Books, 1991.

Hurley, F. Jack. *Marion Post Wolcott*. Albuquerque: University of New Mexico Press, 1989.

—. *Portrait of a Decade: Roy Stryker and the Development of Documentary Photography in the 30's*. Baton Rouge: Louisiana State University Press, 1972.

—. *Russell Lee Photographer*. Dobbs Ferry, N.Y.: Morgan and Morgan, 1978.

Jackson, Clarence S. *Picture Maker of the Old West: William Henry Jackson*. New York: Charles Scribner's Sons, 1947.

Jensen, Oliver, Joan Paterson Kerr, and Murray Belsky. *American Album*. New York: Simon and Schuster, 1968.

Jones, Jacqueline. *The Dispossessed: America's Underclasses from the Civil War to the Present*. New York: Basic Books, 1992.

Kalish, Stanley E., and Clifton C. Edom. *Picture Editing*. New York: Rinehart Co., 1951.

Karsh, Yousuf. *Portraits of Greatness*. Nashville: Thomas Nelson and Sons, 1959.

Korn, Jerry. *Photojournalism*. New York: LIFE Library of Photography, 1971.

Lange, Dorothea. *The American Country Woman: Photographic Essay*. Fort Worth: Amon Carter Museum, 1967.

—. *Dorothea Lange, Documentary*. New York: Museum of Modern Art, 1966.

Lanker, Brian. *I Dream a World*. New York: Stewart, Tabori and Chang, 1989.

Lewis, Harold. *Photography Year Book, 1949*. London: Journal of Photography, 1949.

Lieberman, Archie. *Farm Boy*. New York: Harry N. Abrams, 1974.

Light, Ken. *To the Promised Land*. N.p.: Aperture/California Historical Society, 1988.

Light, Ken, and Paula DiPerna. *With These Hands*. New York: The Pilgrim Press, 1985.

Literary Guild, N.Y. *America and Alfred Stieglitz*. New York: Doubleday, Doran and Co., n.d.

Lopes, Sal. *The Wall: Images and Offering from the Vietnam Veterans Memorial*. New York, Collins, 1987.

Lorentz, Pare. *The River*. New York: Stackpole Sons, 1938.

Lortigue, J. N., and S. A. Edita. *Boyhood Photos of J. N. Lortigue*. Switzerland: Ami Guichard, 1966.

Lucey, Donna M. *Photographing Montana: The Life and Work of Evelyn Cameron, 1894-1928*. New York: Alfred A. Knopf, 1991.

McCombe, Leonard. *You Are My Love*. New York: William Sloane Associates, 1952.

McDougall, Angus, and Veita Jo Hampton. *Picture Editing and Layout*. Columbia, Mo.: Viscom Press, 1980.

McDougall, Angus, and Gerald D. Hurley. *Visual Impact in Print*. Chicago: Visual Impact, Inc., 1971.

Márquez, Gabriel Garcia, and Peter Matthiessen. *The Circle of Life: Rituals from the Human Family Album*. San Francisco: Harper, 1991.

Memorable LIFE Photographs. Museum of Modern Art, 1951.

Meredith, Roy. *Mathew Brady's Portrait of an Era*. New York: W. W. Norton and Co., 1982.

Mich, Daniel D., and Edwin Eberman. *The Technique of the Picture Story*. New York: McGraw-Hill Book Co., 1945.

Mydans, Carl. *More than Meets the Eye*. New York: Harper and Brothers, 1945.

National Press Photographers Association. *The Best of Photojournalism*. Sponsored by the NPPA and the School of Journalism, University of Missouri. Annual.

Newhall, Beaumont. *The History of Photography*. New York: The Museum of Modern Art, 1964.

———. *Photography: A Short Critical History*. New York: Museum of Modern Art, 1937.

Newhall, Beaumont, and Diana Edkins. *William H. Jackson*. Dobbs Ferry, N.Y.: Morgan and Morgan, 1974.

O'Neal, Hank. *A Vision Shared: A Classic Portrait of America and Its People, 1935-1943*. New York: St. Martin's Press, 1976.

Parks, Gordon. *A Choice of Weapons*. New York: Harper and Row, 1965.

———. *Songs of My People: African Americans, A Self-Portrait*. Boston, Toronto and London: Little, Brown and Co., 1992.

Pollack, Peter. *The Picture History of Photography*. New York: Harry N. Abrams, 1958.

Rayfield, Stanley. *How LIFE Gets the Story*. Doubleday and Co., 1955.

———. *LIFE Photographers: Their Careers and Favorite Pictures*. New York: Doubleday and Co., 1957.

Rees, David. *The University of Missouri*. Marceline: Walsworth Publishing Co., 1989.

Reflections on the Wall: The Vietnam Veterans Memorial. Washington, D.C.: Smithsonian Institution, 1987.

Richardson, Jim. *High School, U.S.A.* New York: St. Martin's Press, 1979.

Riis, Jacob. *How the Other Half Lives*. New York: Charles Scribner's Sons, 1904.

Rosten, Leo. *The Look Book*. New York: Harry N. Abrams, 1975.

Rothstein, Arthur. *Photojournalism: Pictures for Magazines and Newspapers*. New York: American Photographic Book Publishers, 1956.

Rotkin, Charles E. *Professional Photographer's Survival Guide*. New York: American Photographic Book Publishers, 1982.

Salomon, Erich. *Portrait of an Age*. New York: Macmillan Co., 1967.

Sandburg, Carl. *Steichen, the Photographer*. New York: Harcourt, Brace and Co., 1929.

Scherman, David E. *The Best of LIFE*. Alexandria, Va.: Time-Life Books, 1973.

Severin, Werner. "Photographic Documentation by the Farm Security Administration, 1935-1942." Master's thesis, University of Missouri, 1959.

Smith, Verna Mae Edom. "A Survey and Evaluation of the Use of Photography in the Field of Sociology." Master's thesis, George Washington University, 1965.

Smith, W. Eugene. *Let Truth Be the Prejudice*. Milan: Aperture, 1985.

Smith, W. Eugene, and Aileen M. *Minamata*. New York: Alskog Sensorium, 1975.

Smolan, Rick. *A Day in the Life of America*. New York: Collins Publishers, 1986.

Steichen, Edward. *The Bitter Years, 1935-1941: Rural America as Seen by the Photographers of the Farm Security Administration*. Garden City, N.Y.: Doubleday, 1962.

———. *The Family of Man*. Museum of Modern Art, 1955.

———. *A Life in Photography*. Garden City, N.Y.: Doubleday, 1963.

Stieglitz, Alfred. *Exhibition of Photographs*. New York: National Gallery of Art, Smithsonian Institute, 1958.

Strode, Bill. *Barney Cowherd, Photographer*. Louisville, Ky.: Courier Journal, 1973.

Stryker, Roy E., and Nancy Wood. *In This Proud Land: America 1935-43 as Seen in the FSA Photographs*. Greenwich, Conn.: New York Graphic Society Books, 1973.

Student Publications, Inc. *A Week at Kansas State*. Manhattan, Kans.: College Photographers Kansas State University, 1987.

Taft, Robert. *Artist and Illustrators of the Old West, 1850-1900*. New York: Scribners, 1953.

———. *Photography and the American Scene*. New York: Macmillan Co., 1942.

Thomas, F. Richard. *Literary Admirers of Alfred Stieglitz*. Carbondale: Southern Illinois University Press, 1983.

Trachtenberg, Alan. *The American Image: Photographs from the National Archives, 1860-1960*. New York: Pantheon Books, 1960.

Weegee [Fellig, Arthur]. *Weegee's People*. New York: Duell, Sloan and Pearce, 1946.

Weston, Edward. *The Daybooks of Edward Weston*. Rochester, N.Y.: George Eastman House, 1961.

Whiting, John R. *Photography Is a Language*. New York: Ziff Davis Publishing Co., 1946.

Williams, Sara Lockwood. *Twenty Years of Education for Journalism, a History of the School of Journalism, University of Missouri*. Columbia: E. W. Stephens Publishing Co., 1929.

Wright, Richard, and Rosskam, Edwin. *Twelve Million Black Voices*. New York: Viking Press, 1941.